Henri Cartier-Bresson

Henri Cartier-Bresson

Jean Clair

A Bulfinch Press Book
Little, Brown and Company
Boston • New York • London

Translated from the French *Henri Cartier-Bresson: des Européens* by Anthony Rudolf

First published in Great Britain in 1998 by Thames and Hudson Ltd. London

Photographs copyright © 1998 by Henri Cartier-Bresson
Text by Jean Clair and design copyright © 1997 by Maison Européenne
de la Photographie/Seuil
English translation copyright © 1998 by Thames and Hudson Ltd. London,
and Bulfinch Press, Boston

First North American Edition
Second Printing, July 1999

ISBN 0-8212-2522-7

Library of Congress Catalog Card Number 97-75772

Bulfinch Press is an imprint and trademark of Little, Brown and Company (Inc.).

PRINTED IN FRANCE

Europeans

In 1955 a collection of photographs called *Les Européens* was published. It was conceived and designed by Tériade, with a jacket by Joan Miró. Henri Cartier-Bresson had worked on it for five years, a short period if one considers that the celebrated photographs in *Images à la sauvette* (1952, published in English as *The Decisive Moment*) were selected from work spanning twenty years. The book offered a closely woven portrait of Europe after the war: accumulated ruins and the marks of hunger and woe on people's faces still appearing very clearly. In the preface, however, Cartier-Bresson gave a warning: 'Whether you are passing through or staying put, in order to give expression to a country or a situation you must have established, somewhere, close working relations, be supported by a human community; living takes time, roots form slowly....'

Often fertilized by the use of his first Leica, these slowly growing roots emerged during his early travels: Spain and Italy from 1932 in the company of André Pieyre de Mandiargues. The twenty-four-year-old Cartier-Bresson brought back never-to-be-forgotten photographs. Then came the experience of the Popular Front in 1937, that brief interlude of sunshine during an oppressive and threatening time. He followed the progress of the Liberation with the Allied armies, filming it as if, with the acceleration of time, for once he had to document it with a cine-camera; then came more travels in 1955, Germany in particular, Berlin in 1962....

A passionate pilgrim who, at twenty-something, left for Africa – where humidity ruined his first negatives – then Mexico, India, Indonesia, China, the United States, and came back with the same passion. In a regular and quasi-organic motion, following the beat of an adventurous heart, contracting and dilating, returning again and again to the Europe of ancient parapets. From Austria to Portugal, from Sweden to Turkey, from Lapland to Ireland, for half

a century he made a survey of the region which over the years – from the Monnet Plan to the Maastricht Treaty – has started to become our own.

Primarily a place, a landscape, a land perhaps, whose geological components are still discernible. The long row of sand dunes in the north, and the sensation of walking over ground from which the sea withdrew the night before.

Modest little houses sheltering behind dunes and pigs squelching in mud behind low brick walls. Then hills of sandstone, of fine sand, of clay and of sediment which little by little became *terra firma*, where towns have now been built. The plain, stretching to infinity, the long plain which begins in Flanders and ends only in Poland, with its rows of poplars and beeches, its rich, soft pastures, its swamps. A river at last, the Rhine.... A landscape with the precision of a diagram, waterlogged, with its mist, its fog banks, its snows – an ideal North. Why do photographs trace such an accurate portrait of the North, as solidly engraved in our memory as it is inscribed on the negative plates?

The South, a contrasting image, with.... But what is the use of describing it? Here too, who does not remember essential features: Tuscany, the Abruzzi, Spain, a Mediterranean whose components do not blend?

Thus, in the first instance, Cartier-Bresson is this incomparable geographer whose eye, attentive to the accidents of terrain, as well as to the multiple signs marking man's age-old occupation of hollowing out, ridging and hedging the earth by hand, has become the inhabitant of a Europe whose features have suddenly begun to resemble each other. From the Scandinavian shield to the Yugoslavian *karst*, from the Breton granites to the Irish bogs, it is now one country, scorning frontiers and customs posts. He restores the vanished features of rural Europe, strangely silent, where the motor did not exist, and

where everything was still done by draught animals and human hand. Like a lord he holds sway over a single land, imposing on the infinite diversity of cultures, on the deeply cunning anarchy of soil, on the complexity of hills and valleys, on the variety of fields and foliage, on the jumble of roads and fallow, the unity of his eye.

Doubtless, some time is needed before one can understand how the photographer works to domesticate nature, and even bend it to his law. Take, for example, three different landscapes that are surprisingly related: the first of snow-covered slopes by the Rhine, the second of an arid Spanish *mesa*, the third of hills in the south of Portugal. Now, if in reality they differ greatly, the photographic print connects them by a single code.

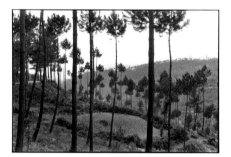

Amarante, Alto Douro, Portugal, 1955

First of all, the land takes up almost the entire sheet, leaving little room for the sky. It rises up before one's eyes, furrowed, divided, slashed, scored by a horizontal network of enclosures, hedges or low walls. Half way up, a curtain of trees, or even its equivalent, a fog bank, presents like some glacier the delicate *velatura* of an atmospheric depth. In the foreground there is a second grid, vertical this time, which completes the grouping of elements across the entire sheet: black boles, equidistant, traced with the rigour of a Mondrian. Organized in this way on the surface, the photograph, now an imperiously planned and austerely geometrical composition, has dissolved the mere accidents of landscape.

Only the greatest painters have known how to impose this imperious unity of an order and an eye on the diversity of all that is visible. Here, after a moment of hesitation, one understands that these represent multiple shots – and not the counterfeit inspiration of chance – taken at different heights in relation to the vanishing line, always finding the

perfect equilibrium between shadow and light, between background and foreground, between the variegated grid layout of the lands and the geometry of the woods.

Panoramas therefore that are always rigorously organized, whatever the nature of their soil, their vegetation or their cultivation. What is it that speaks to us in a European landscape if not this invitation to walk across it, the thrill of crossing it, of penetrating it on foot, so unlike those landscapes of India or America which you can barely traverse with your eye and seem eternally elusive? 'The shadow zone,' writes Julien Gracq, '*then* the sheet of light, *then* the slope to descend, the fordable river, the house already appearing solitary on the hillside, the black wood to cross which the house backs on to, and at the end, the very end, the sun-shot mist like a halo.'

The unquestionable family likeness which emerges from these photographs, over and above the diversity of the localities they illustrate, derives from the obstinate reworking of a chosen subject. Concerning the paintings of Elstir, Proust says that they always present elements of the same world, the unknown quality of a unique world renewed fragment by fragment. Did he not also say of genius (and how apt this remark is to the work of a photographer) that its owner has the power to turn his personality into a mirror, 'genius consisting in reflecting power and not in the intrinsic quality of the scene reflected'? An axiom which a follower of the Tao would not deny, for so strongly does the writer insist here, not on the brilliance of an intelligence, the grandeur of a culture or the worldly quality of a mind – external qualities whose brilliance blurs and obscures the spectacle in which one wishes to bask – but, to the contrary, on this somewhat passive power, on this ability of the body to reflect – unhindered by refraction – the image of life passing by. Out of this affinity with oriental philosophy is born the particular attention that Cartier-Bresson lends to these figures as they sleep, dream and are absorbed by reverie or meditation, absorbed into rather than absent from the world, reconciled, calm, already receptive to another life of glimmering possibilities.

Proust again: 'Each artist seems thus to be the native of an unknown country.' How illuminating his remark is with regard to someone like Cartier-Bresson who has taken such pains to trace the cartography of a continent where the stippling of frontiers and the colouring of nations have yielded to the iridescence of places reunited by one man's attention, one man's love. What better way than through

this artist's eye, this lover's impulse, to express the view that today Europe itself has become the native land of its inhabitants? Doesn't the family likeness which can be traced from one photograph to the next, and which strongly resembles the way Robert Musil tracks changes in the lands of the old Austro-Hungarian Empire, suffice to make us forget we lack the words to explain its makeup – and at a time when the feeble word 'Euro', for example, is being employed, even though beautiful words such as 'florin', 'thaler' and 'écu', which are part of Europe's history, are available? Replace Musil's 'Kakania' by 'Europe', and his analysis of the destiny of the Dual Monarchy appears to announce that of the continent itself: 'And so if one asked a European what he was, he naturally could not answer: "I am from the non-existent European Community represented in Brussels and Strasbourg." If only for this reason he preferred to say: "I'm a Pole, a Czech, an Italian, a Friulian, a Ladin, a Slovene, a Croat, a Serb, a Slovak, a Ruthenian, or a Wallachian." And that was nationalism, so called.... This was, however, the relationship the Europeans had to each other, regarding themselves and one another with the panic and dismay of limbs hampering each other, united as they stood, from being anything at all. Since the earth has existed no being has ever died for want of a name. All the same, that is what happened to the community of Europeans: it perished of its own unutterability.'

Thus, if the mission of the writer is to name things and beings which don't yet have a name, that of the photographer, in this case, is to supply them with the face they are waiting for. Will this endeavour, which has been devolved to artists in advance of economists and technicians, namely to reassemble fragments under a single sign, to designate and to delineate countries and forms, suffice to rescue Europe from anonymity and ruin?

For already in these landscapes, throughout them, we find man. Sometimes man alone, a face, and even, on occasion, the lustre of a single gaze. But also, often, couples. Virtually twin figures, mirrored individuals, linked solitudes. Two women strolling beneath the Athens sun, walkers on the Paris quais, lovers of course. How many couples do we find in Cartier-Bresson's work? But the solitary man, is he ever actually alone? He surprises you, he looks at you, he solicits you; the playful solitude in which he is enclosed already encourages encounters with others. And then, crowds. How many crowds! Does Europe, today invaded by motorcars, still remember its streets, its squares, when they were swarming only with people on foot? Streets for walking

in. May 1968 was possibly the last moment in European history when crowds tasted the pleasure of possessing the street, a pleasure that only the countries of the East still retain to a small extent and not for ever.

From 1937 till the post-war period, Henri Cartier-Bresson traced the portrait of a Europe which was apprehensive, fragile, unstable, a Europe whose nervous image corresponds little with that of today's dull, sad and arthritic Europe. That Europe where often everyone, both young and old, seemed to be constantly on the move, to lead busy lives, to become excited, to chase after pressing affairs, to jump over puddles rather than skirting around them, but also where everyone daydreamed, dozed off, hung about, tippled on the terraces, took their time. Where has that Europe gone?

Looking at these prints from long ago and not so long ago, why am I struck, first of all, by the *bearing* of those people? From the beggar to the banker, from the barrow girl to the academician, from the soldier to the bargee on his boat, everyone, before going out into the street, or rather, as Victor Hugo's Gavroche says when he leaves the shelter of his elephant, before 're-entering the street', everyone dressed up. Nothing slovenly, nothing sloppy, nothing rakish. Cartier-Bresson speaks to us of a Europe antedating the blue uniform of jeans. In that Europe, different colours entered into dialogue with each other: the deep black of Abruzzi peasants under their cloaks and hats; the white of Polish priests in alb or cassock; the bourgeois grey of the City of London with its bowler hats and furled umbrellas; the gold braid of the academician in uniform; the shine on the boots of Russian soldiers; the lustreless caps and blouses of the Lapps; the peasant women of the Algarve with their fichus and calicos, and the *torero* with his suit of lights.... From the dispossessed to the powerful, everyone displayed openly their accoutrements, their weapons and their colours: there the tramp was proud to be a tramp and not ashamed to be 'of no fixed abode'. The blind man holding out his wooden bowl was more at home on his pavement than the 'visually-challenged' person one prefers not to see; in short, a time (says the photographer) when the clothes people wore, like the words they spoke, still had a meaning, when costume like custom meant one thing and not the appearance of its opposite. A sort of pride, when – still valuing the idea of distinction – every person knew how to *make the best of their position*, wherever they were in the pecking order.

Yet poverty is often present during the years stretching from Black October to the very beginning of the Glorious

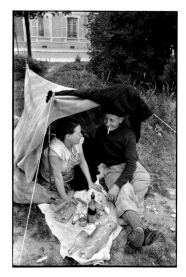

The first paid holidays, France, 1936

Thirties and to the construction of the Berlin Wall: vagabonds, railwaymen, metalworkers, operatives, street hawkers, labourers, odd-job men, cleaning ladies, secondhand dealers, market porters, processions of lost sheep, throngs of nomads, streams of émigrés, displaced persons, never did so many people spill out on to the streets, employed on temporary building sites, moving from more or less fixed places of abode to chance refuge. At the beginning of this twenty-year period, the fragile tents of the first holidaymakers he photographed in their throngs were not so much the banner of a new *Partie de campagne* into which proletarians had finally been permitted, but rather the deceptive emblem of years of wandering. Those who sheltered under fragile tents – hastily erected on river banks – thought they were entering, like the Jews at the end of the Exodus, the Promised Land, in this case the Promised Land of paid holidays. But how many of them, during a sunny spell, smiling trustfully at the wheel of their little Renaults, with their cardboard suitcases and Thermos flasks, suspected they were conducting a trial run for the new living conditions that they would experience as they fled from cities beneath the roar of Stukas which preceded the roll of German Panzer divisions?

At the risk of shocking the reader, I shall say that we can sometimes glimpse elements of the dandy amid the cosmopolitan elegance of this well-bred man. For a long time now there has been an image of Cartier-Bresson as

a turbulent buddhist, an anarchist, a rebel. This is a well-known and accurate portrait. Who has not known his rages, his glamour, his generosity, his eternal impulsiveness? If, however, he had been merely that, apart from the fact that his reputation might quickly have been lost down paths which are now rather well-trodden, indignation alone not being enough on which to base a work, he would not have revealed the qualities which allow one to say that he has possibly the *best eye* of any photographer of our age. By 'best' I mean those qualities which are born of rigour, discipline, reason, classicism. Just as it is not enough, it seems to me, to see him as that admirable photographer of the Midi countryside, that incomparable witness of Italy, Spain and Portugal, preferring, for my part, to discover in him the man of the North he has never ceased to be, this Norman who has given us an unforgettable picture of the landscapes of Flanders, Germany and Sweden. Who does not remember the photograph of the Rhine in snow, more than half iced over, through which three boats glide silently, a surreal vision whose dark brilliance recalls Hölderlin? So, too, I seek in him a figure more secret or less obvious than that of the rebel, at ease among the people, like a fish in water. He is the man who has left striking images of powerful people in this world only because he also belonged in part to their world and therefore knew not only how to bring their secrets to light but also how to avoid being caught in the act.

Thus, if he had not become a photographer, he could have been a diplomat. I imagine him as an ambassador, deploying in his dispatches the dry, precise, spicy and yet delicate style – often containing an unusual and gentle sense of humour – that one finds in the writings of Jean Giraudoux. In fact his photographs are often composed with a particular rigour, elegance, precision, humour and compassion – poised to seize in the coming moment the most appropriate instant, just as the writer knows how to seize the most appropriate word. Both activities require the same sense of being there at the right moment, with that politeness which consists in not being late, in never being burdensome, in just dropping by. Touching the flower lightly without ever plucking it – in a sort of god-given harmony with the calendar, with the clock, with time, never late, never early; refinement of the rarest kind, that of a man at one with time.

And yet it is surely well known that early on some kind of fury had distanced him from his milieu, an impatience incompatible with the standards of his career, a rebellion in complete contrast to professional caution. And what can be

said about the miracle of his art? It was doubtless the ability to blend a style, an order, a form, which allies him to what was most admirable in the French rhetoric of the thirties. At that time, a certain brusqueness, speed and frenzy, a concern with 'convulsive beauty' and 'the savage eye' (as André Breton termed them) led him by a completely different route to the poetry of Breton and the Surrealists. 'We poets', wrote Apollinaire in 1909, within a year of Cartier-Bresson's birth, 'shall henceforth be eternally torn between Order and Adventure...'.

So if there was something in him of Paul Morand's *L'Homme pressé* and Anouilh's *Le Voyageur sans bagage* – for if you want to keep your seat for the duration, you must be on time and travel light – he was also someone who sought out the chance meetings Breton describes in *Nadja* and *Poisson soluble*, and for whom every street corner, every crossroads, every sign and every doorway signified surprise and promise. But, I repeat, the miracle is that, although he

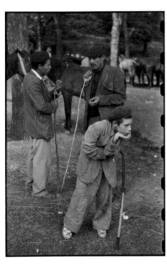
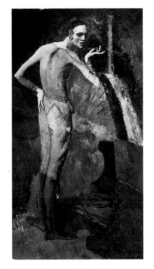

Livestock market, Fiesta de San Fermín, Pamplona, Spain, 1952

Pablo Picasso, *The Actor*, 1904– 1905 © Succession Picasso 1997

had learned, as he says, 'to fish around in the rubbish of chance and the unconscious' (André Breton, *Roi Soleil*, Fata Morgana, 1995), he knew how to invest these ragman's dawn finds with the imperious form of necessity, with the sunlit clarity of consciousness.

I have always admired the incomparable sureness of touch with which Cartier-Bresson poured the most incidental aspects of life into a mould of eternity. How, for example, did he discover in the posture of this boy photographed at a livestock market in Pamplona, with his legs slightly apart,

his head inclined, his chin resting on his hand with its unusually long fingers, virtually the same pose that Picasso gives his *Actor* in the painting in New York's Metropolitan Museum of Art? How does he manage to give his washerwomen the corporeity of the *kore* of the Erechtheion? Only an eye practised since childhood in effortlessly and spontaneously appreciating the treasures of the museums of the West, combined with early lessons in anatomy, would be capable of such *style*, such classical rigour; and only such an eye, contrary to all the silences and stammerings, could *follow up* the questions posed by the present.

Having arrived at maturity, he has retained the dreamy look of childhood beneath the luminous brow of an old Chinese man, as much at ease in the community of scholars as he is familiar with the treasures of humble folk. I find it easy to imagine him as a student at Cambridge, daintily pouring out tea for Lady Frazer, with the practised composure of the ethnologist he had already become, preparing himself at the beginning of the thirties for his first campaign on the territory of the working class.

Now, as a wizard of speed, he needed a certain lightness of touch, something airy, mercurial. Hermes, god of commerce and of thieves, could well be the god of photographers. With quicksilver as the escutcheon of his equipment, this disciple of hermetic knowledge, borrowing the powers of the god with winged hat and shoes, sets out to purloin the fulgurating moment at the crossroads of appearances and to conserve something of Mercury's spark. As a stealer of fire, the photographer makes a career out of always remaining invisible or at least, like a thief at the fair, of not being spotted while he pilfers.

For these moments which have escaped from time are nonetheless mere *nothings*, and mere nothings three times over. A peculiar magnetic attraction happens when one reads writers' journals. Throughout the journals of those great Europeans who lived, as it were, in the intimacy of a spiritual continent – Thomas Mann, Stefan Zweig, André Gide, Paul Valéry – one also finds domestic jottings, reminders of appointments, memory joggers, unimportant meetings, small facts of little interest. And yet, though we may be fascinated by these endless offerings of trivia, one never follows them up. Disconcerted, one notes carefully what they are saying, but, without stopping, one sweeps past them. Those nothings existed, that event really happened, once and for ever – and in this 'for ever' resides the sudden shadow cast by a moment of eternity. Those

simple words have been spoken once, and once only, with that intonation. Those gestures, so ordinary, were made – the evidence speaking more loudly than Tolstoy's account of the din of the Battle of Austerlitz. Somewhere amid these confidences, in this whispered and continuous tone, far from the great feats of History – although sometimes they too require recognition and briefly noise abroad the distant hum of daily life – the work of the photographer has its place. His assays in this field mysteriously produce the same conviction. Those ordinary people, those exchanged looks, those gestures of simple affection, those manners, that light step, that awkward gait, that eye raised for a moment towards the sky, that furtive surrender or that unexpected way of regaining self-control, that silhouette projected in an alleyway or that motionless shadow of a fleeting sun in the square, that woman passing by – all that, before the curtain falls, a flashing glance before night falls, all that took place, all that existed. See, all you have to do is lean closer to decipher their traces. And we read these photographs with the same emotion with which we read writers' journals. They speak of the same daily ceremony, of the sweet and painful doggedness of people in the ongoing business of living, just as there is a ceremony of darkness to help them die, whose virtue lies in being repeated, and whose nature, as with the pious souls who believed that without daily prayer the world would be destroyed or ruined, allows the everyday to continue existing.

Is there any word more beautiful than 'journal', a word so compromised? The ritual of light, heliophany, the citizen's daily prayer at each revolution of the sun, the salutation offered up to human solidarity, the *memento vivendi* of those who have done us the favour of being our contemporaries. The photographer is their celebrant.

Suspicion briefly enters our minds. Did these moments ever really exist? Did these crowds ever really gather? Were these posters rousing people to action ever really stuck to walls? These ploughed fields, these exchanged looks, these events, were they real? It is indeed difficult to believe that we are the inheritors of this history written before our eyes, given the extent to which characters, faces, manners, clothes, landscapes, streets, houses, even the way we swing or raise or fold our arms, will have changed in the space of half a century. Everything would be but the veil of Maya if the photographer's roll of film, faithfully turning like a monk's prayer wheel, had not recorded their ineffaceable and pious traces.

There are times when one would like words to have the lightness of images, to settle on things with the delicacy of a feather. I envy the agility of the photographer's grasp. Hardly has a word been formed than it is weighed and tips the scale. Never exactly right. Always a little too heavy for what it has to say. Doubtless one can change it, find another. But each time its weight is measured in ink and lead. Doubtless one can amend it, correct it, nuance it, make it more explicit. But this is to pile weight on to existing heaviness. A photograph retains the light and airy aspect of the camera's click. It is like the 'dicky bird' which, it is said, emerges when the shot is taken: little soul, Hadrian's *animula, vagula, blandula*, it escapes to animate, to breathe life into the photographer's negative, and therefore all people are right to fear its power. It sides with the angels, Daniel, Ariel, Gabriel, the sound of its wings a murmur across the sky, while the word remains grey and grounded. There is no escape from words, but photography is blessed with the gift of grace. The print, once selected, remains both immaterial and irrefutable. As a writer, too bound to the soil, I envy Cartier-Bresson his being, in the manner of the angels, the messenger of the gods, someone who enables men to inhabit their own homeland.

Jean Clair

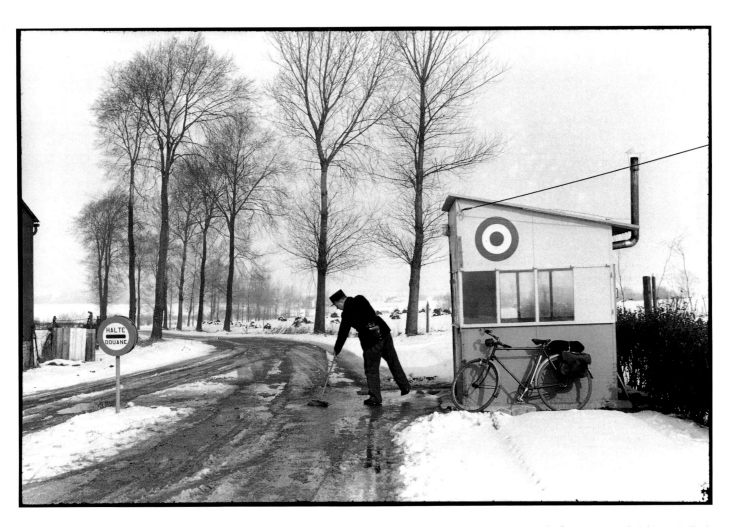

The frontier post with Belgium, Bailleul,
France, 1969

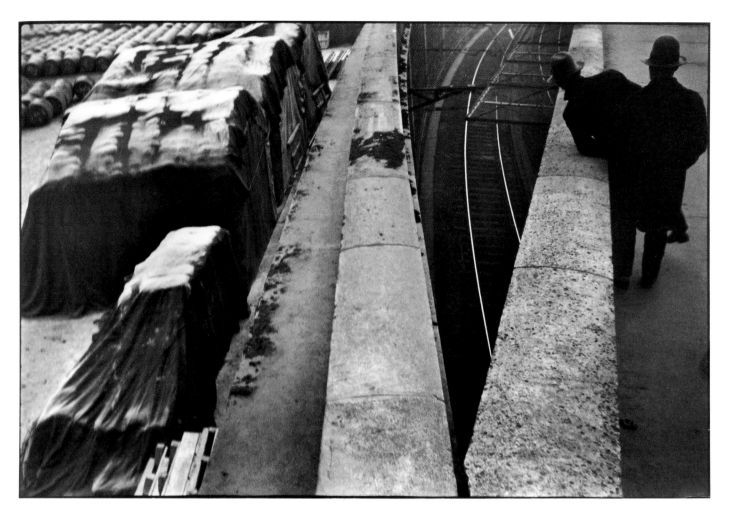

Quai Saint-Bernard, Paris, France, 1932

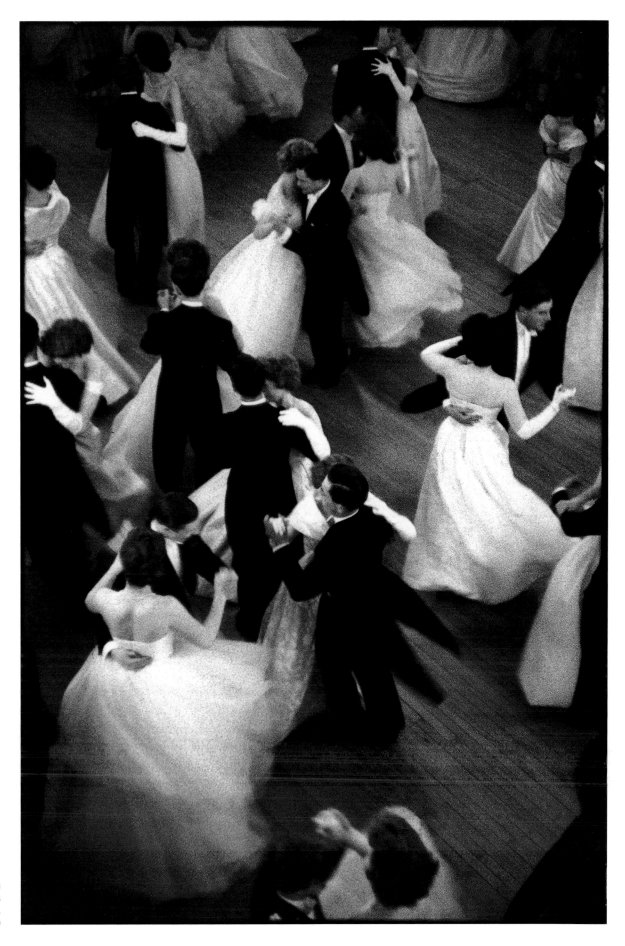

Queen
Charlotte's
Ball, London,
England, 1959

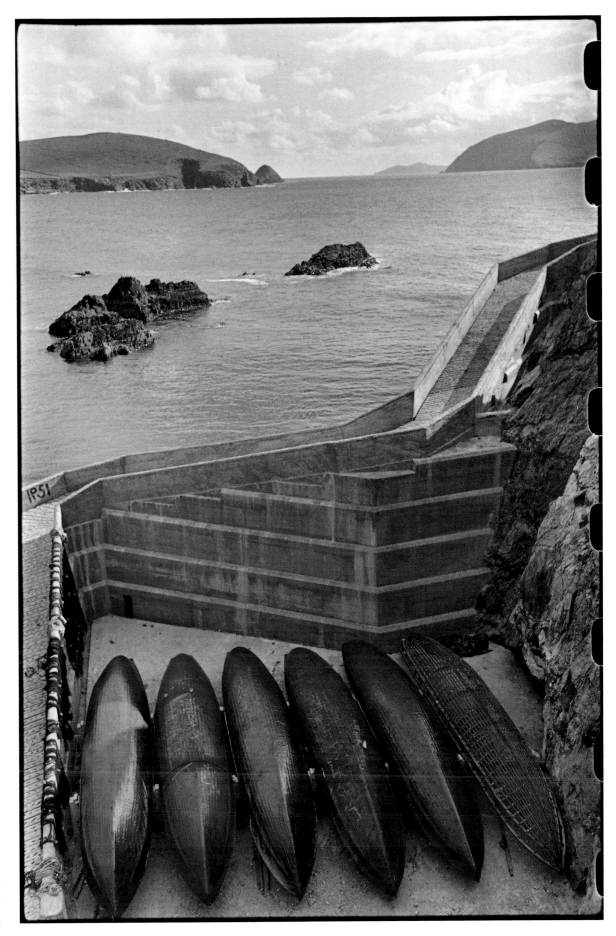

The Dingle
Peninsula,
County Kerry,
Ireland, 1952

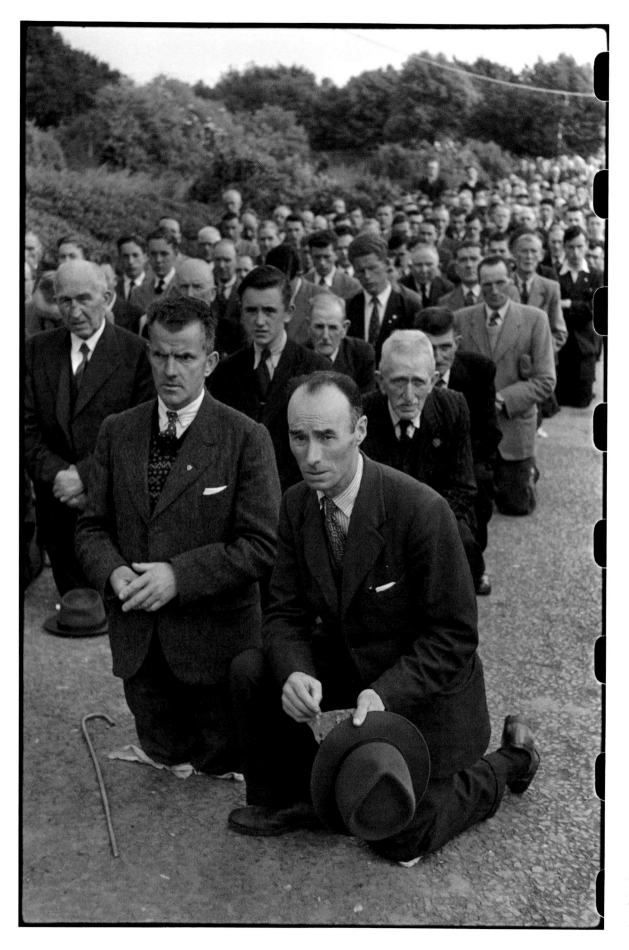

Corpus Christi
procession, Church
of Corpus Christi,
Dublin, Ireland,
1952

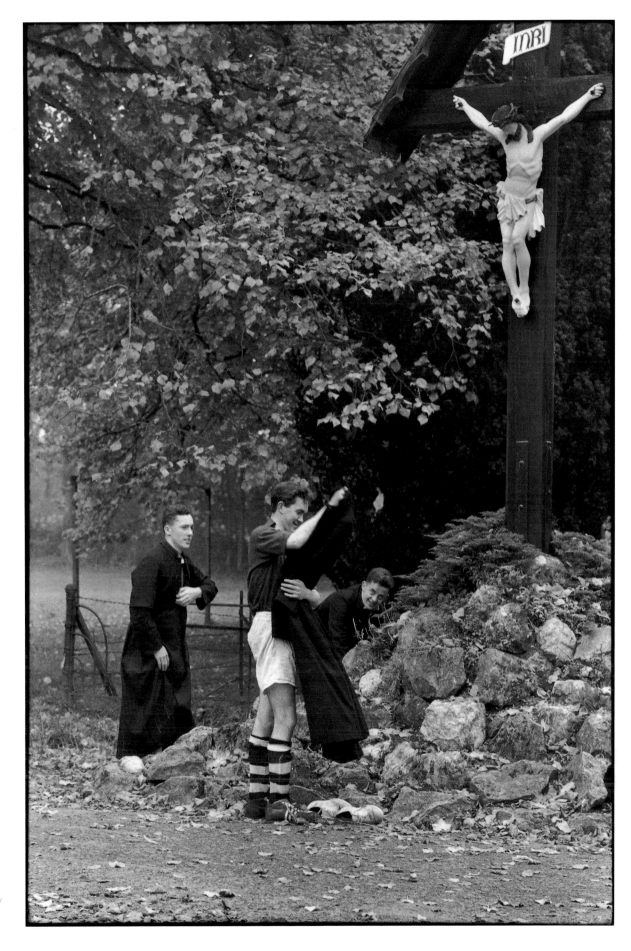

Main seminary,
Maynooth, County
Kildare, Ireland,
1962

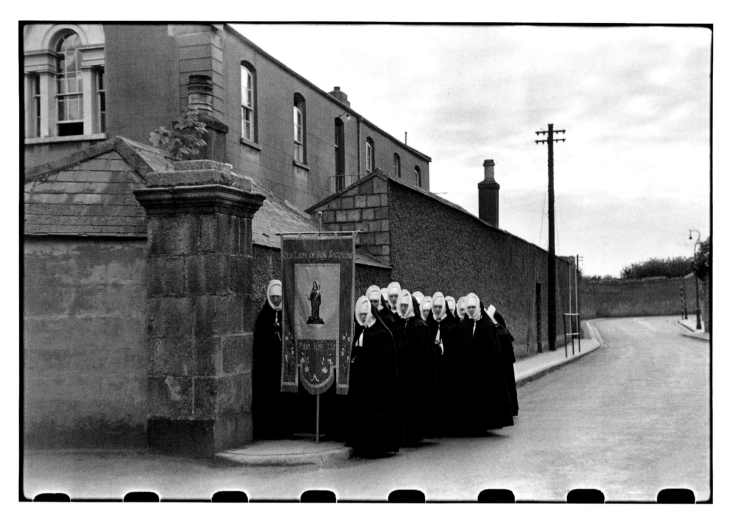

Tralee, County Kerry, Ireland, 1952

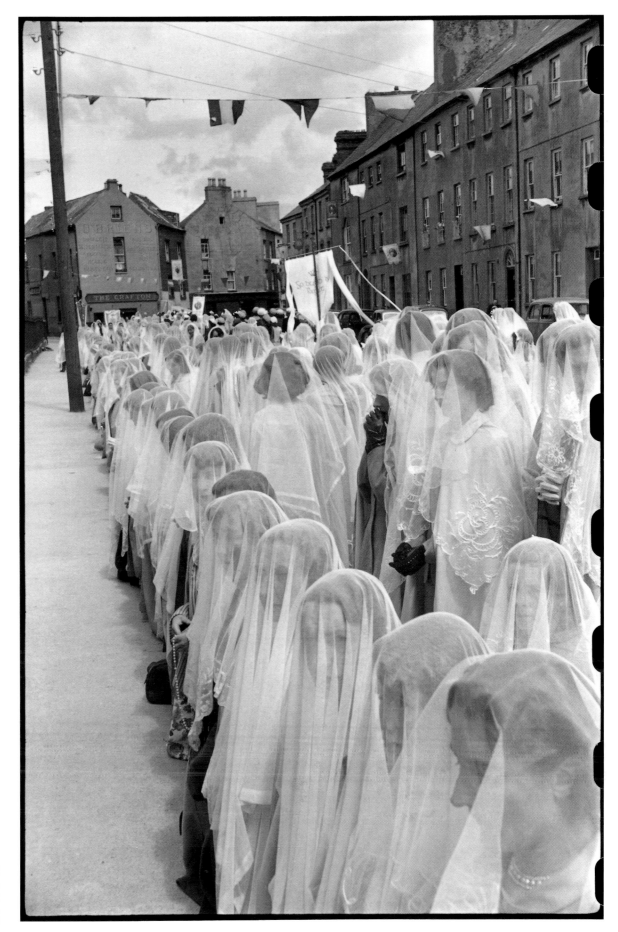

Corpus Christi
procession,
Tralee, County
Kerry, Ireland,
1952

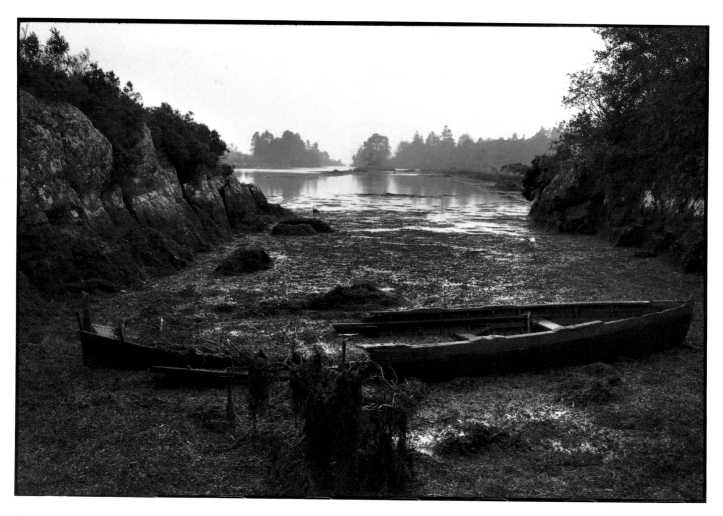

Bantree, County Kerry, Ireland, 1962

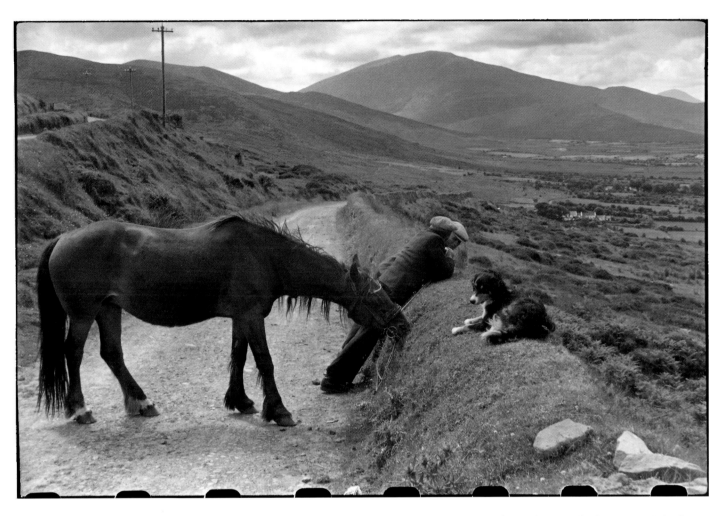

The Dingle Peninsula, County Kerry, Ireland, 1952

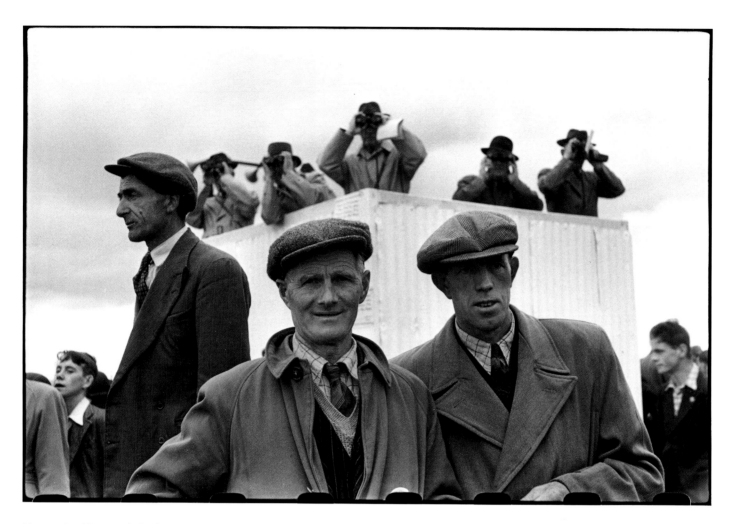

Horse racing, Tipperary, Ireland, 1952

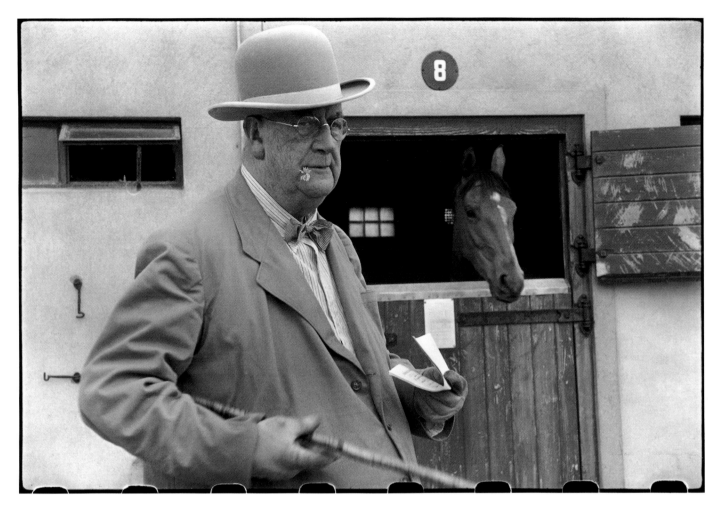

At the Curragh racecourse, Dublin, Ireland, 1952

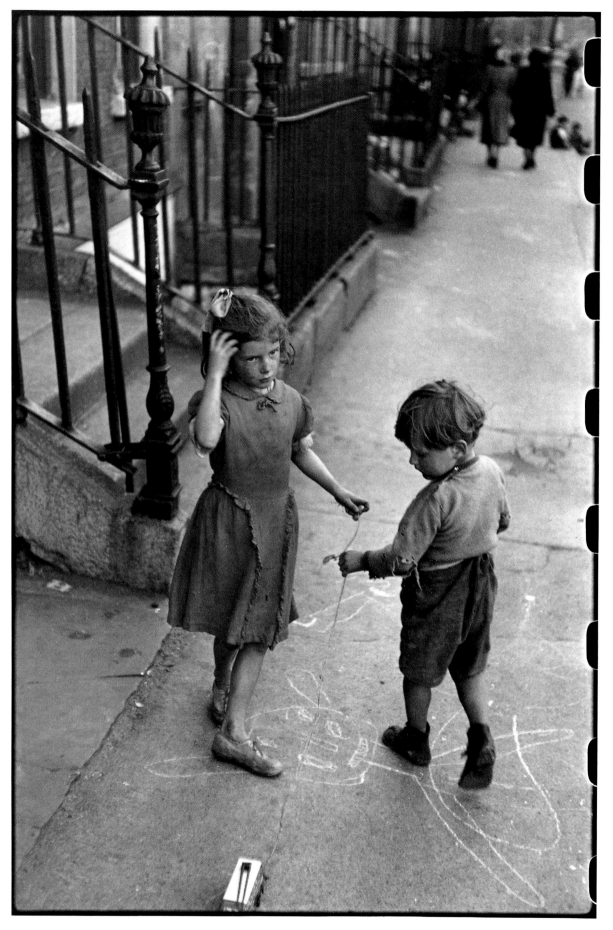

Dublin, Ireland,
1952

Acknowledgments

I would particularly like to thank Jean-Luc Monterosso, the entire team at La Maison Européenne de la Photographie and Maurice Coriat, who organized the presentation of the photographs after carrying out considerable research in the archives with the help of Marie-Pierre Giffey, Magnum's archivist, Martine Franck and Marie-Thérèse Dumas, who co-ordinated everything.

Many thanks to Daniel Mordac and Marie-Pierre Bride of Pictorial Service, without whom there would not have been any prints to look at nor any catalogue.

Thanks are due many times over to Élisabeth Chardin and Jean-François Couvreur for producing this book and to Jean Clair for his fine analysis of Europe.

HENRI CARTIER-BRESSON

La Maison Européenne de la Photographie and Henri Cartier-Bresson particularly wish to thank the Fondation d'Entreprise of Reader's Digest France, Madame Danièle Franck, President and Director-General of *Sélection du Reader's Digest*, and Monsieur Jean-Stanislas Retel, Director of the Fondation d'Entreprise of Reader's Digest France.

This edition was published on the occasion of the exhibition *Henri Cartier-Bresson: Europeans* at the Hayward Gallery, London, 5 February – 5 April 1998.

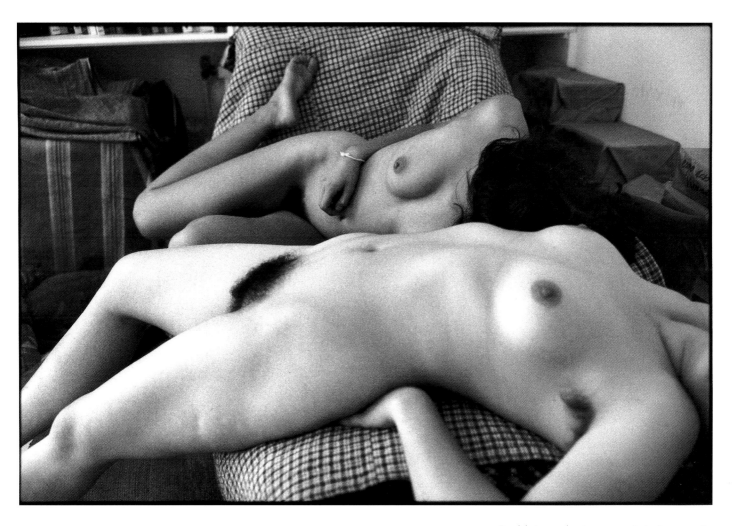

Break between drawing poses, Paris, France, 1989

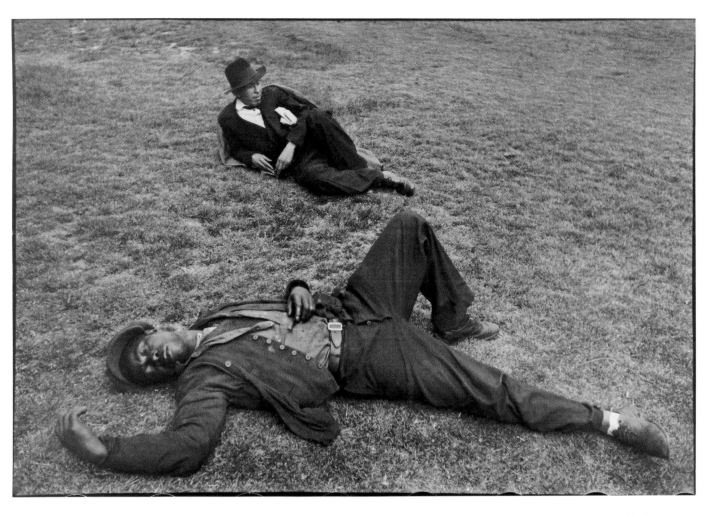

Marseille, France, 1932

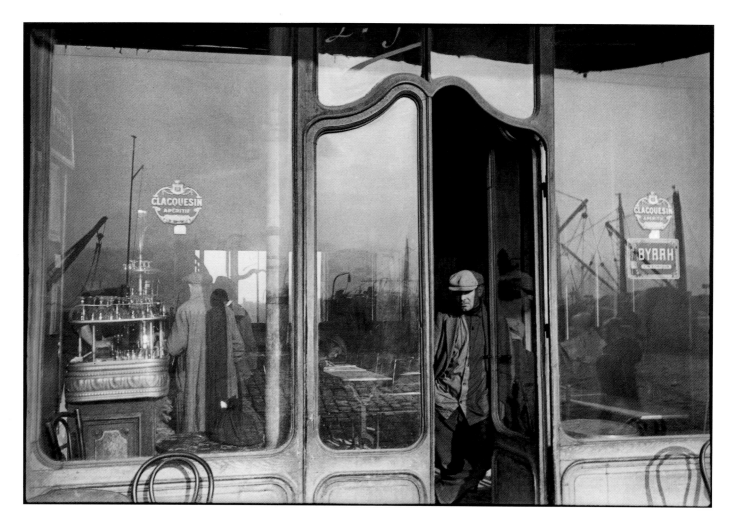

The Old Port, Marseille, France, 1932

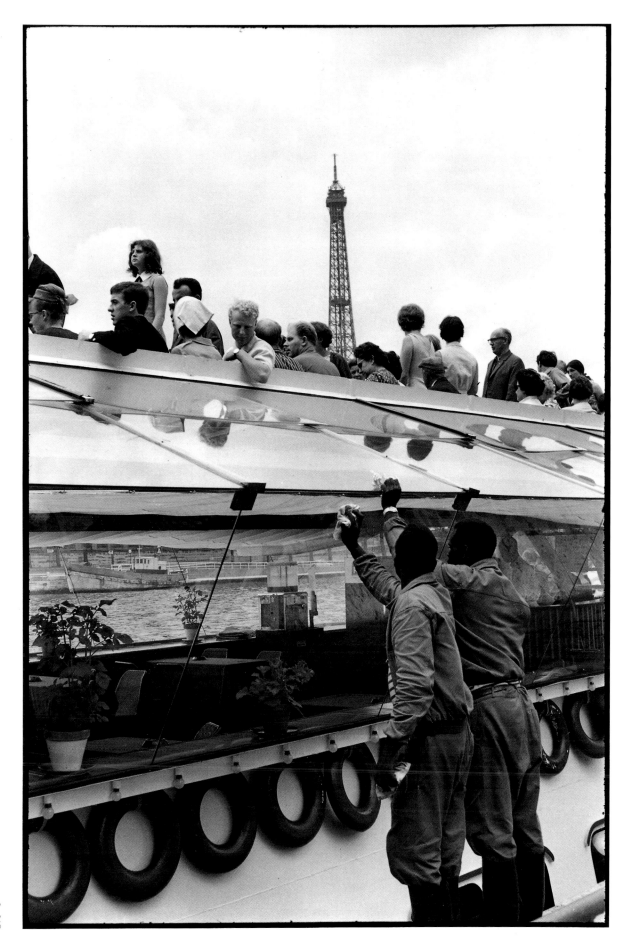

Pleasure boat,
Paris, France,
1966

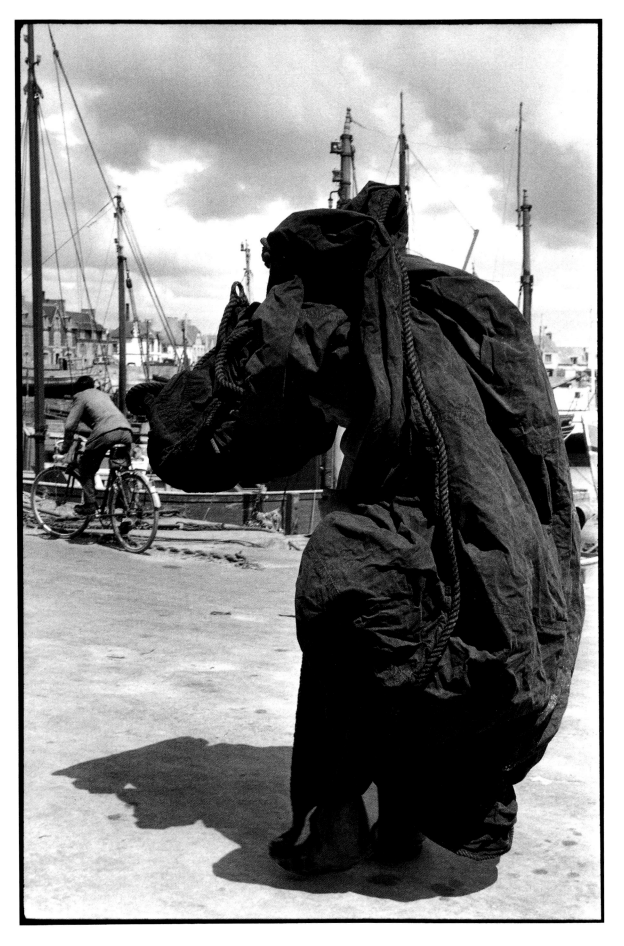

Pointe de
Penmarch,
Brittany, France,
1956

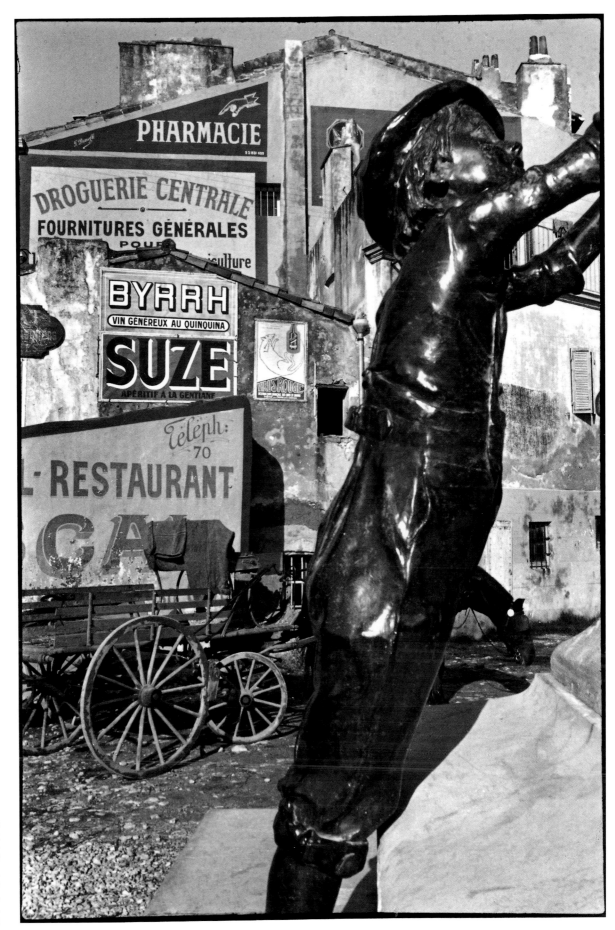

Monument
to the first
Governor
General of
Indochina,
destroyed by
the Germans,
Martigues,
France, 1932

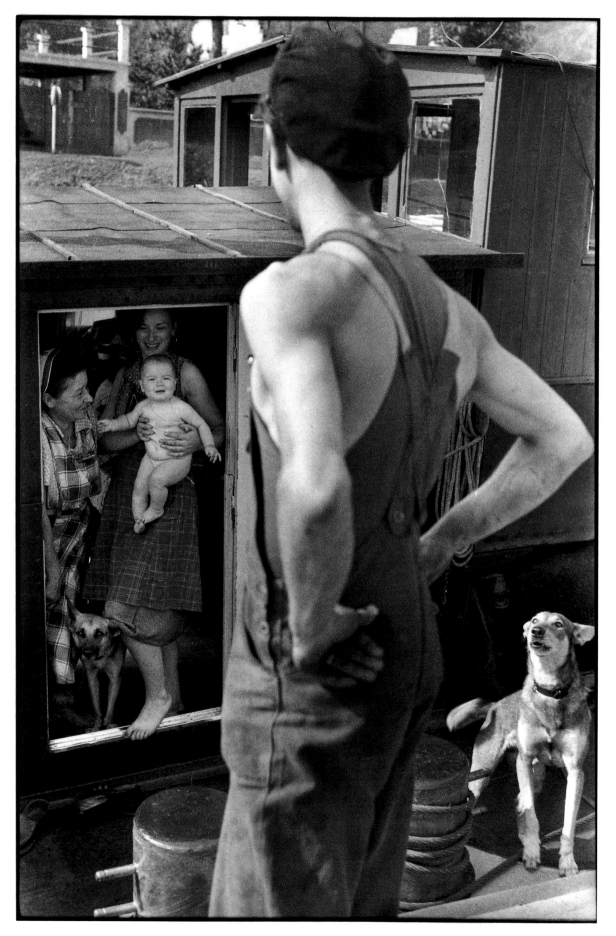

Lock at Bougival,
France, 1956

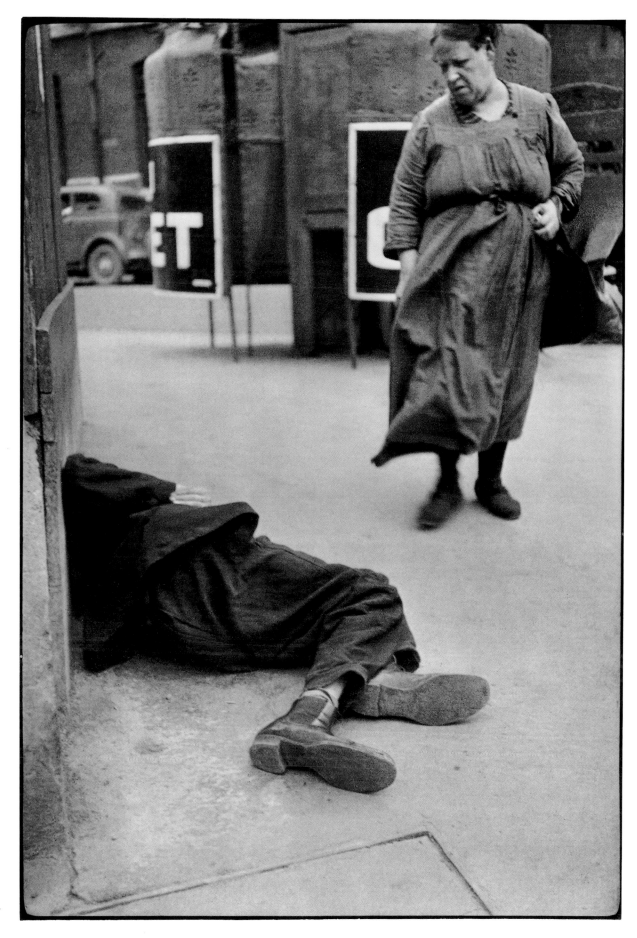

La Villette, Paris,
France, 1929

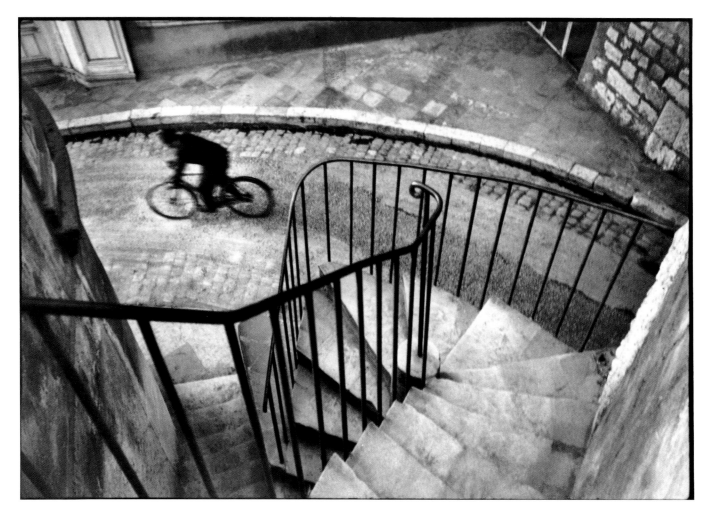

Hyères, France, 1932

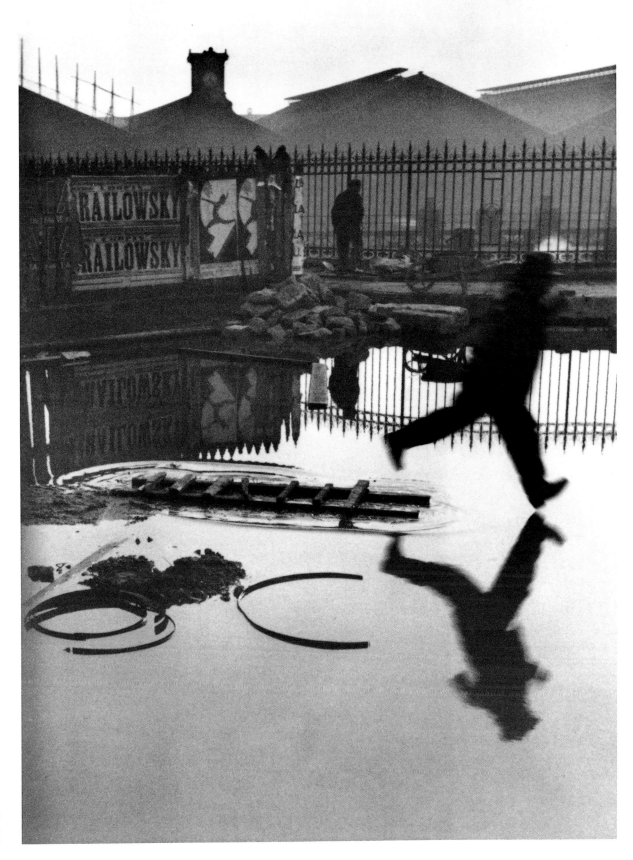

Pont de
l'Europe, Paris,
France, 1932

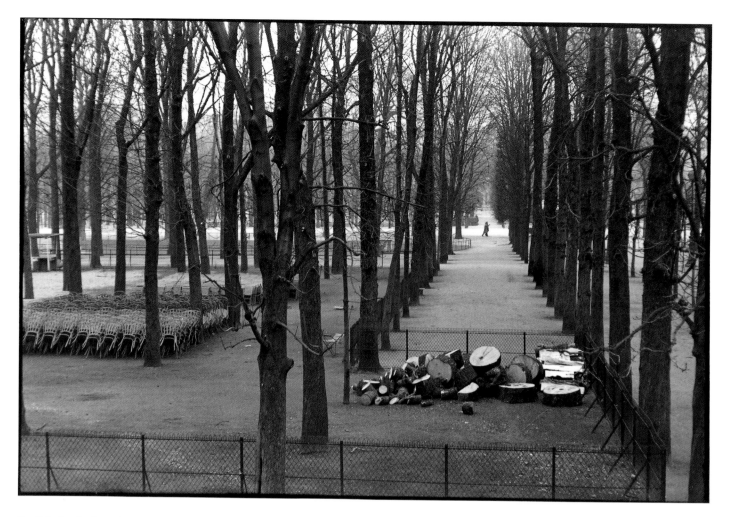

The Tuileries Gardens, Paris, France, 1969

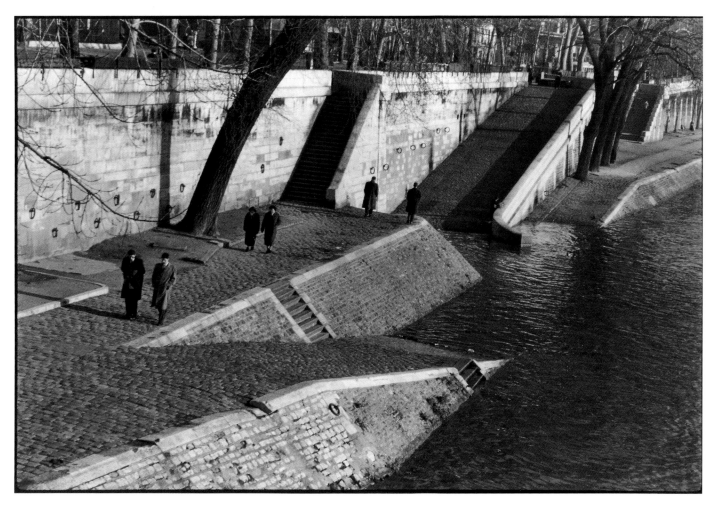

Quai des Tuileries, Paris, France, 1956

Chouzy-sur-Cisse,
France, 1944

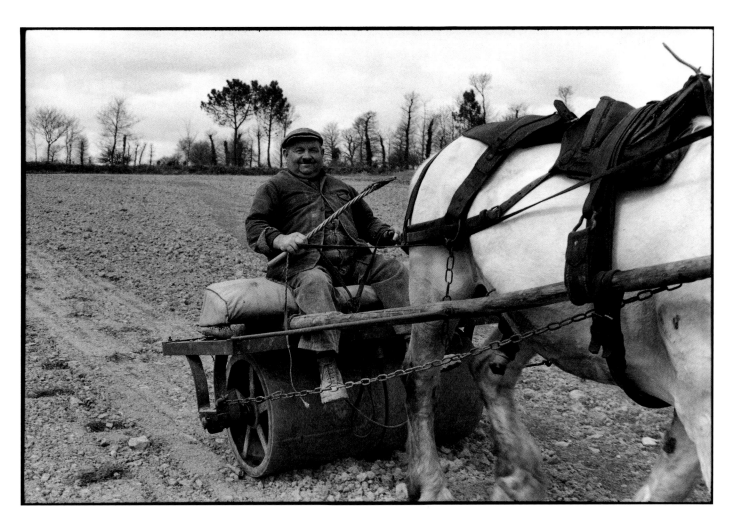

Calvados, France, 1960

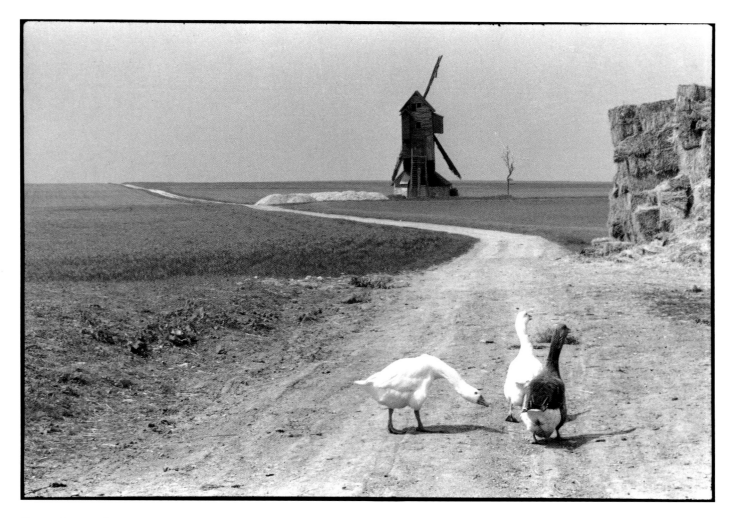

Beauce, France, 1960

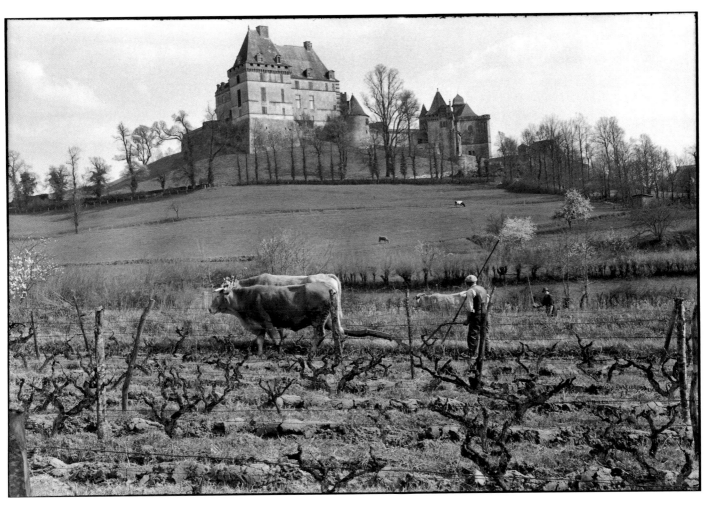

Château Biron, the Dordogne, France, 1968

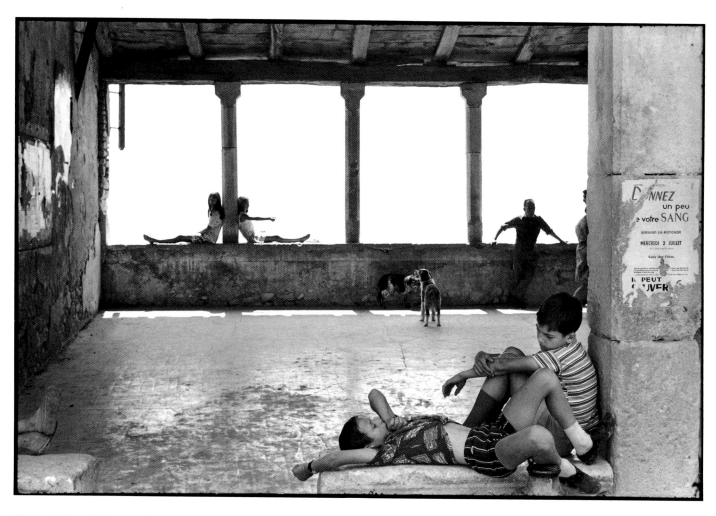

Simiane-la-Rotonde, France, 1969

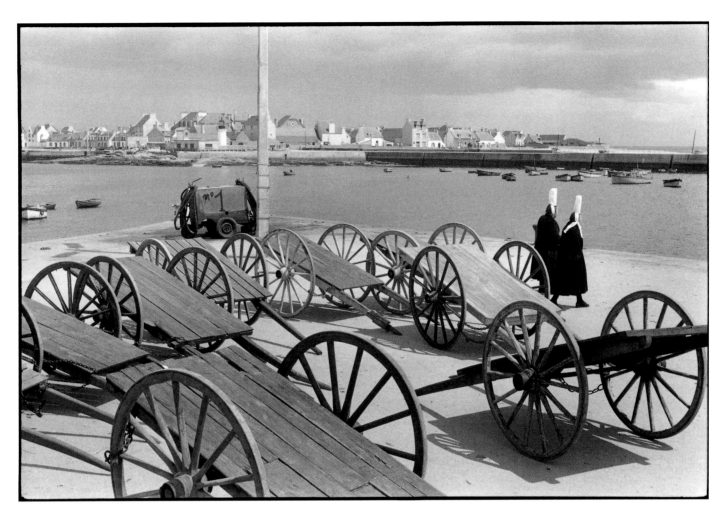

Guilvinec, Brittany, France, 1956

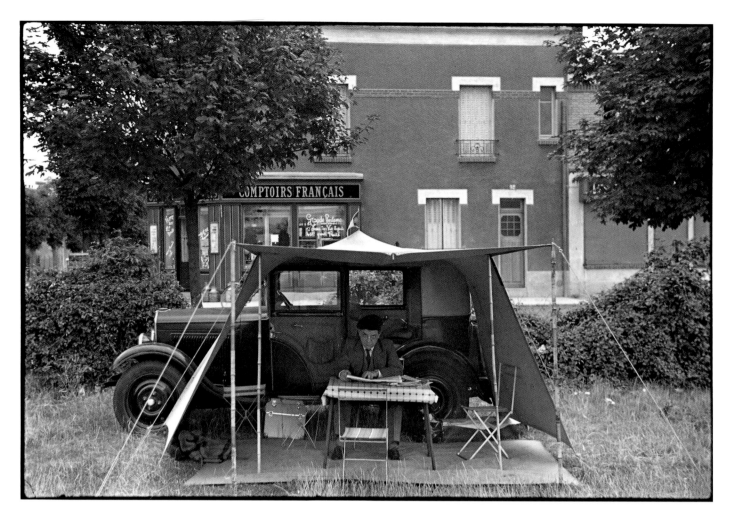

The first paid holidays, France, 1936

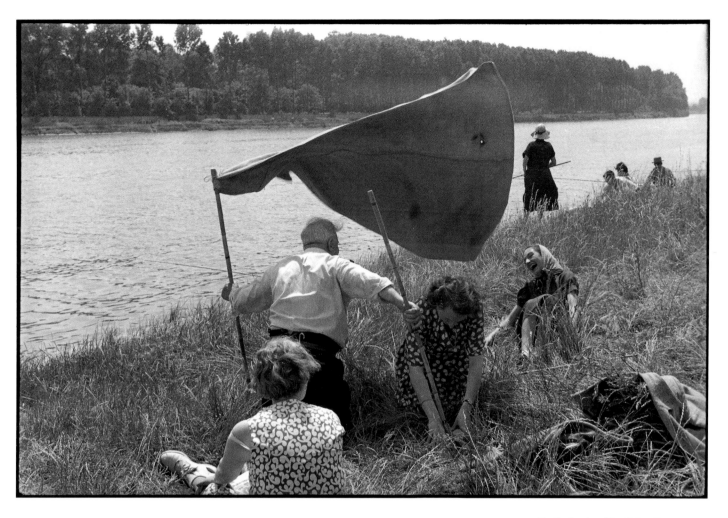

On the banks of the Seine, France, 1955

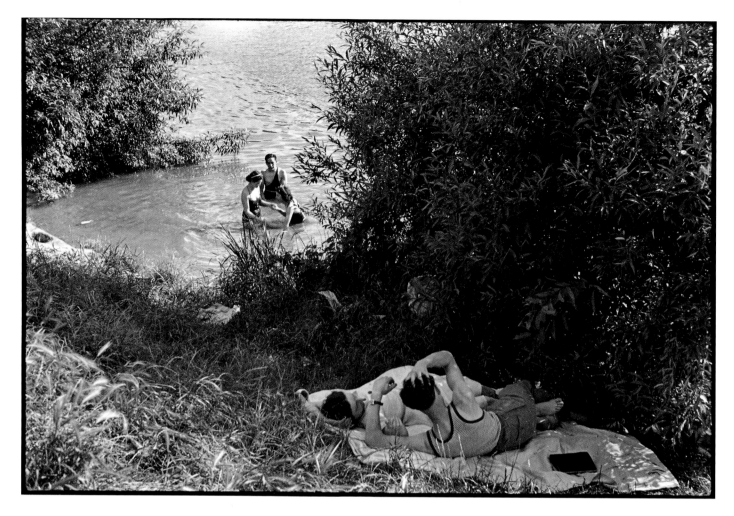

On the banks of the Seine, France, 1936

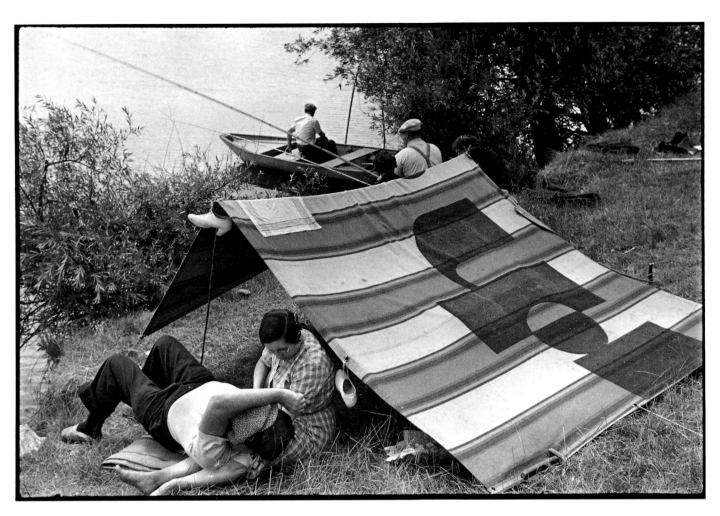

The first paid holidays, France, 1936

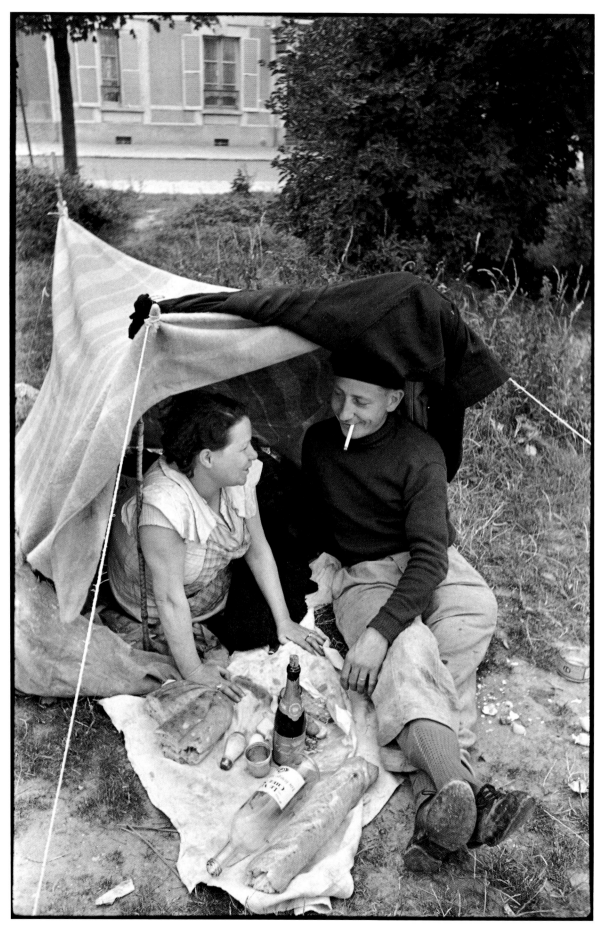

The first paid
holidays, France,
1936

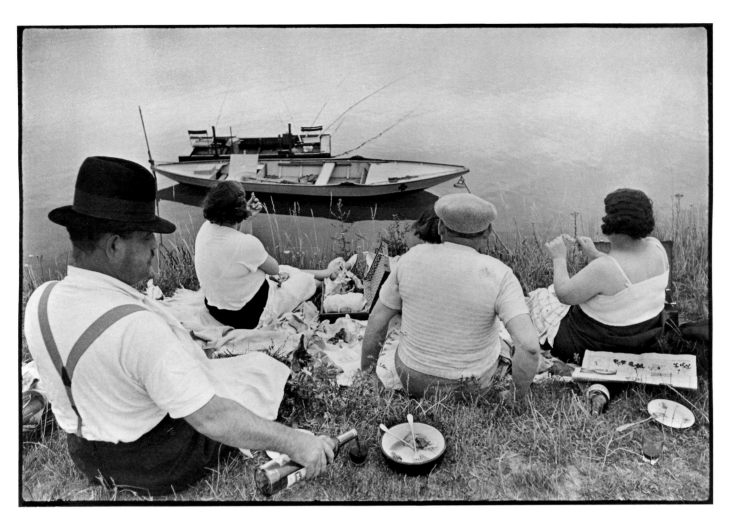

On the banks of the Marne, France, 1938

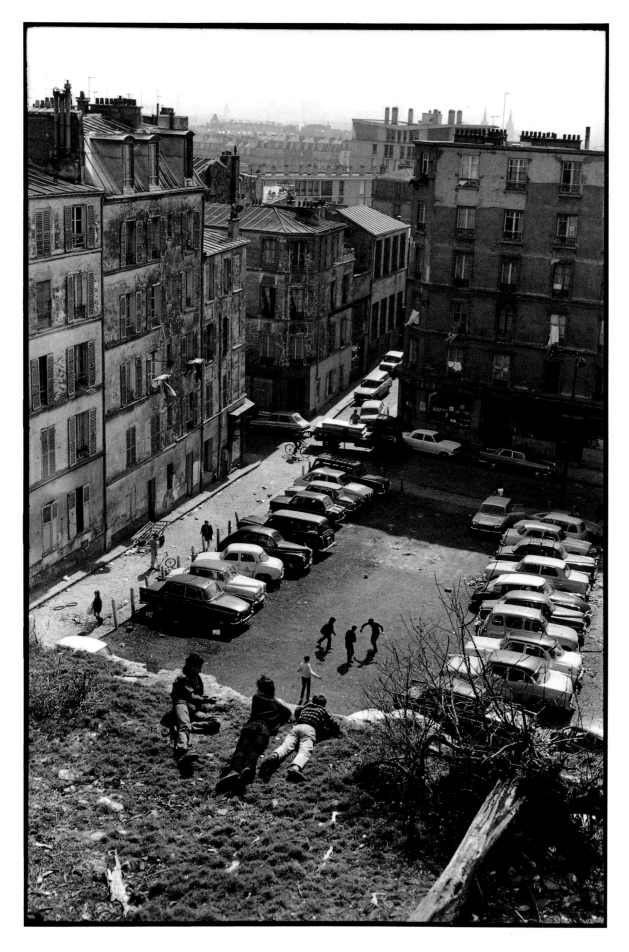

Belleville, Paris,
France, 1968

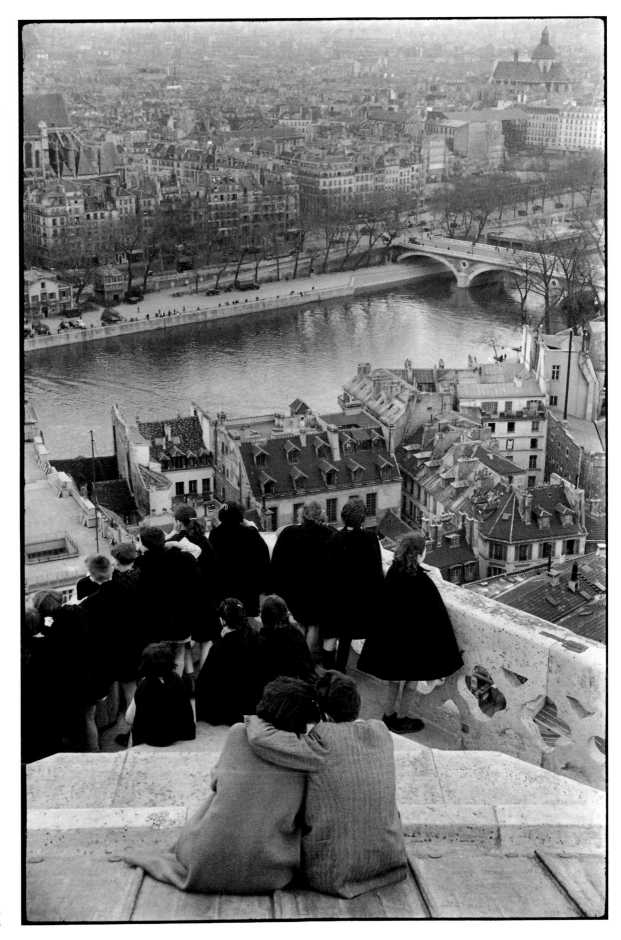

Notre-Dame,
Paris, France, 1953

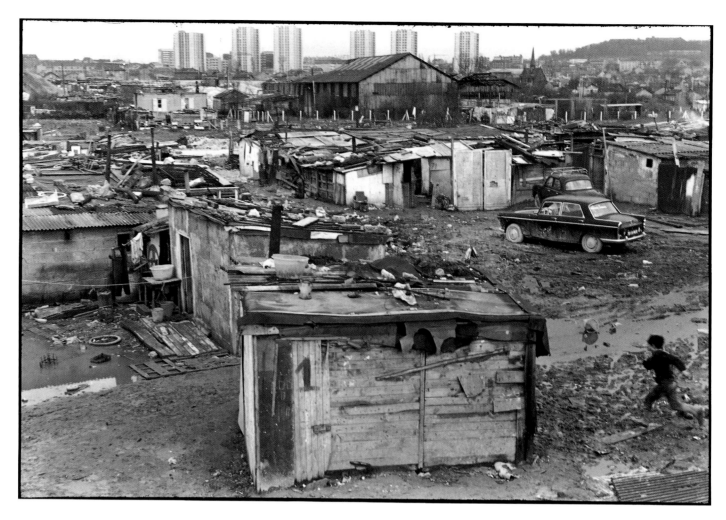

Nanterre, France, 1968

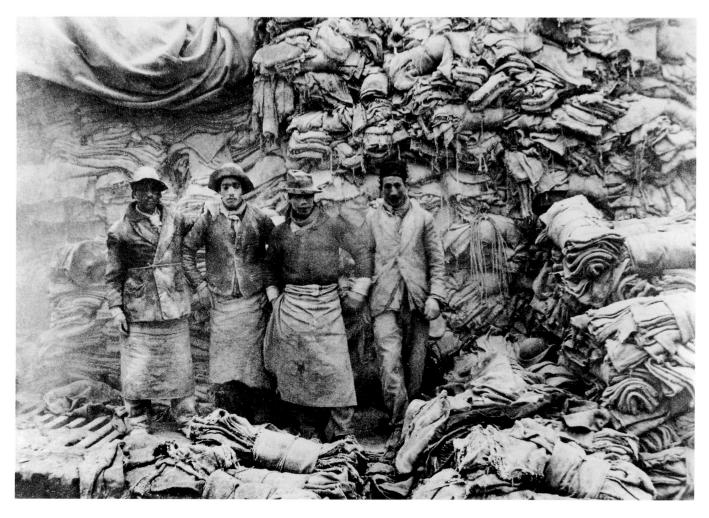

Quai de Javel, Paris, France, 1932

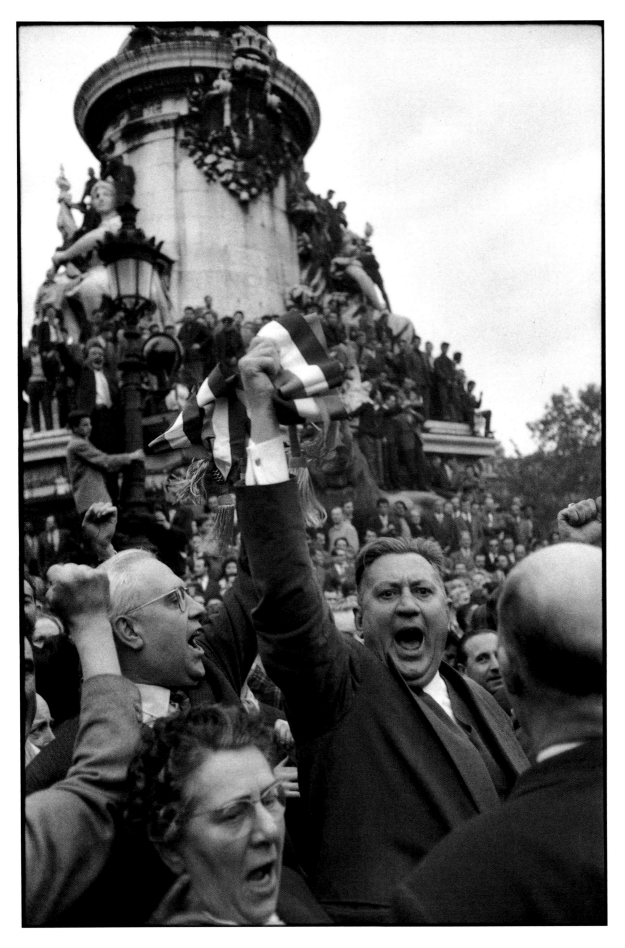

Place de la
République, Paris,
France, 28 May
1958

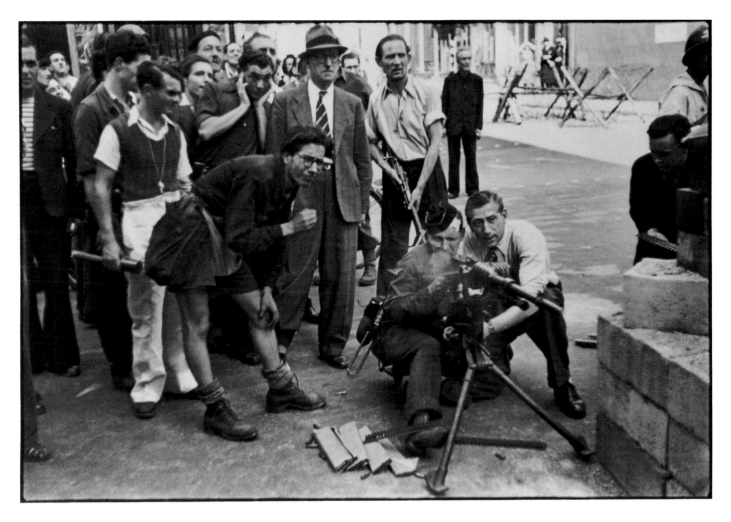

The Liberation, Rue Saint-Honoré, Paris, 1944

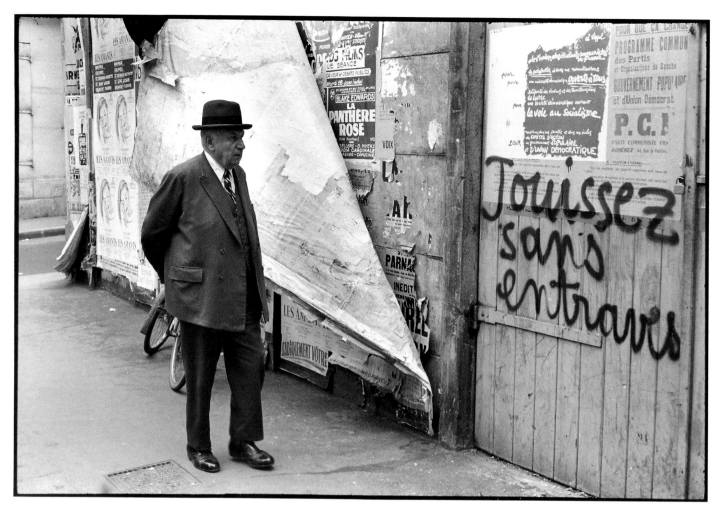

Rue de Vaugirard, Paris, France, May 1968

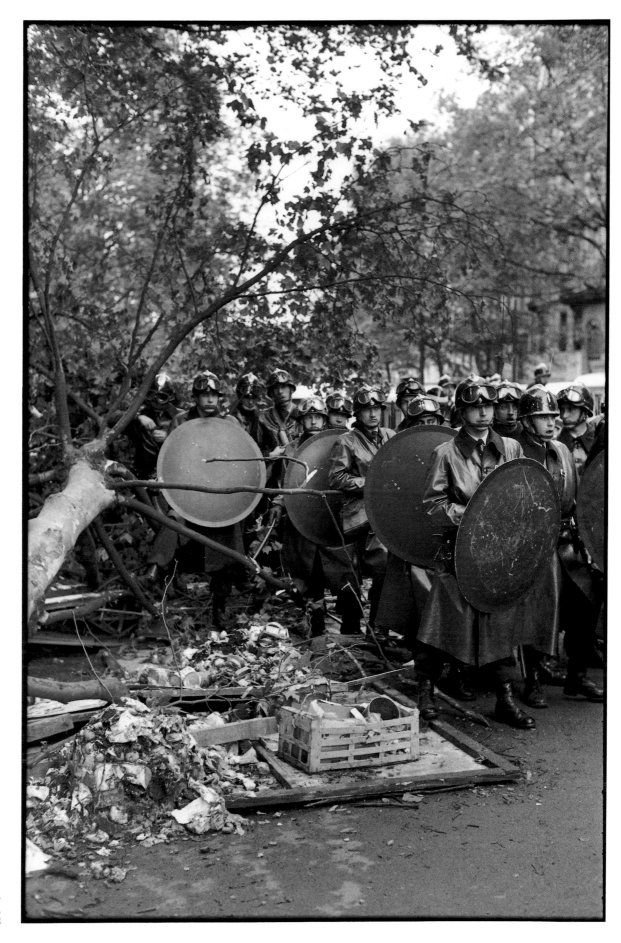

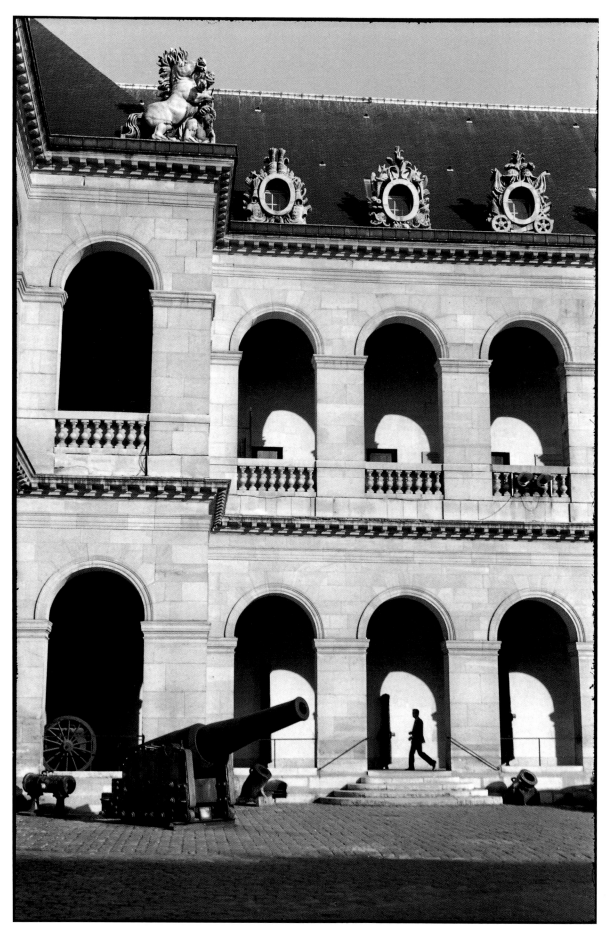

Hôtel des Invalides,
Paris, France, 1969

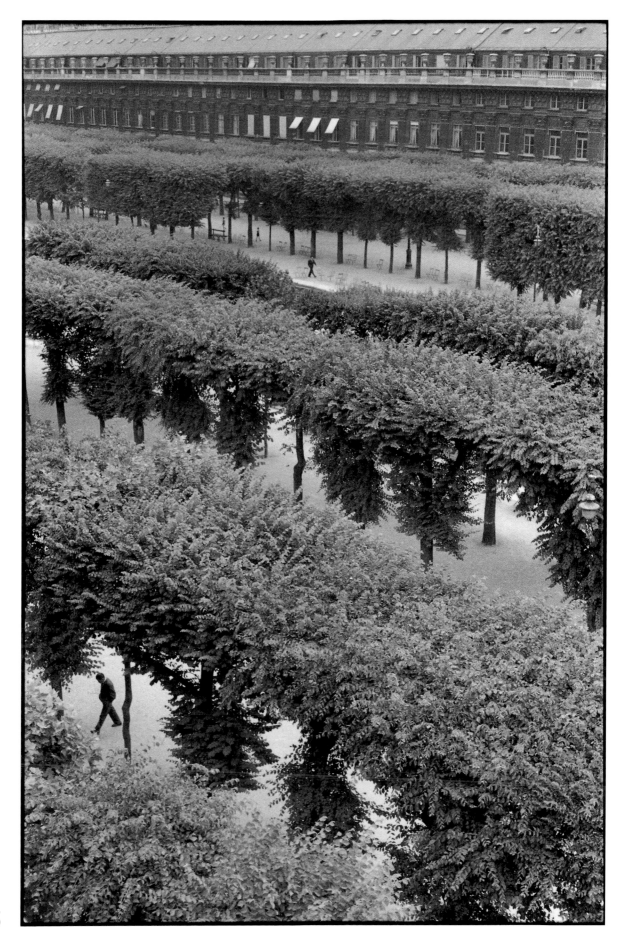

Palais-Royal, Paris,
France, 1959

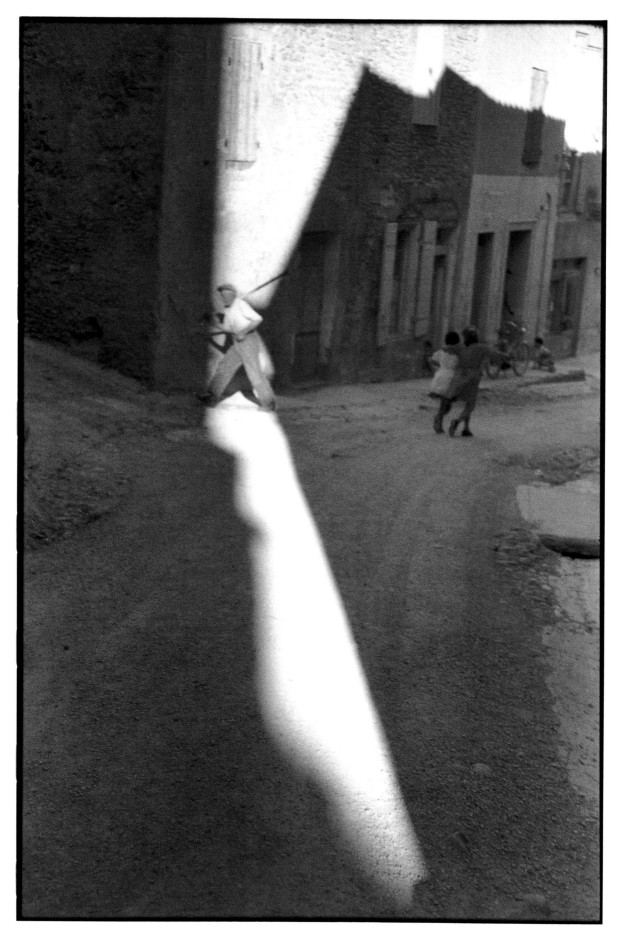

Tarascon, France,
1959

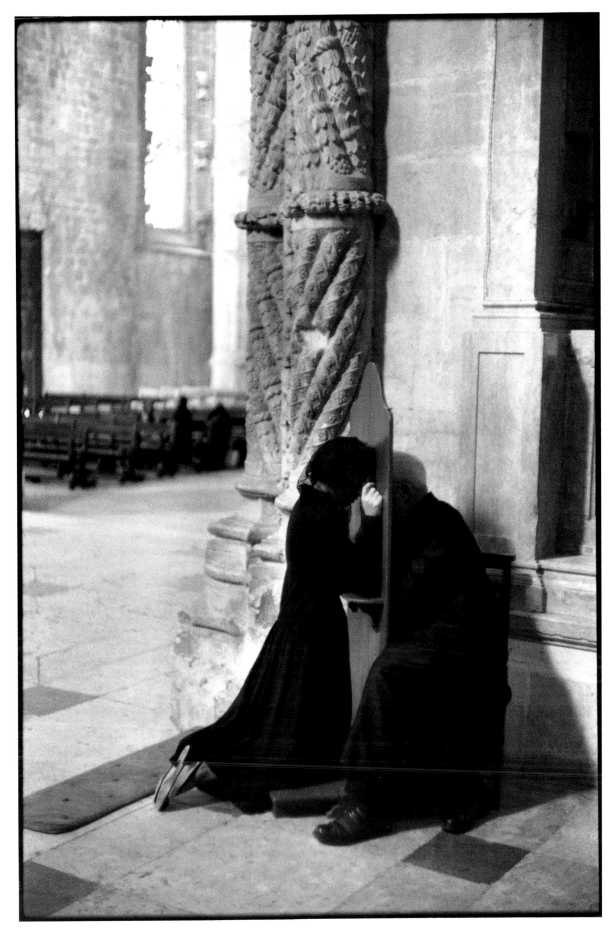

Lisbon, Portugal,
1955

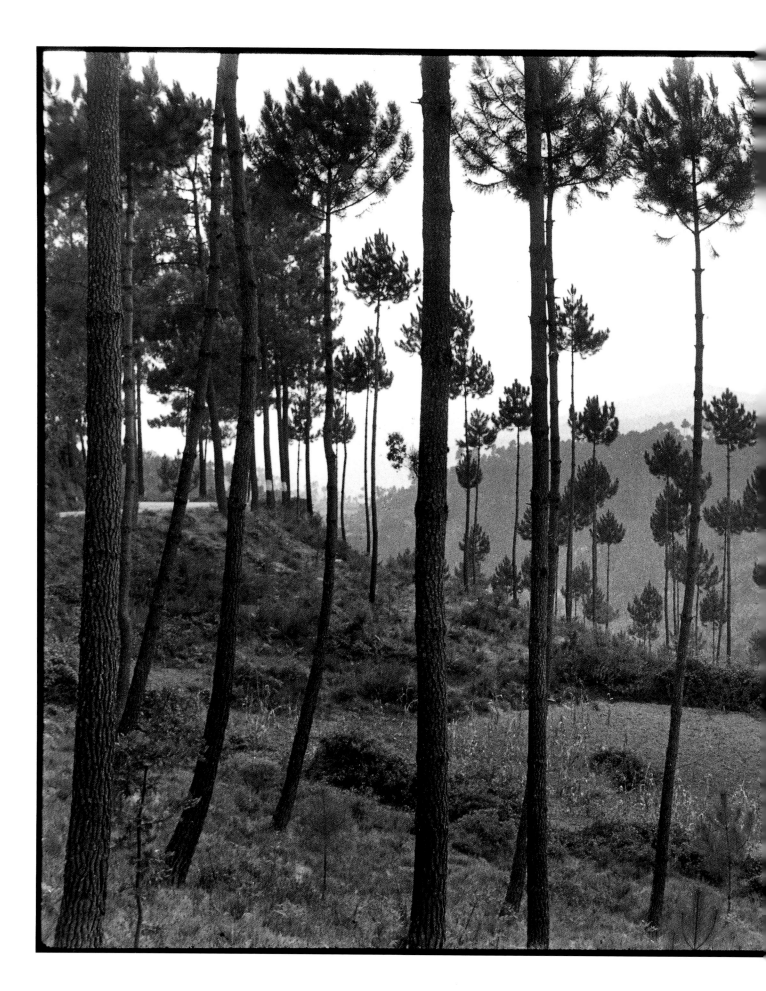

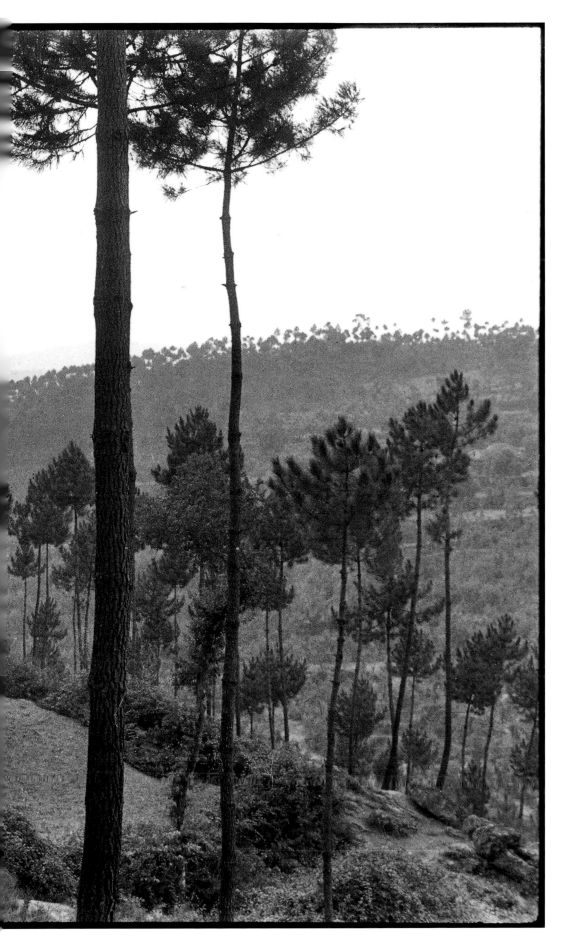

Amarante, Alto Douro,
Portugal, 1955

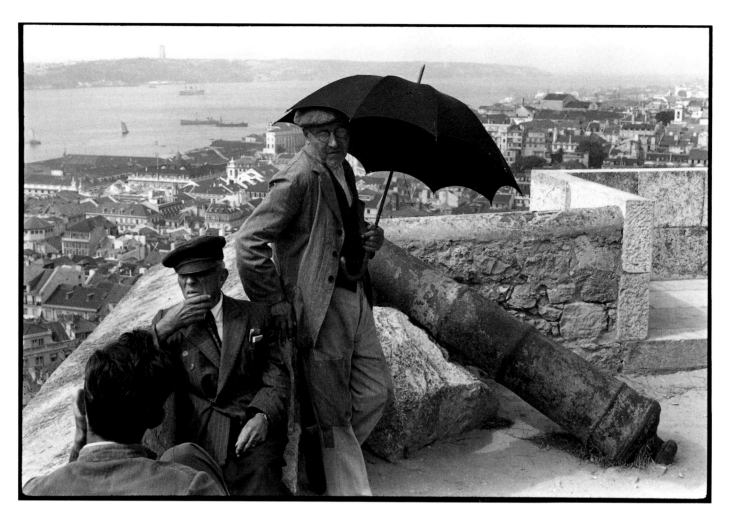

Lisbon, Portugal, 1955

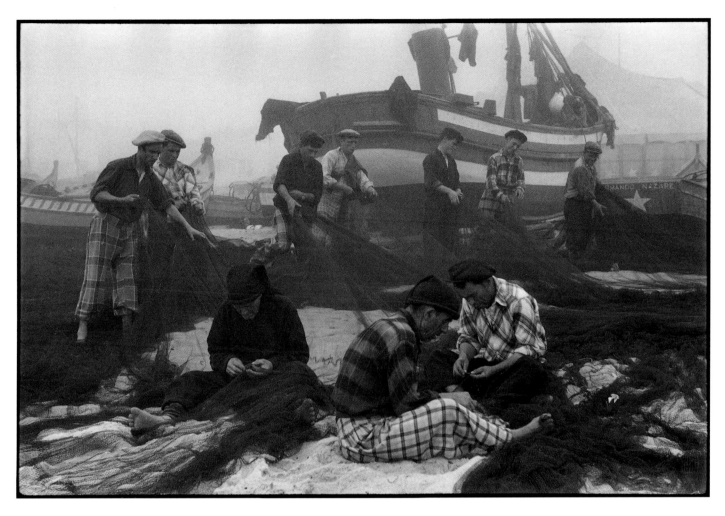

Nazaré, Estremadura, Portugal, 1955

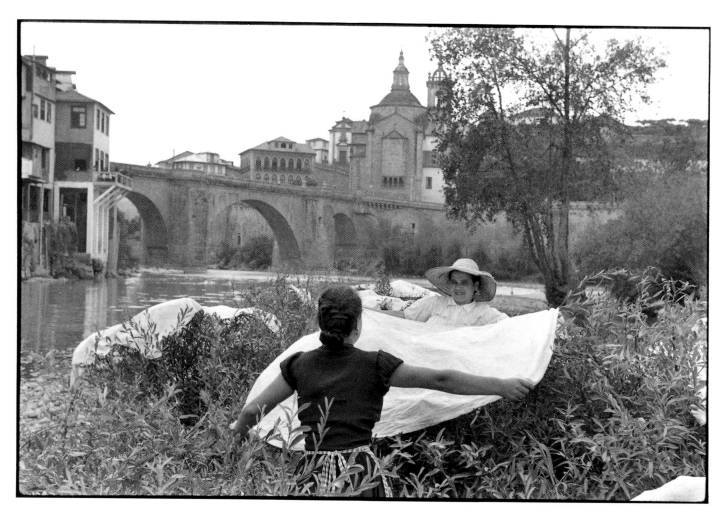

Guimarães, Alto Douro, Portugal, 1955

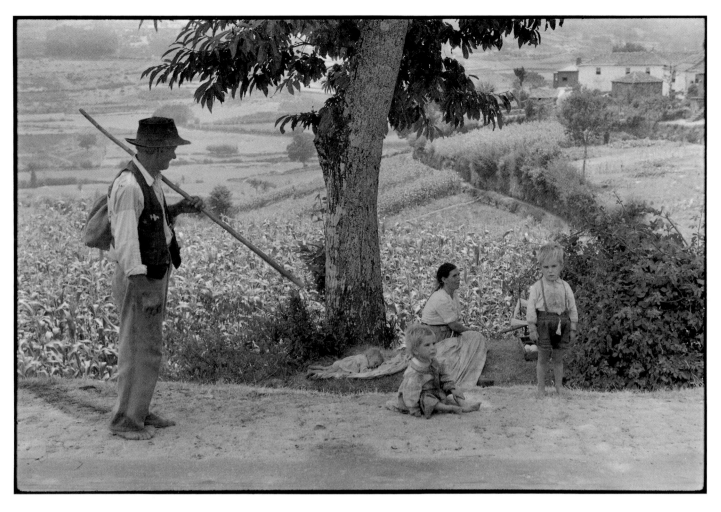

Lamego, Beira Alta, Portugal, 1955

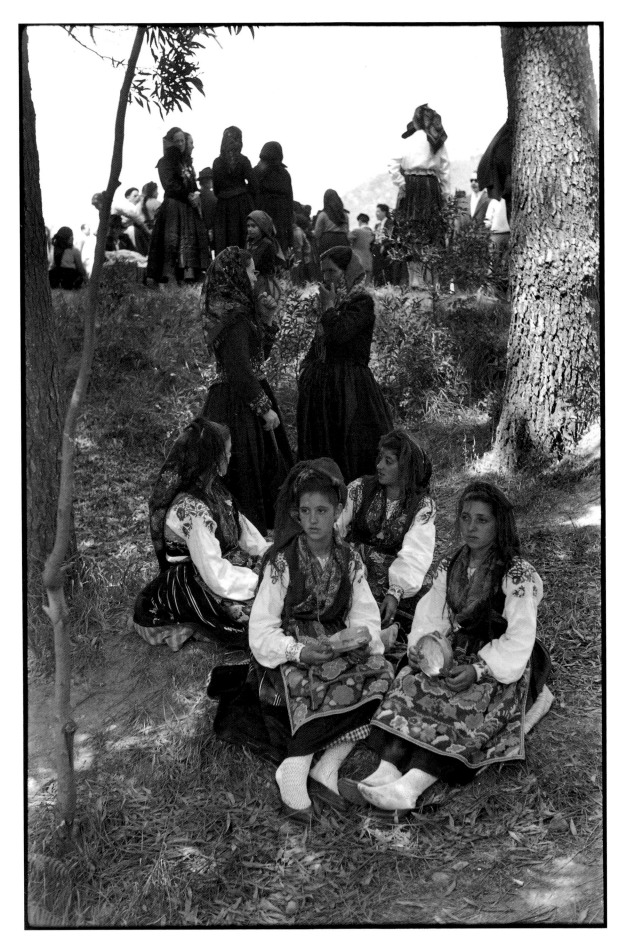

Viana do Castelo,
Alto Douro,
Portugal, 1955

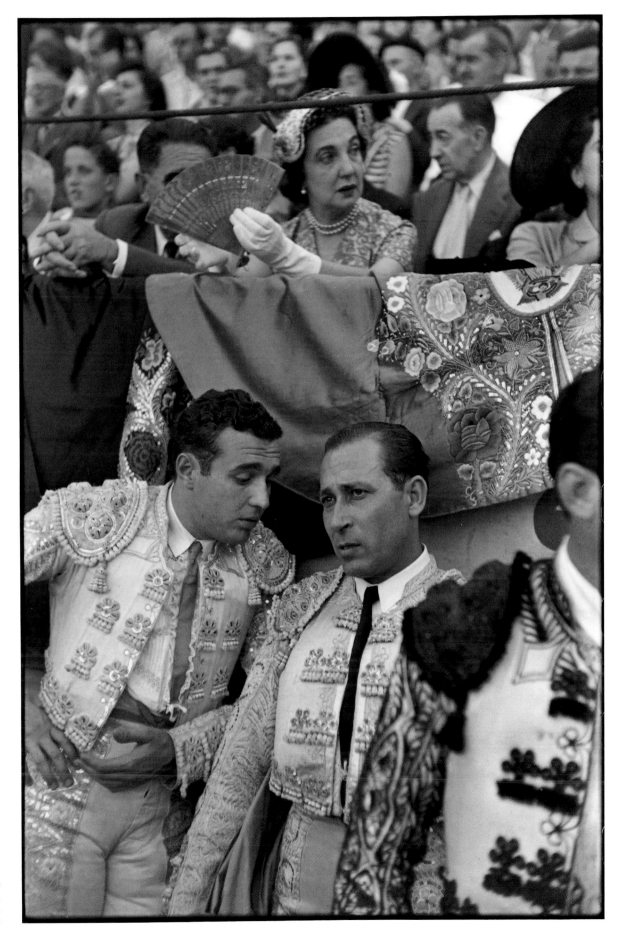

Fiesta de
San Fermín,
Pamplona,
Spain, 1952

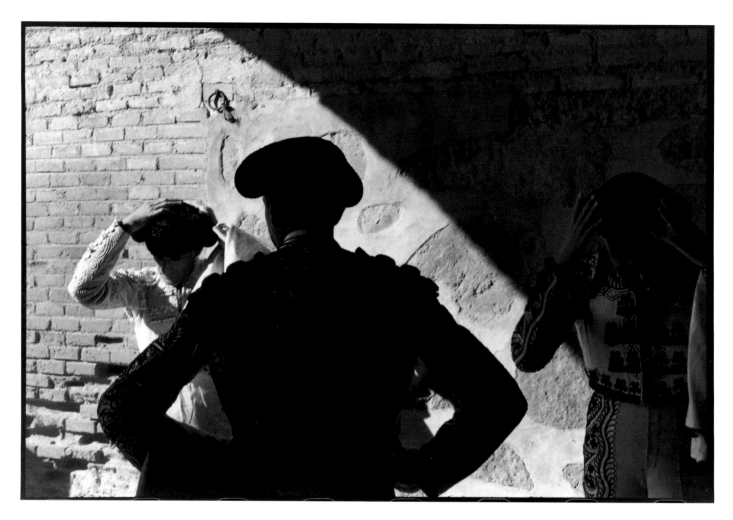

Toledo, Spain, 1963

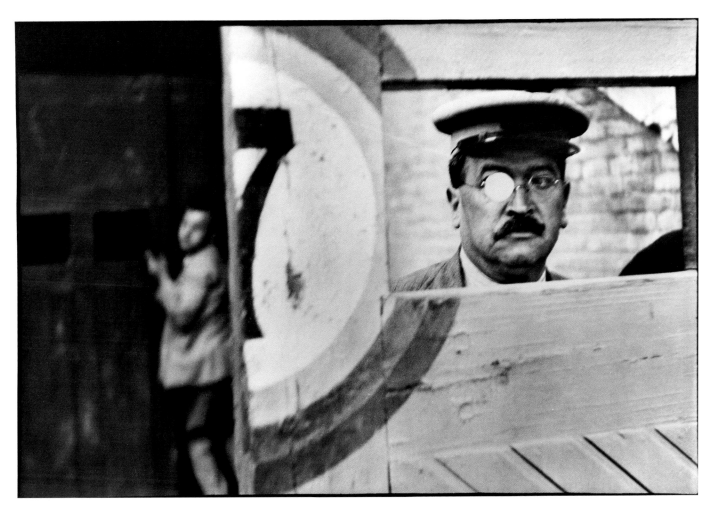

Bullring, Valencia, Spain, 1933

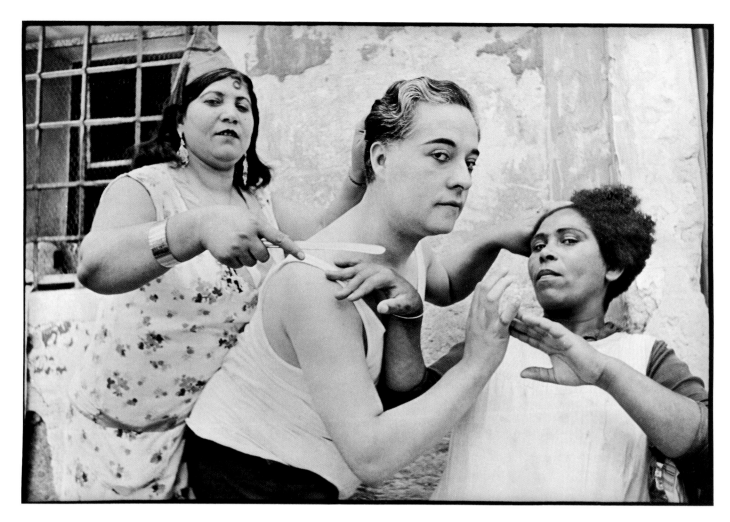

Alicante, Spain, 1933

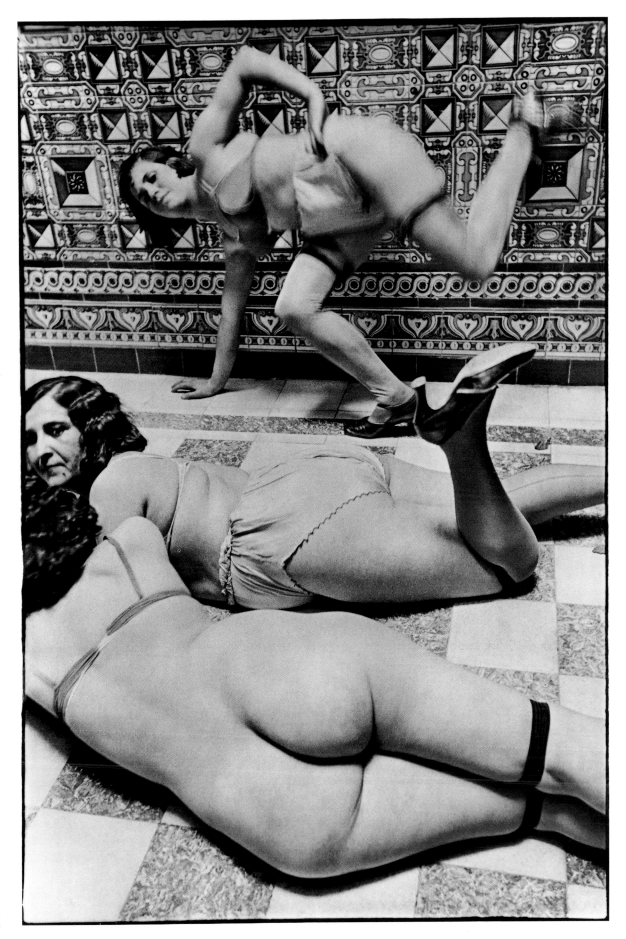

Alicante, Spain,
1933

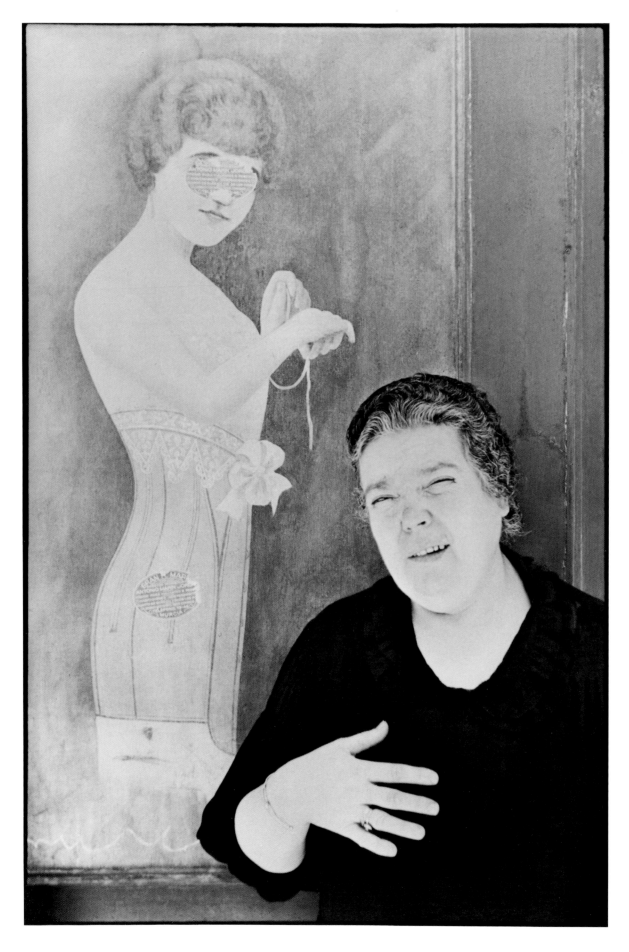

Cordoba, Spain,
1933

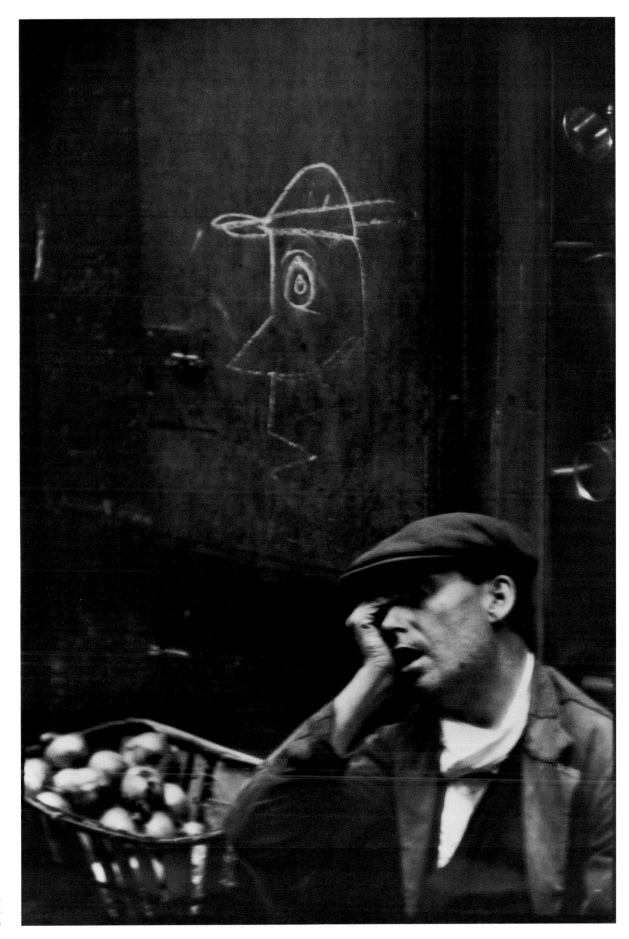

Barrio Chino,
Barcelona,
Spain, 1933

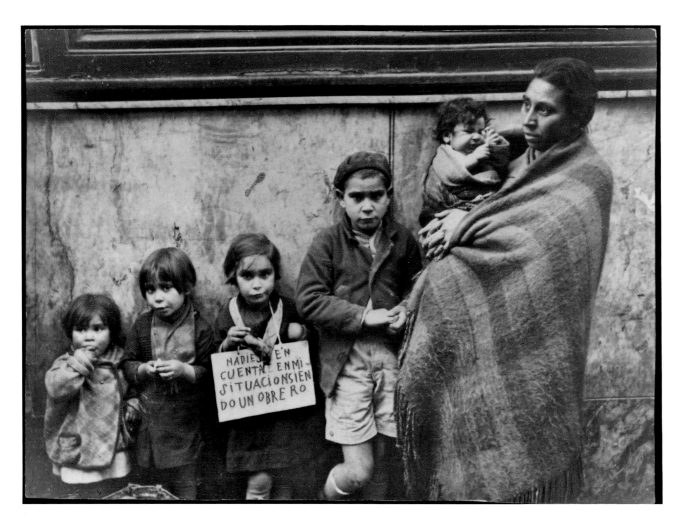

Madrid, Spain, 1932

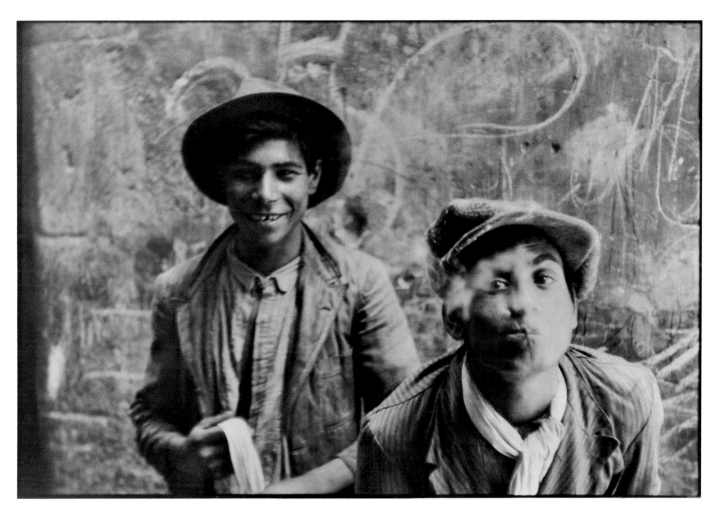

Gypsies, Granada, Spain, 1933

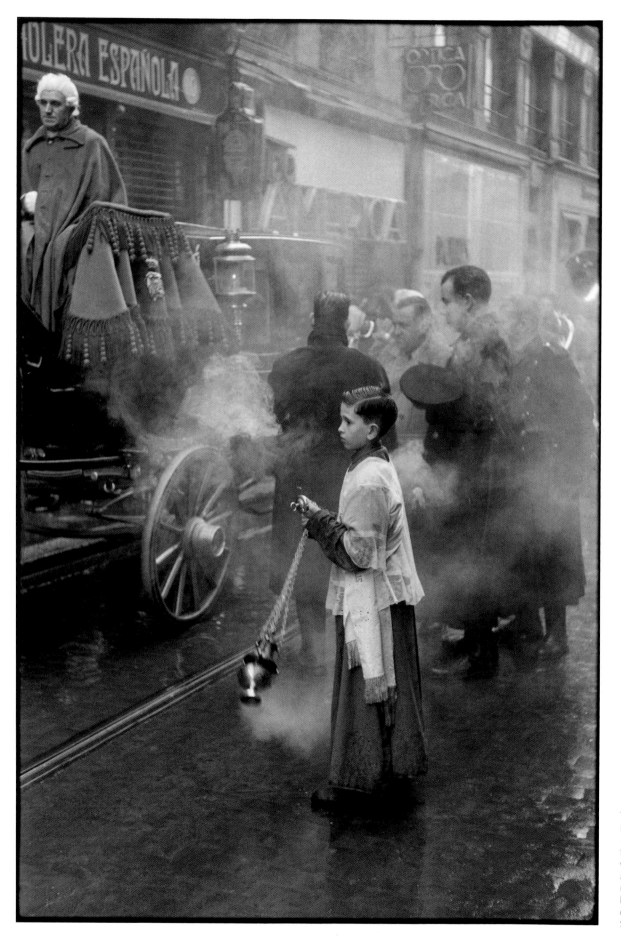

The priest has gone
upstairs to take the
Blessed Sacrament
to a sick person
while the procession,
accompanied by a
military band, waits
below, Puerta
del Sol, Madrid,
Spain, 1953

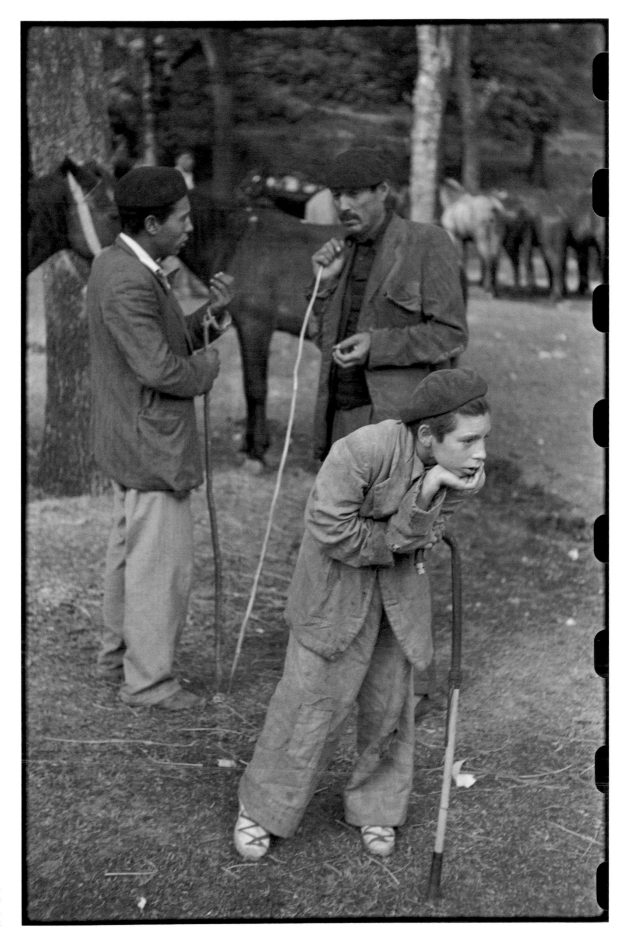

aLivestock market,
Fiesta de San
Fermín, Pamplona,
Spain, 1952

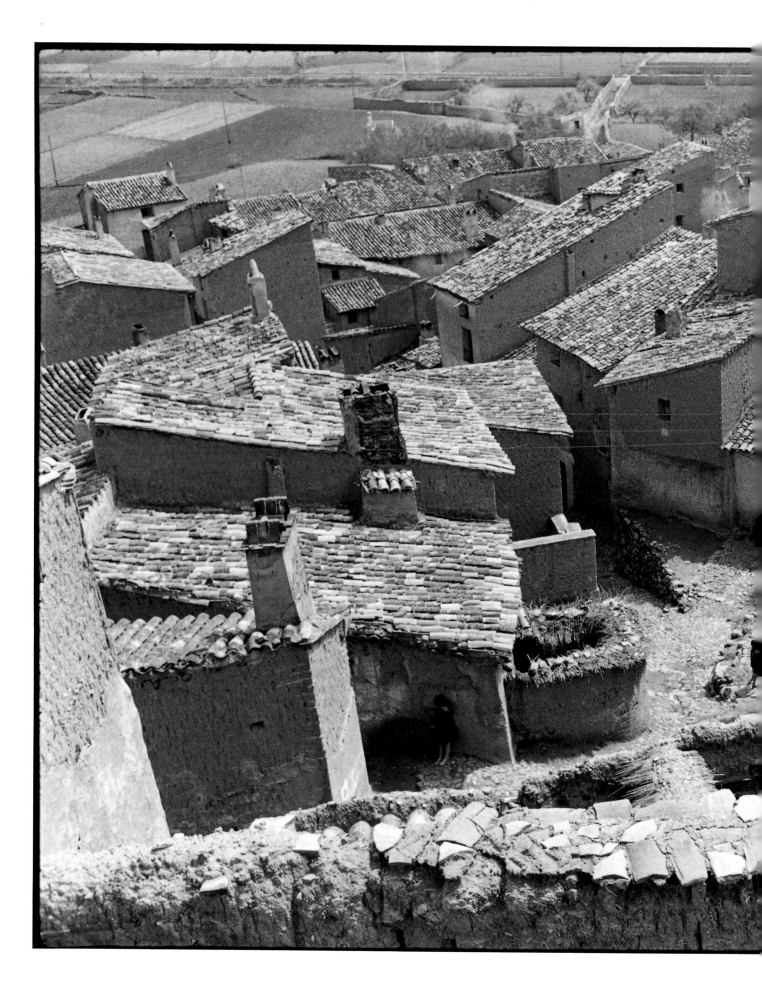

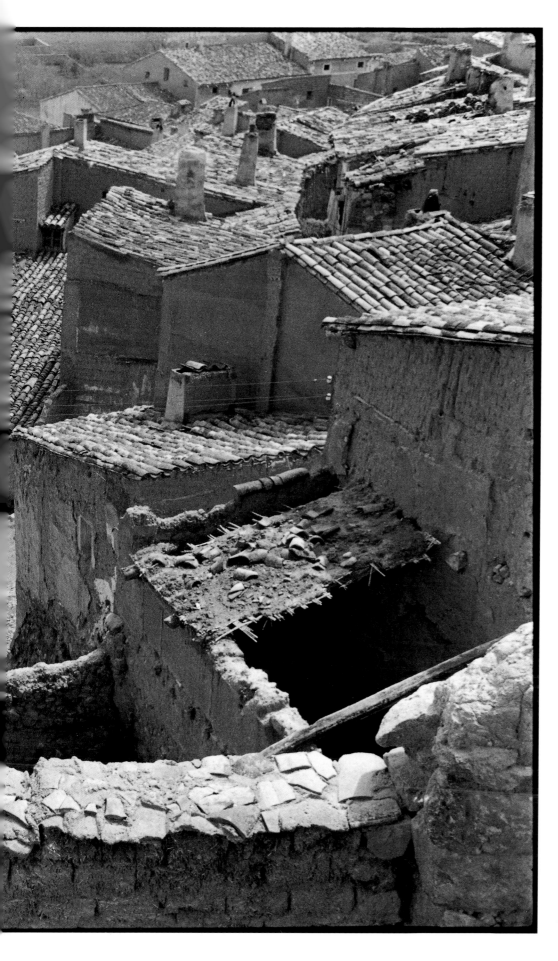

Ariza, Aragon,
Spain, 1953

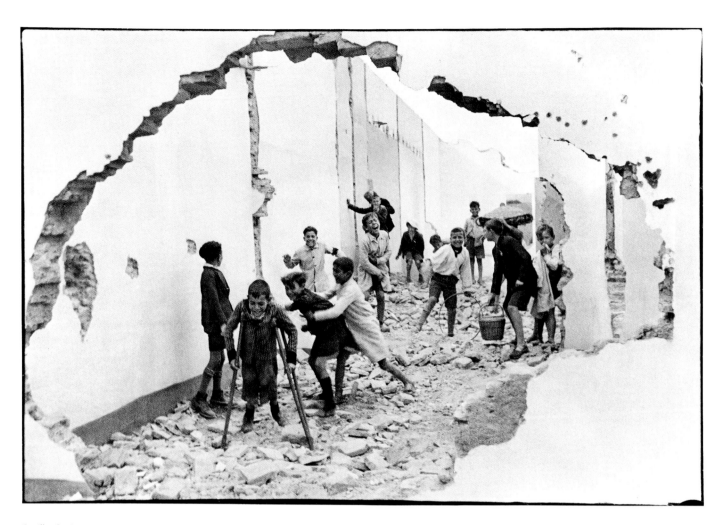

Seville, Spain, 1933

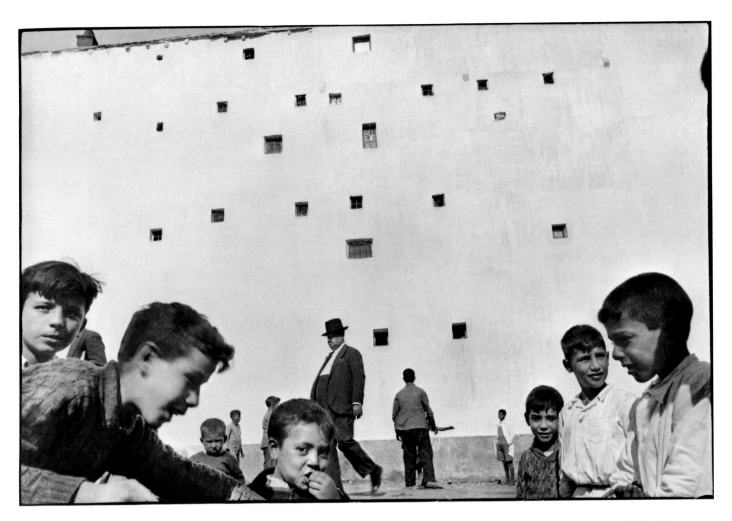

Madrid, Spain, 1933

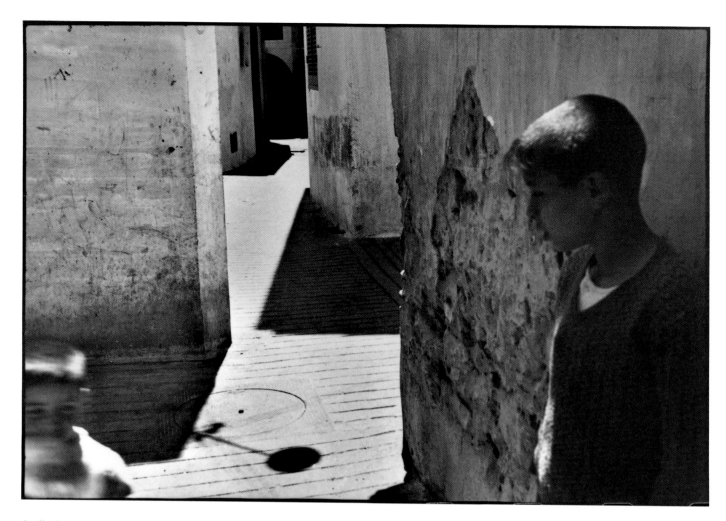

Seville, Spain, 1933

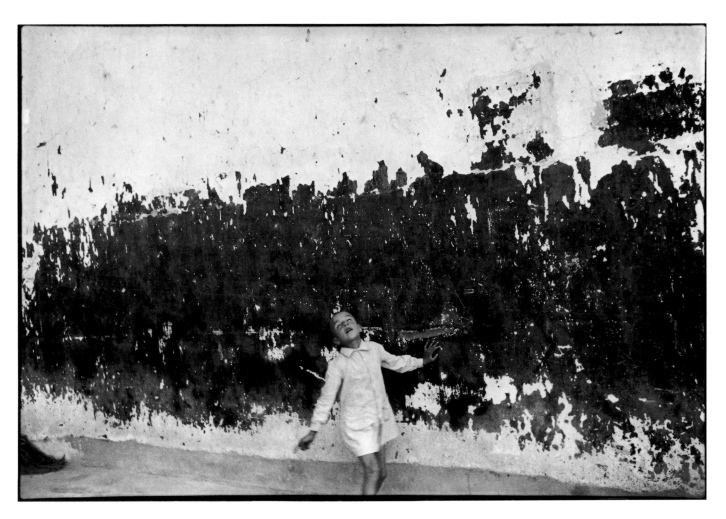

Granada, Spain, 1933

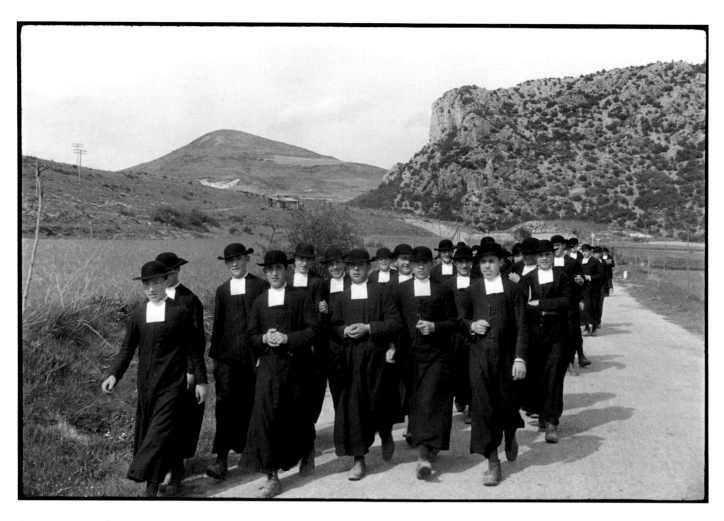

Seminarists on a walk, near Burgos, Spain, 1953

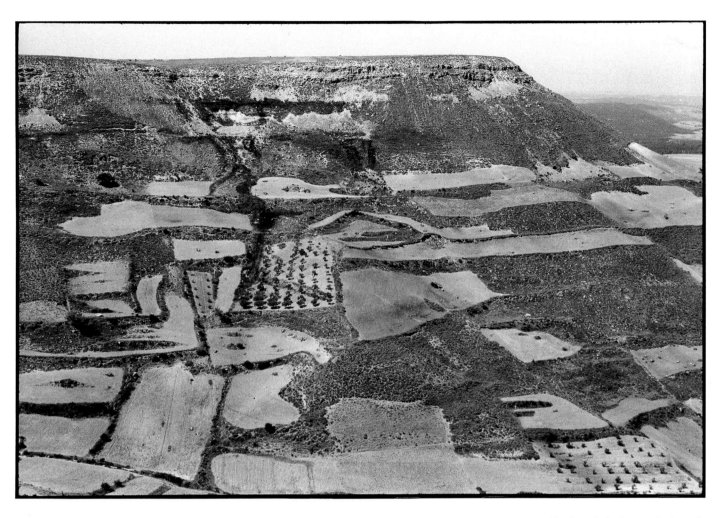

Northern Soria, Aragon, Spain, 1963

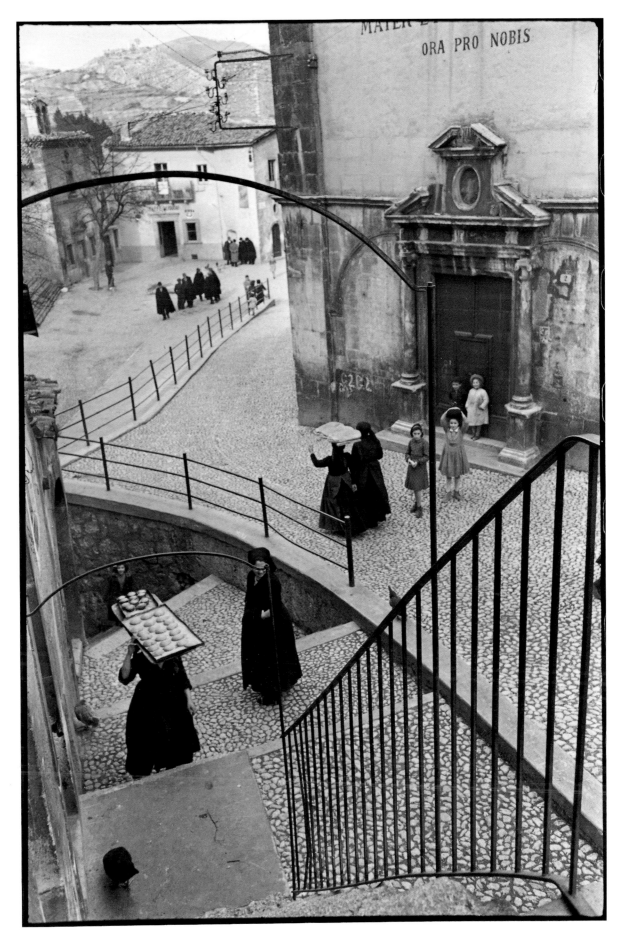

Aquila,
the Abruzzi,
Italy, 1951

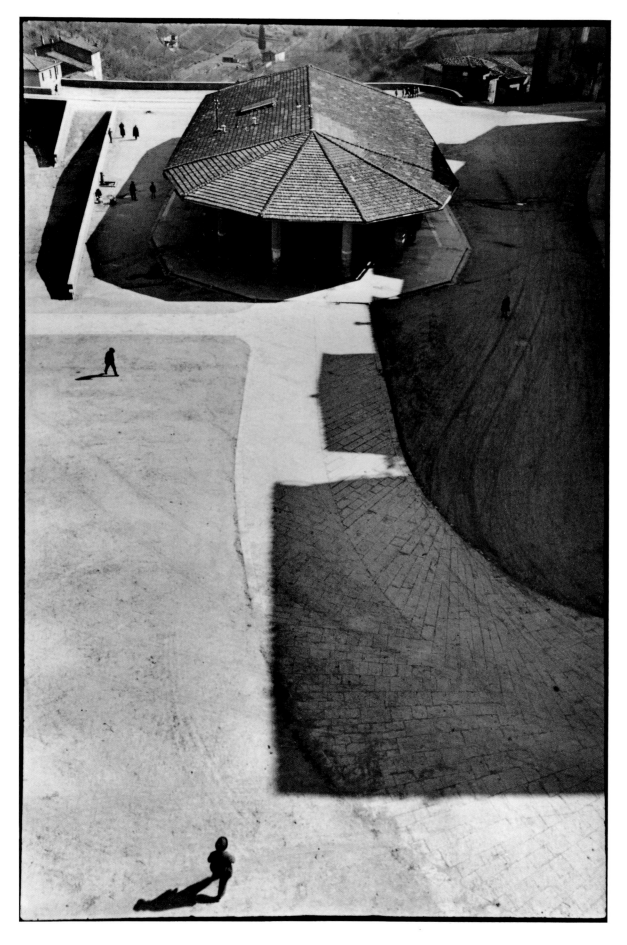

Siena, Italy,
1933

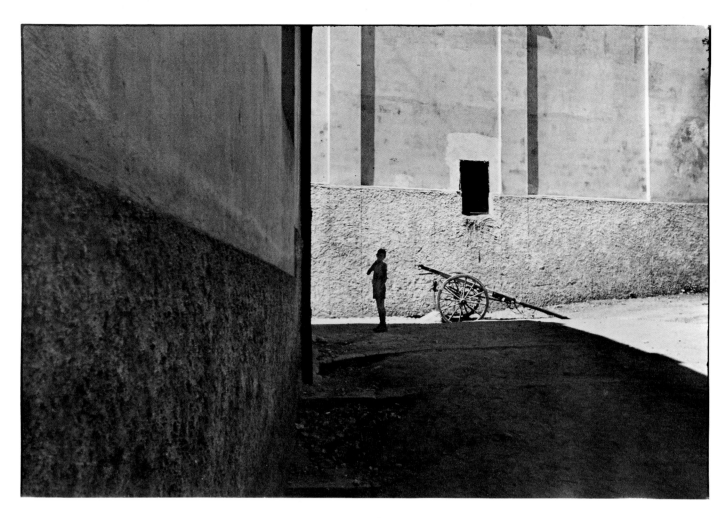

Salerno, Italy, 1933

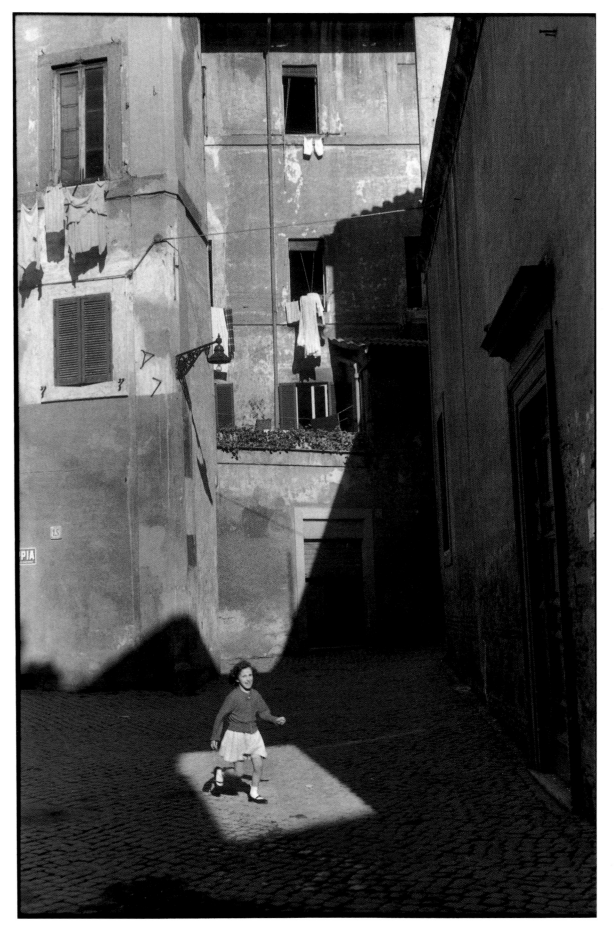

Trastevere, Rome,
Italy, 1959

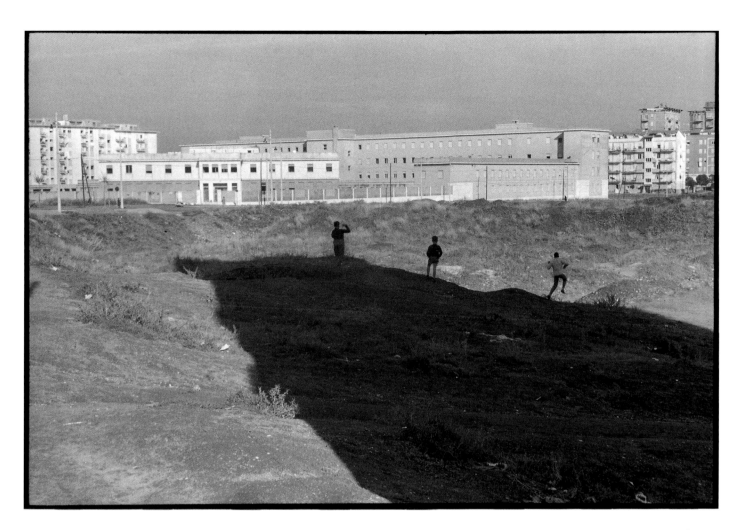

Rome, Italy, 1959

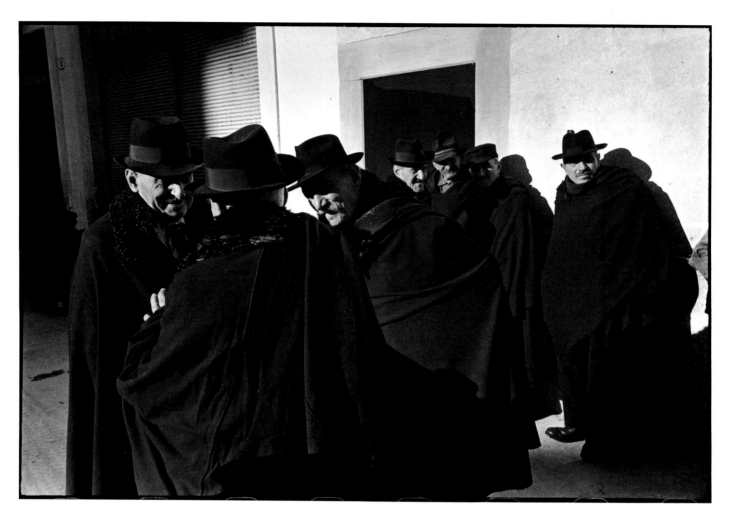

Scanno, the Abruzzi, Italy, 1951

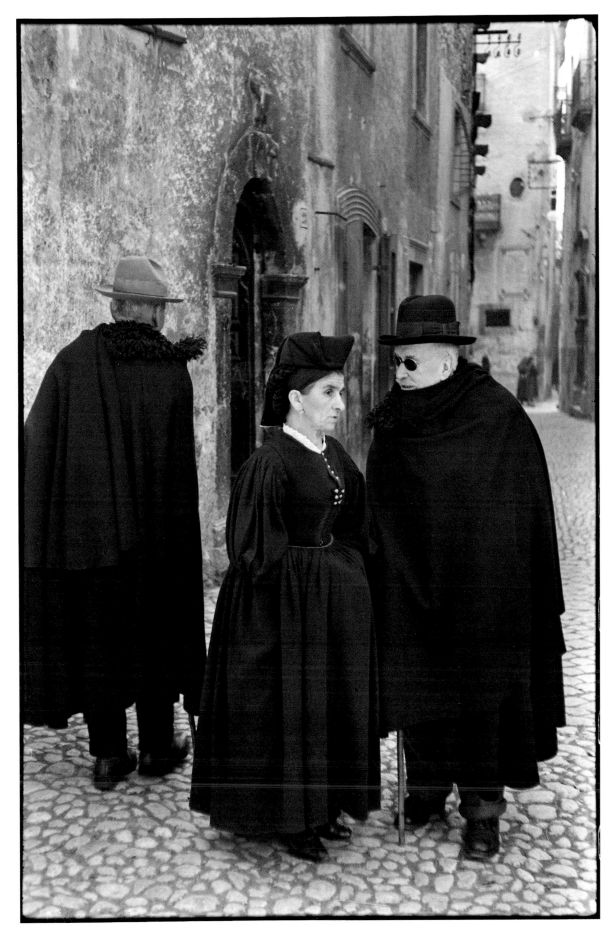

Scanno, the
Abruzzi, Italy,
1951

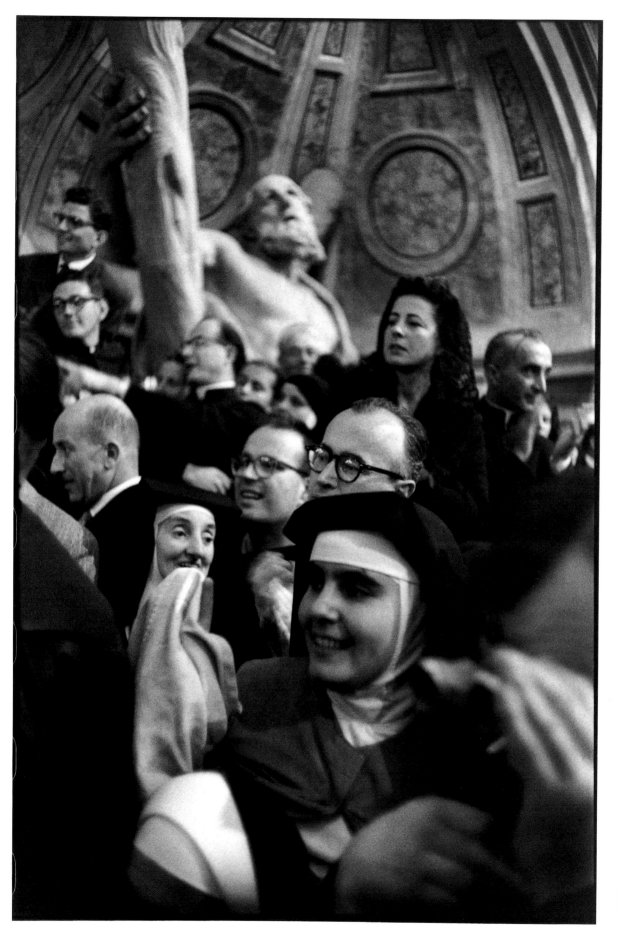

Enthronement of
Pope John XXIII,
Vatican City, Italy,
1958

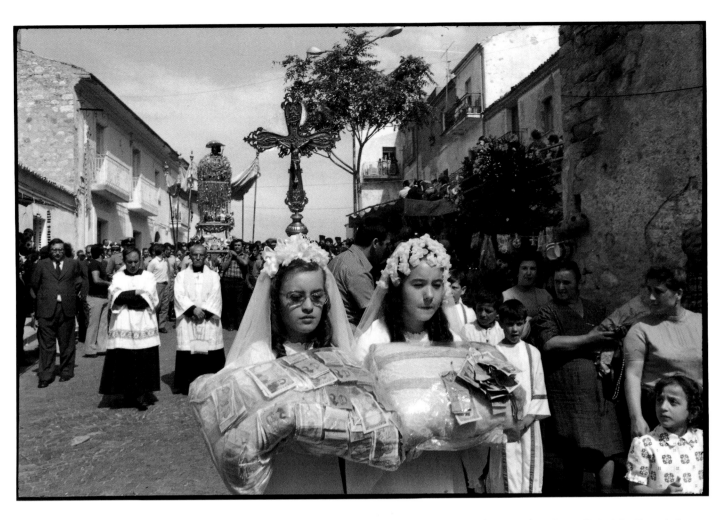

Pilgrimage of San Rocco, Pisticci, Basilicata, Italy, 1973

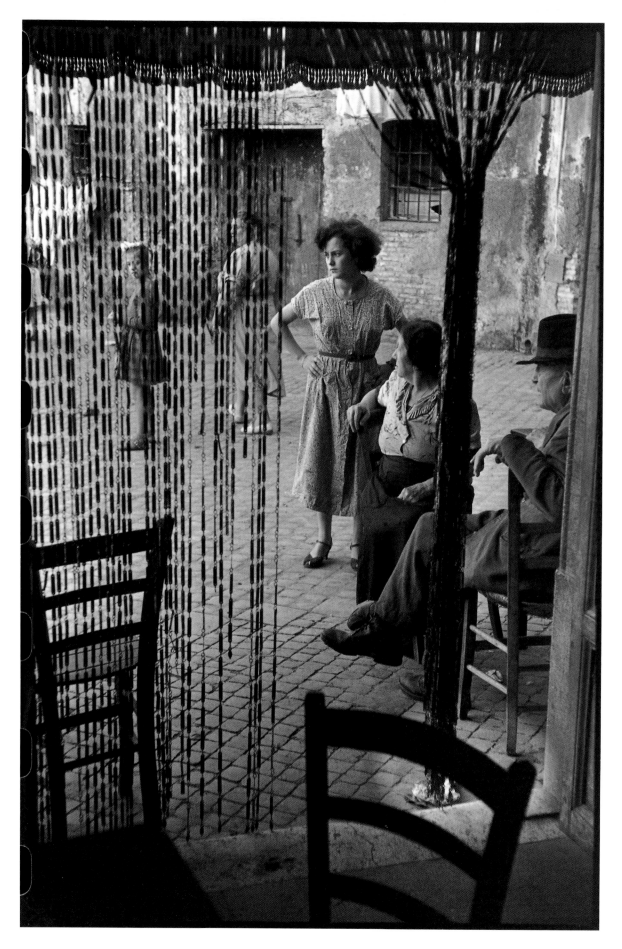

Trastevere, Rome,
Italy, 1959

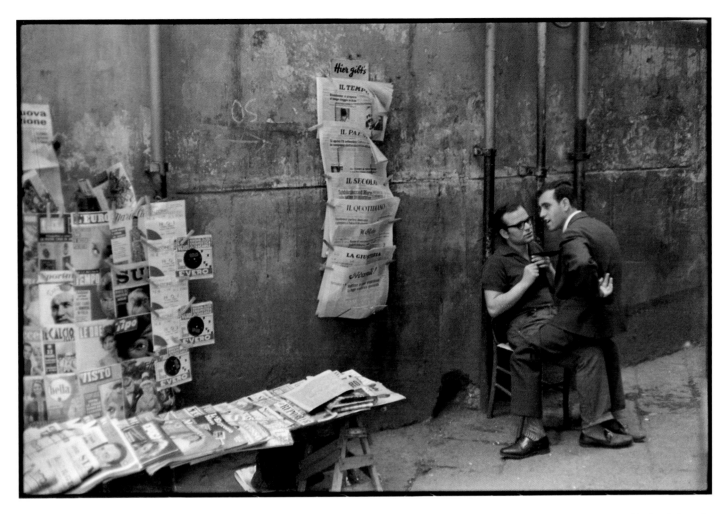

Naples, Italy, 1960

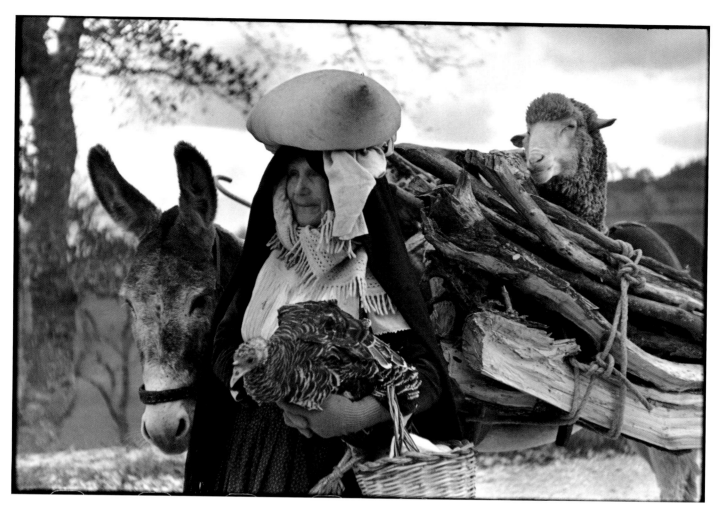

Basilicata, Italy, 1951

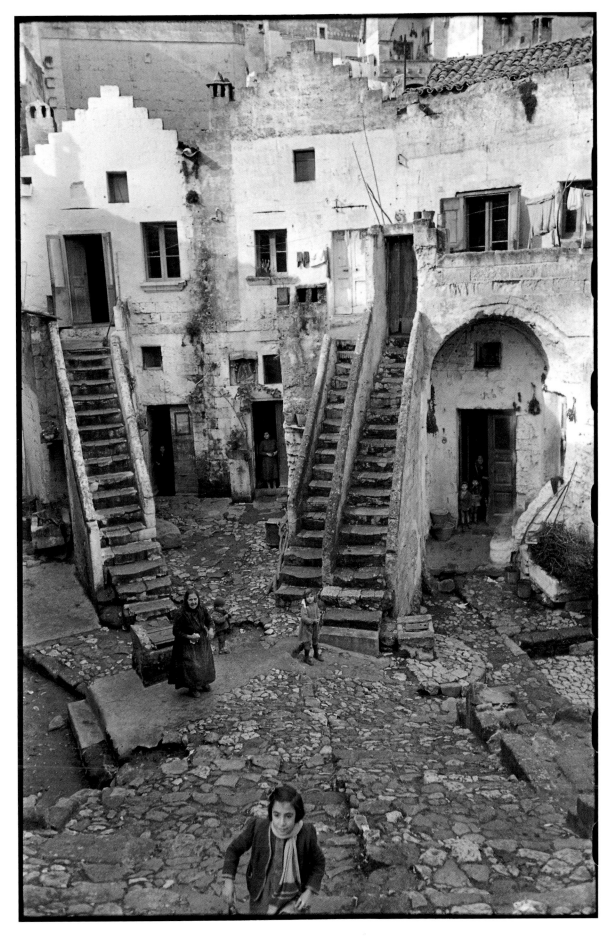

Matera, Basilicata,
Italy, 1951

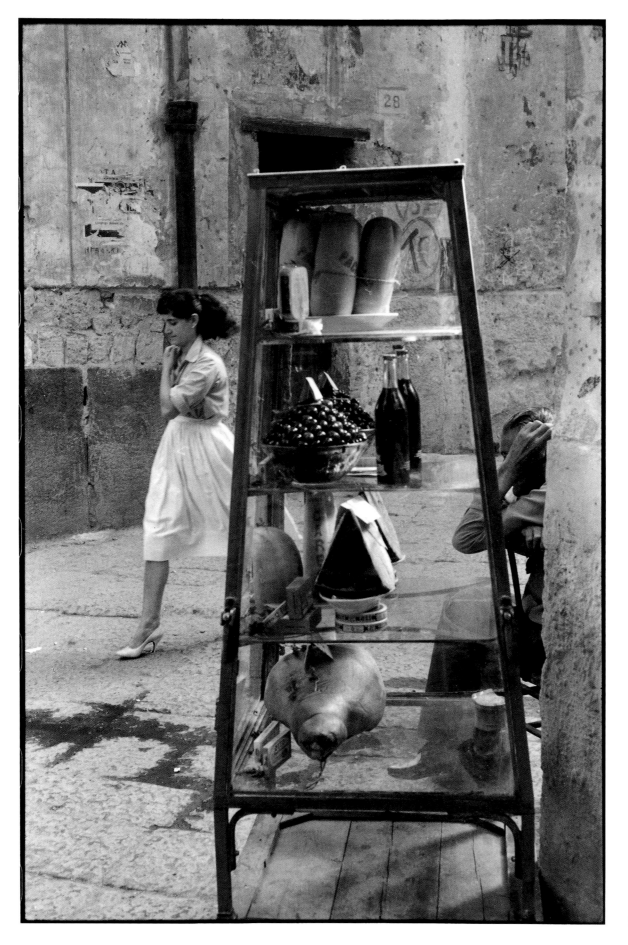

Naples, Italy, 1960

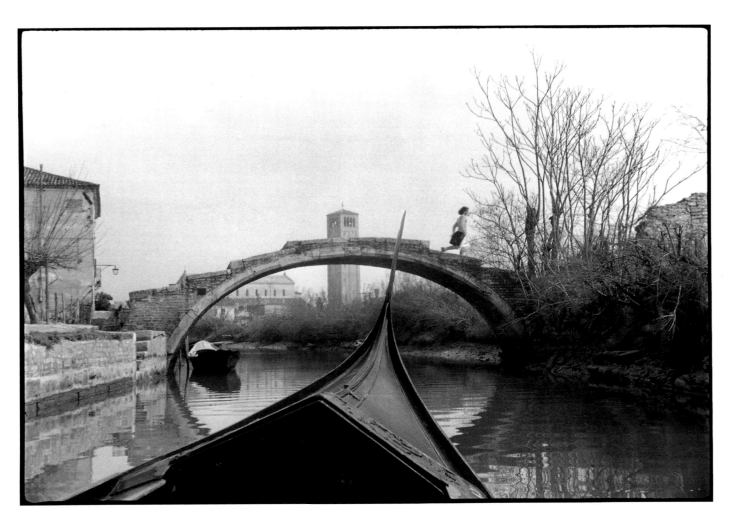

Torcello, Italy, 1953

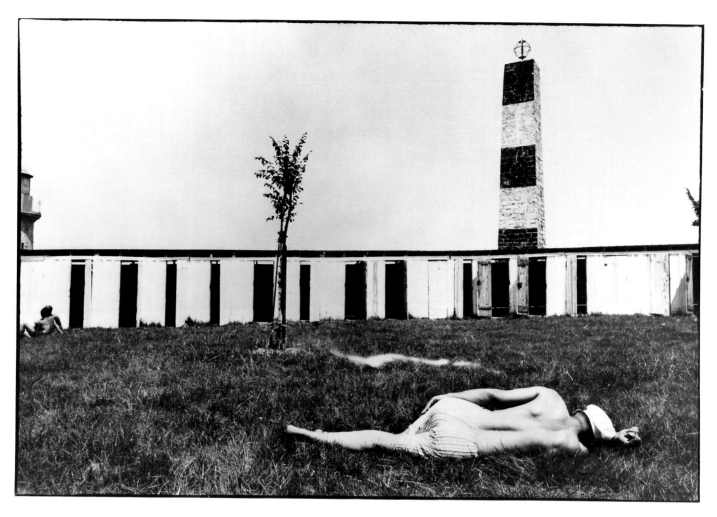

Trieste, Italy, 1933

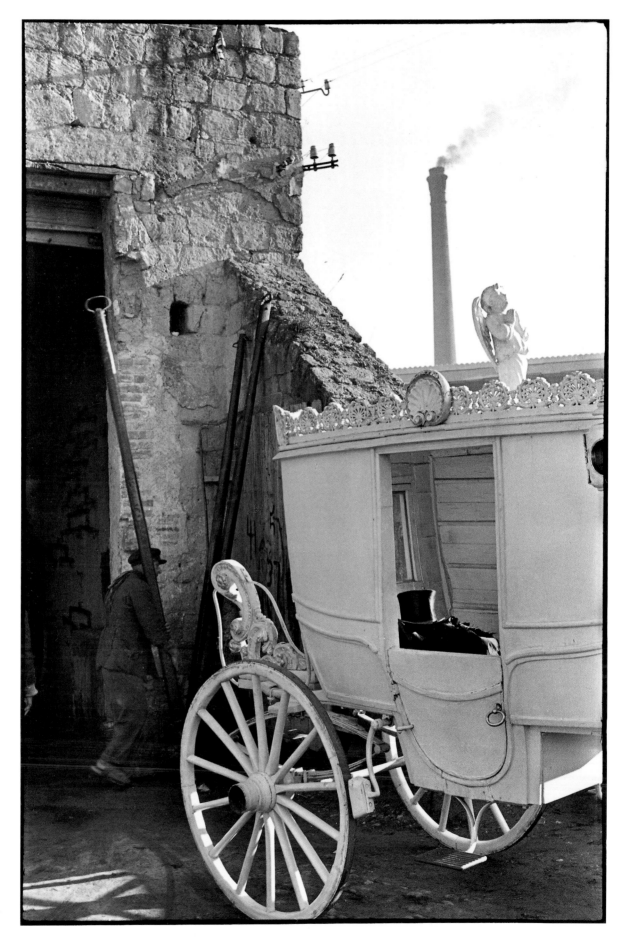

Irsina, Basilicata,
Italy, 1951

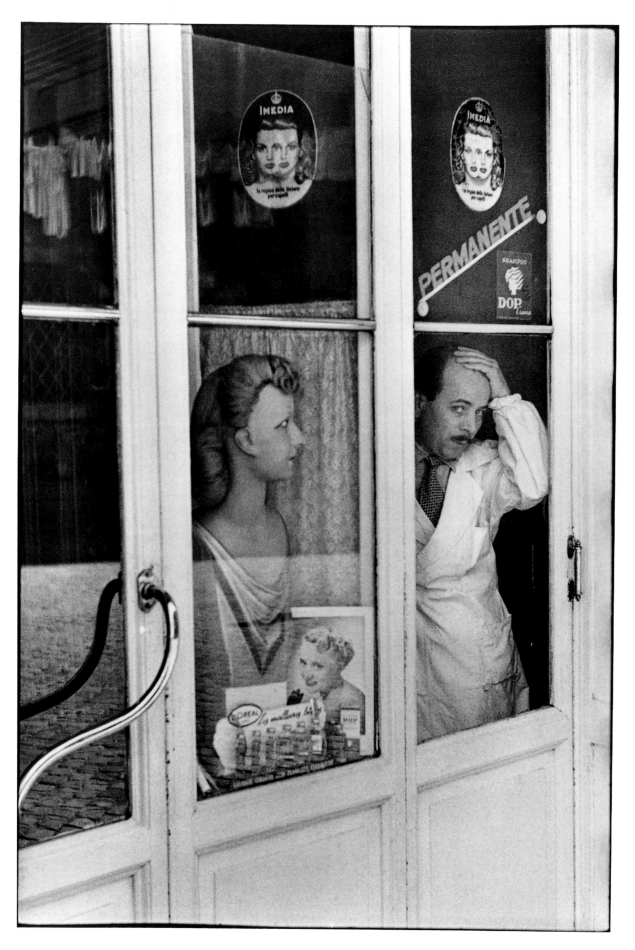

Rome, Italy,
1951

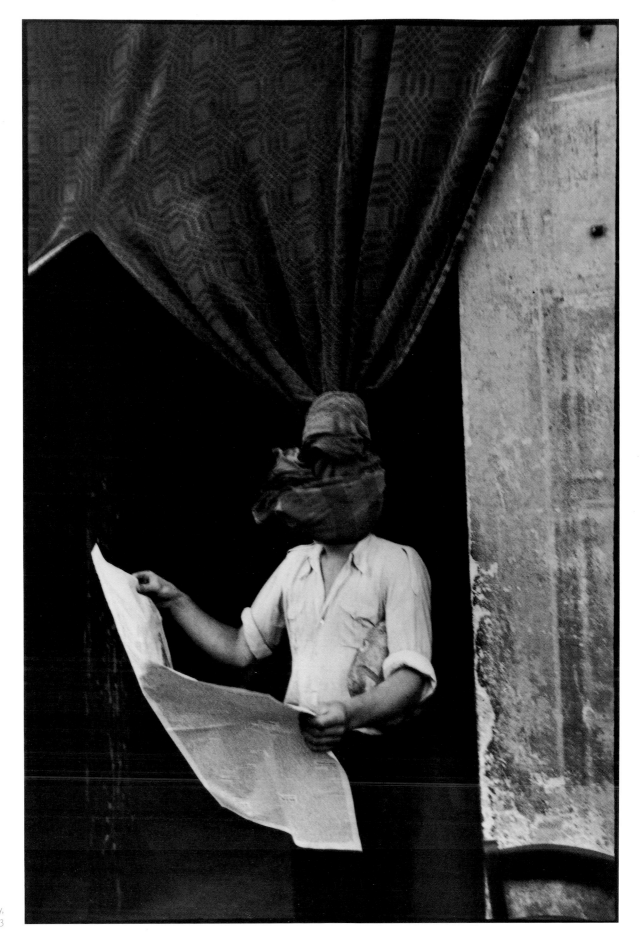

Livorno, Italy,
1933

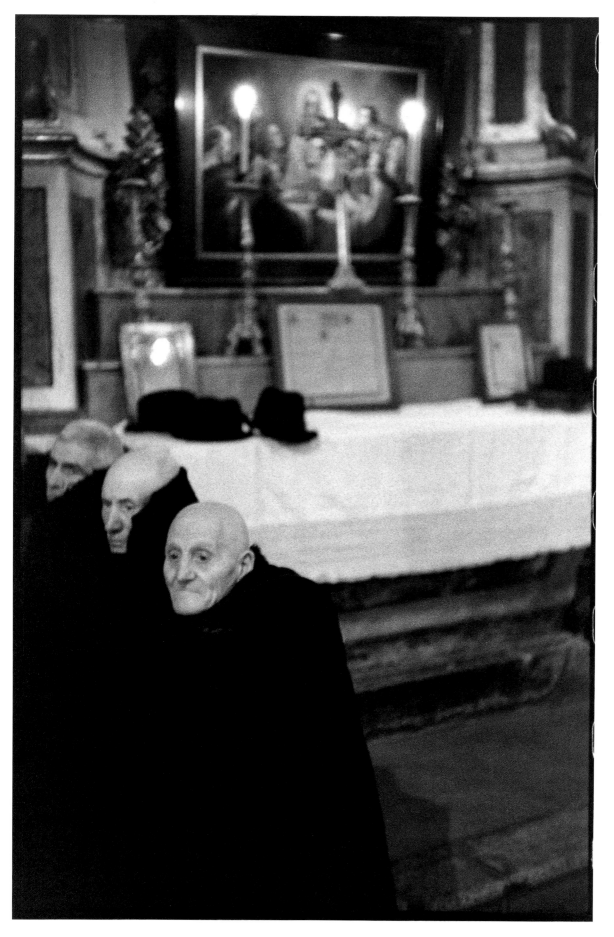

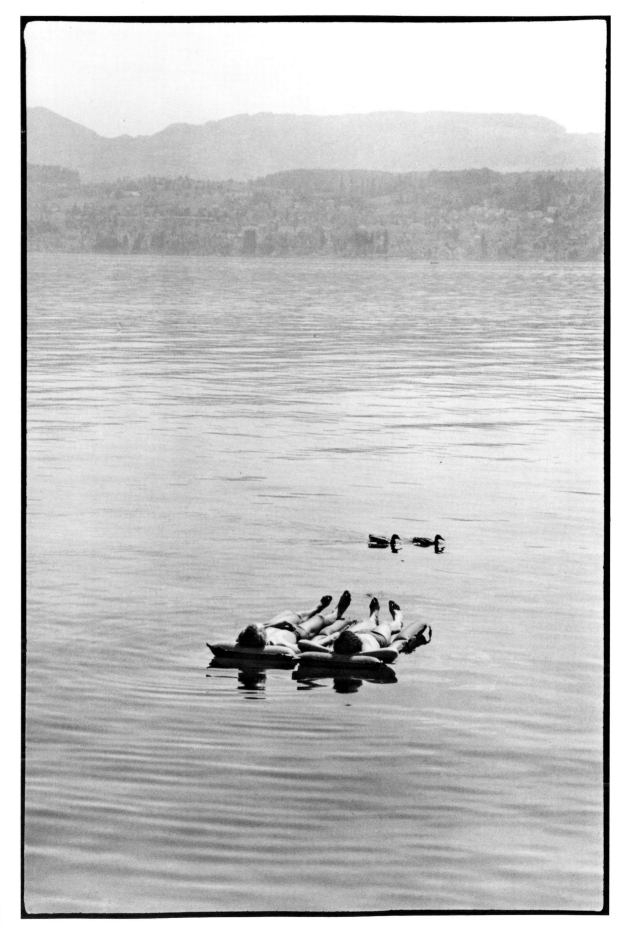

Zurich,
Switzerland, 1953

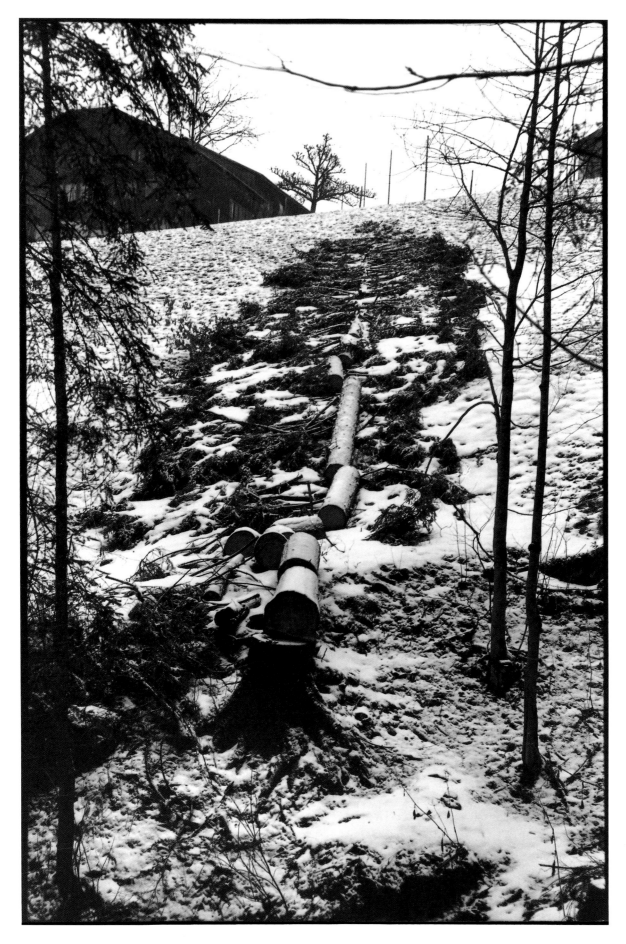

Switzerland,
1978

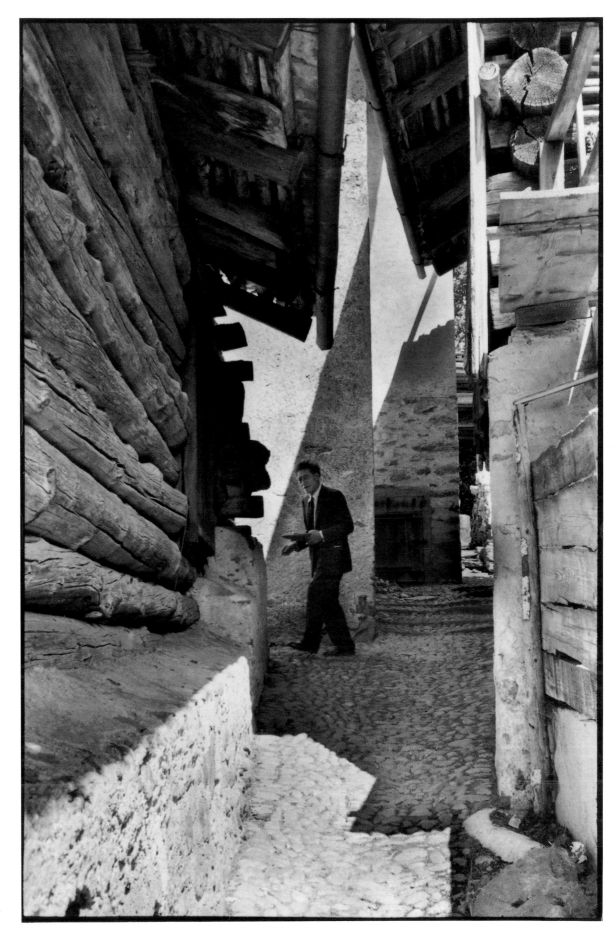

Stampa, Grisons,
Switzerland, 1961

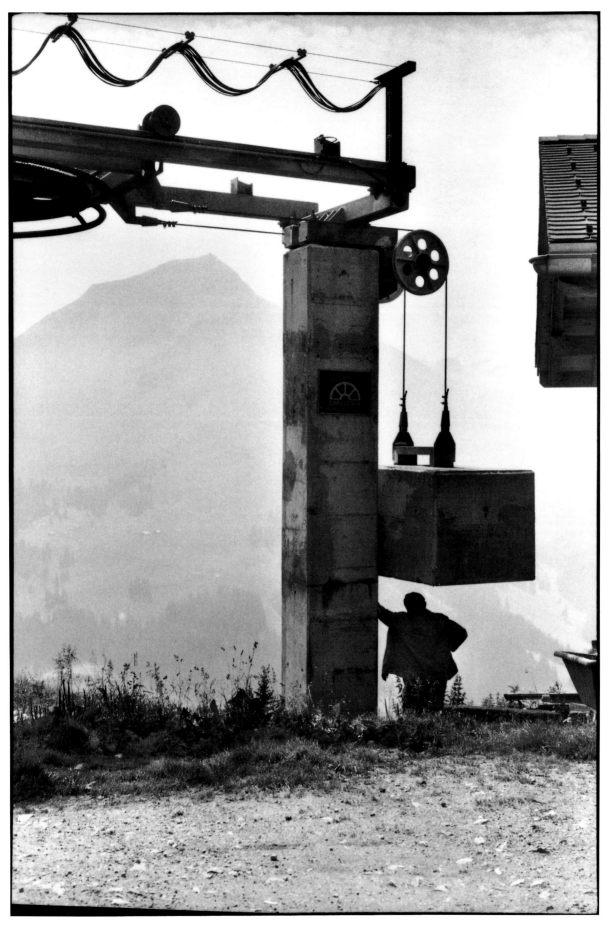

Ski lift, Switzerland,
1991

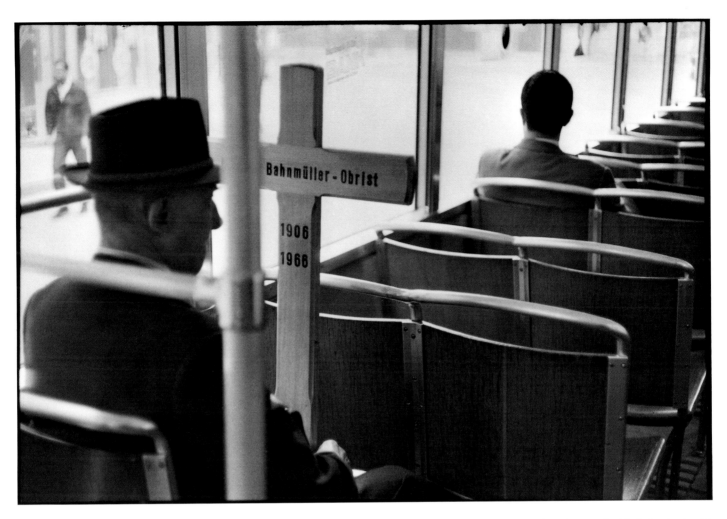

On board a tram, Zurich, Switzerland, 1966

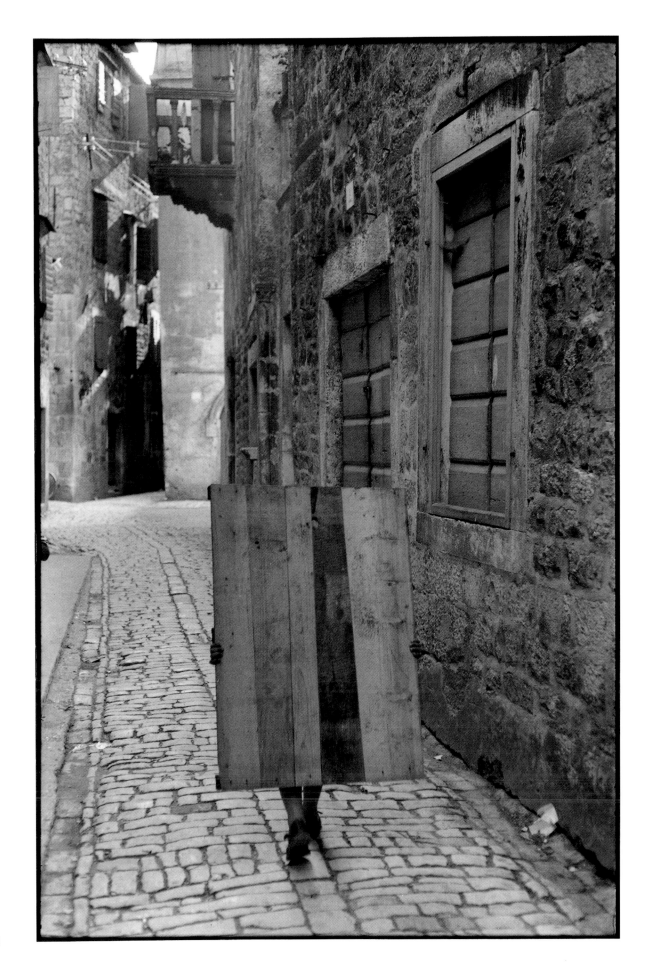

Trogir, Croatia,
Yugoslavia, 1965

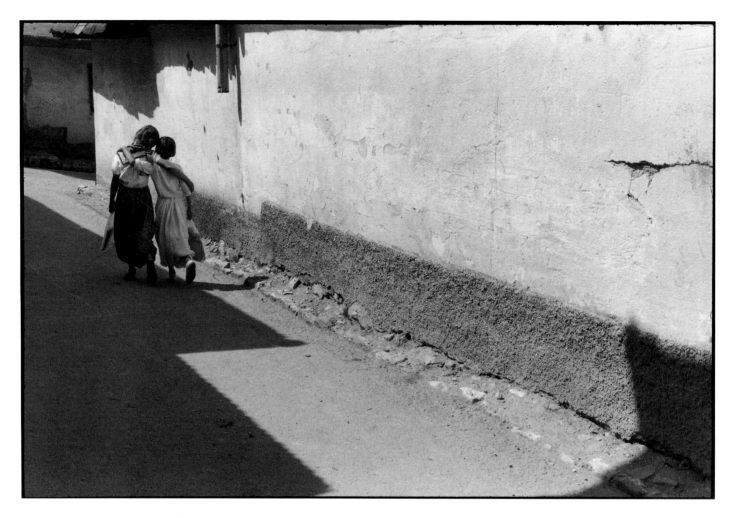

Sarajevo, Bosnia Hercegovina, Yugoslavia, 1965

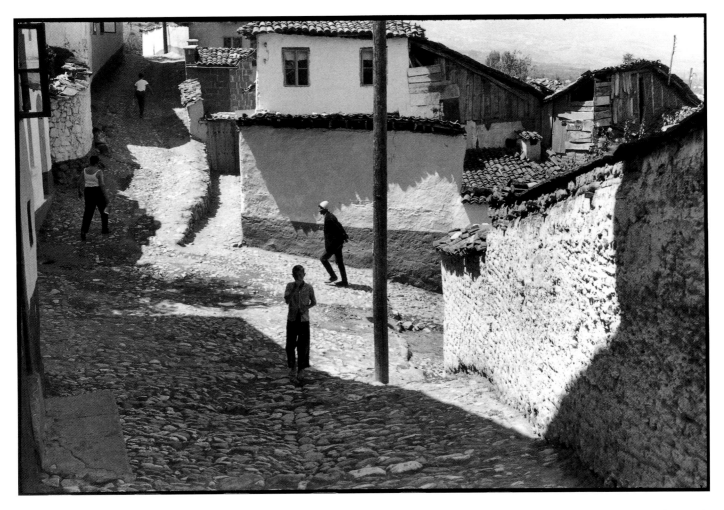

Prizren, Kosovo, Yugoslavia, 1965

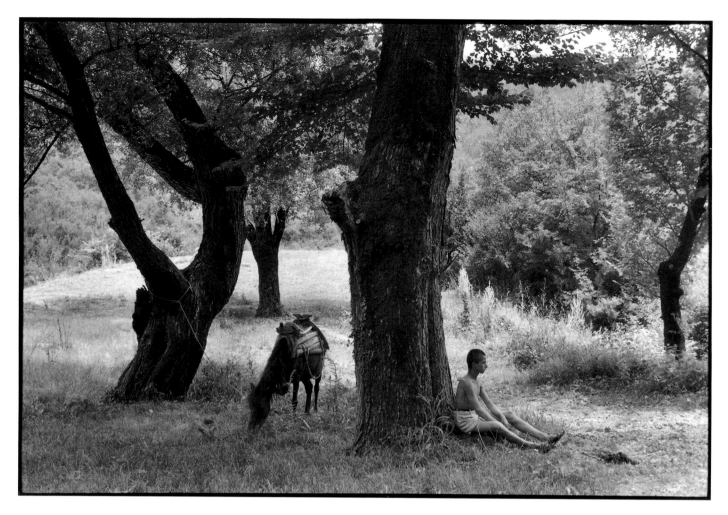

Morača, Montenegro, Yugoslavia, 1965

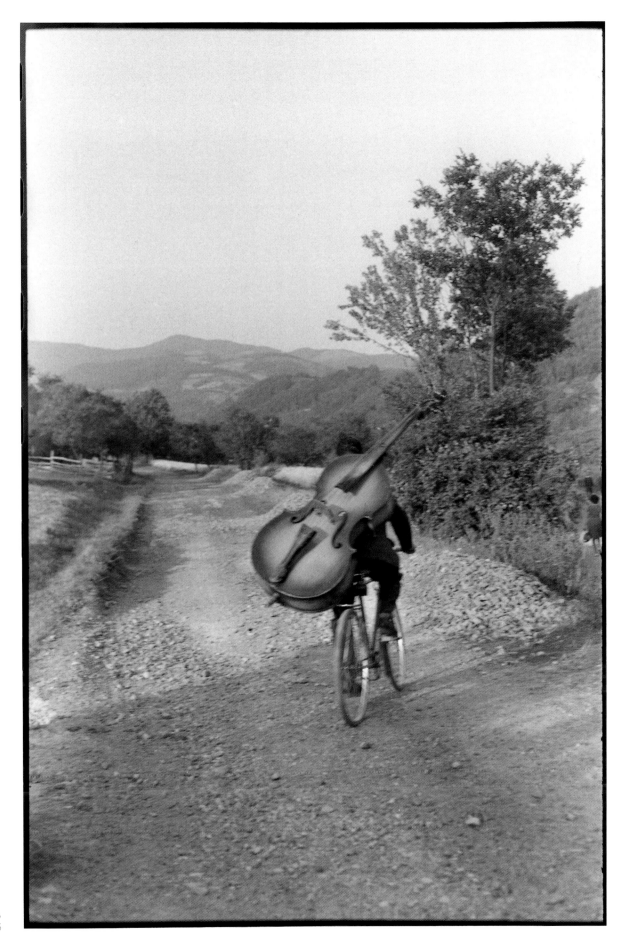

Rudnik, Serbia,
Yugoslavia, 1965

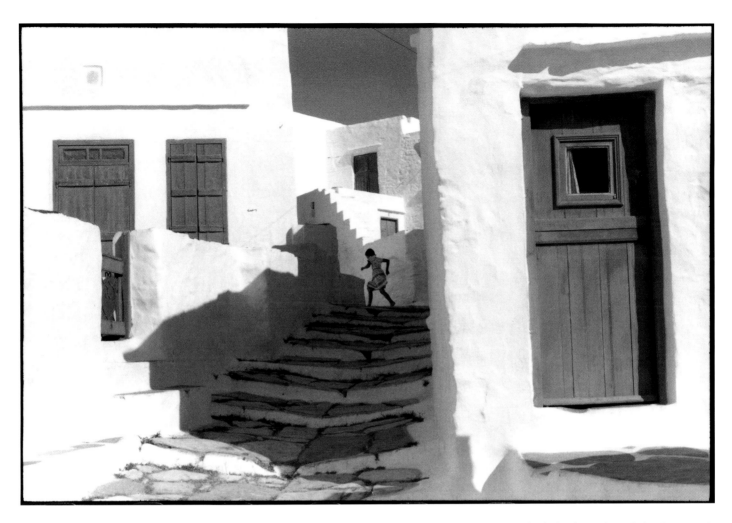

Island of Siphnos, the Cyclades, Greece, 1961

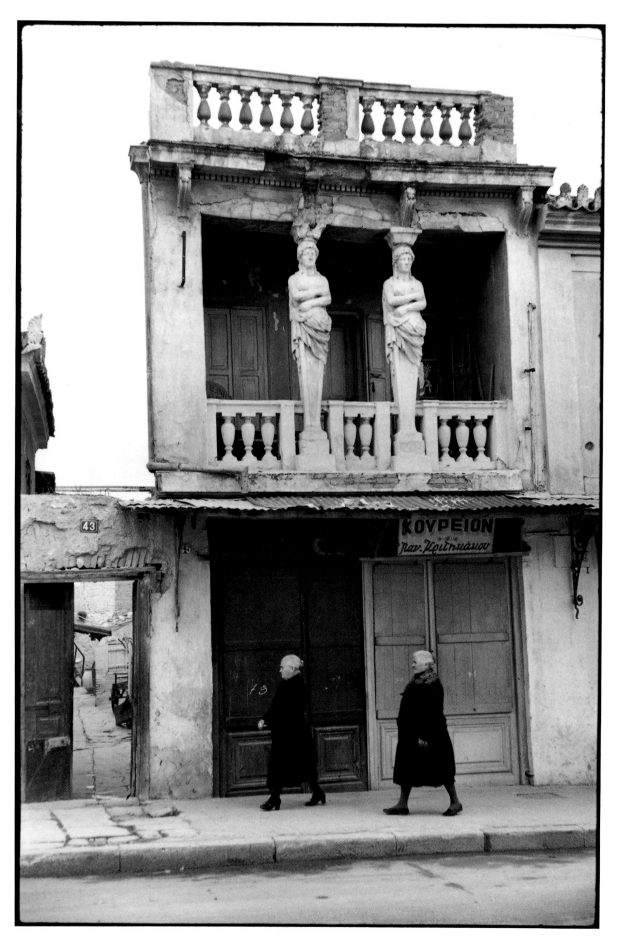

Athens, Greece,
1953

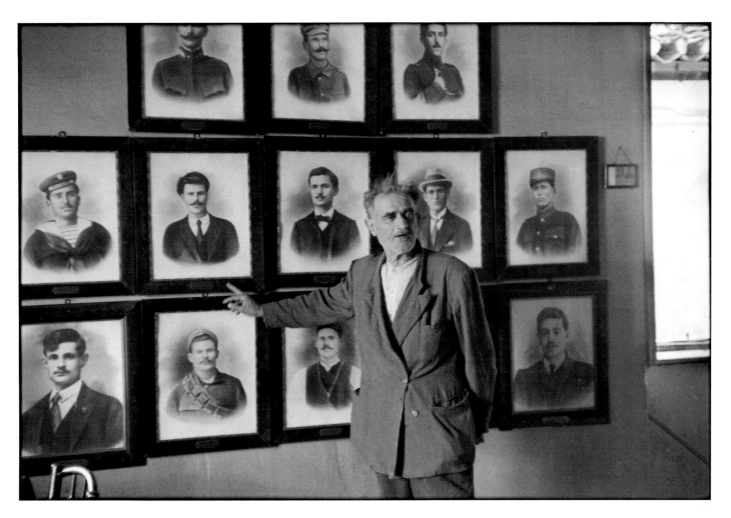

The Peloponnese, Greece, 1953

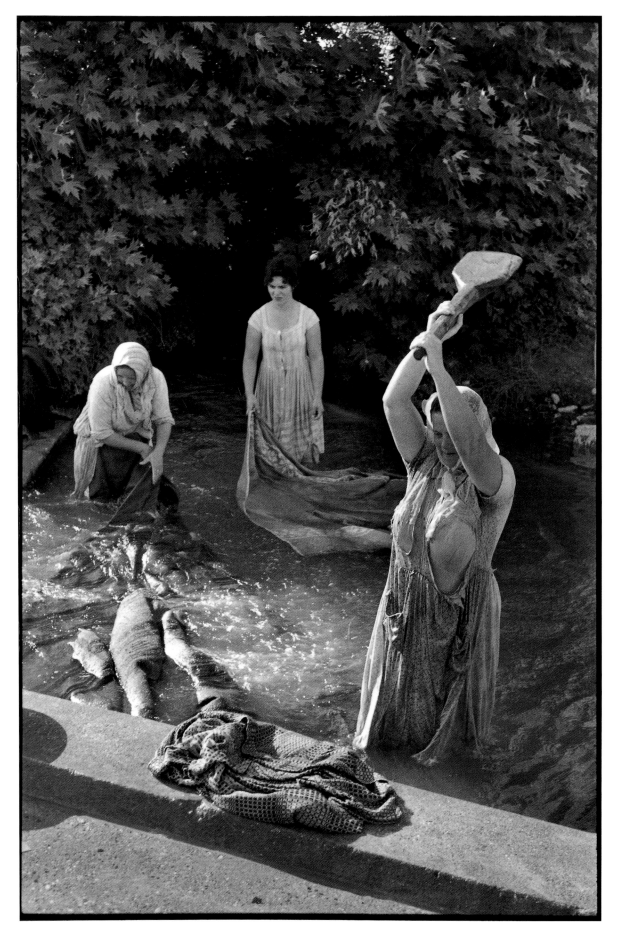

Epirus, Greece,
1961

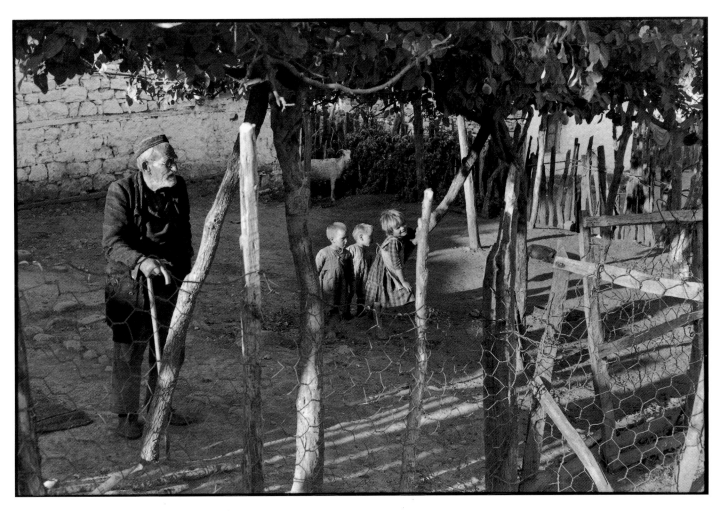

Epirus, Greece, 1961

Epirus, Greece, 1961

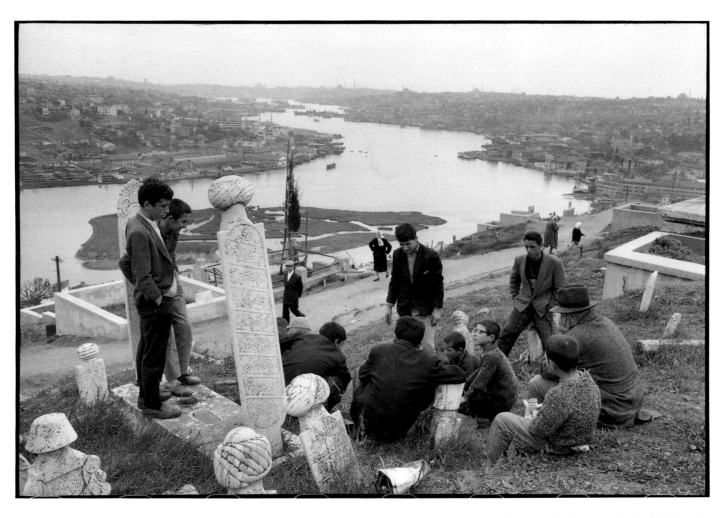

Golden Horn, the Bosporus, Istanbul, Turkey, 1964

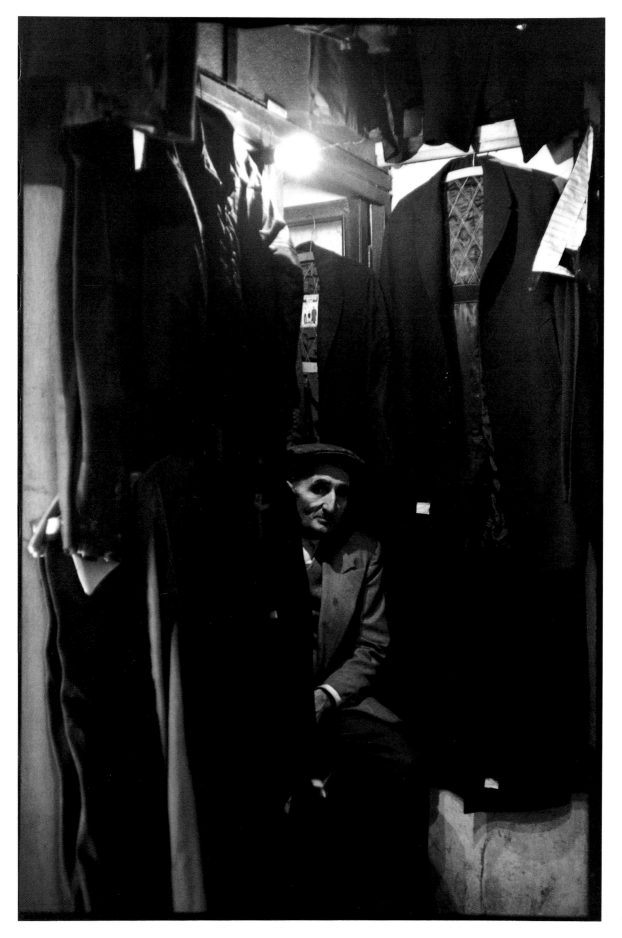

Bazaar, Istanbul,
Turkey, 1964

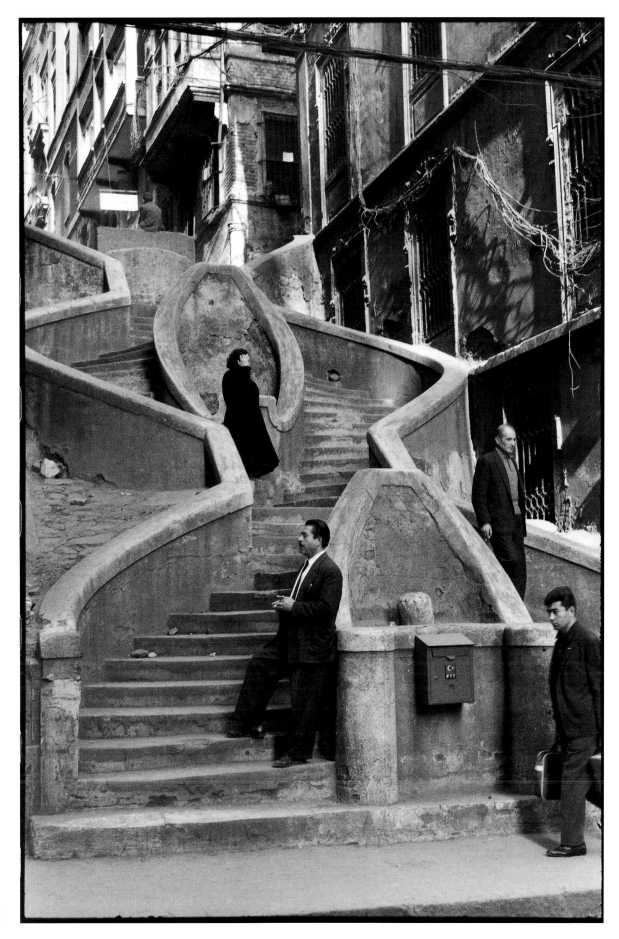

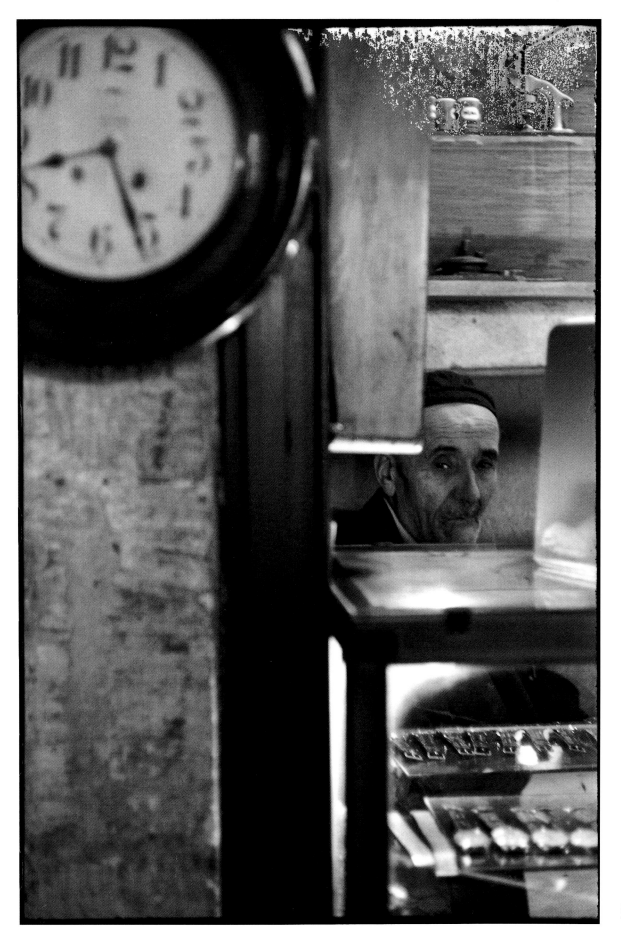

Bazaar, Istanbul,
Turkey, 1964

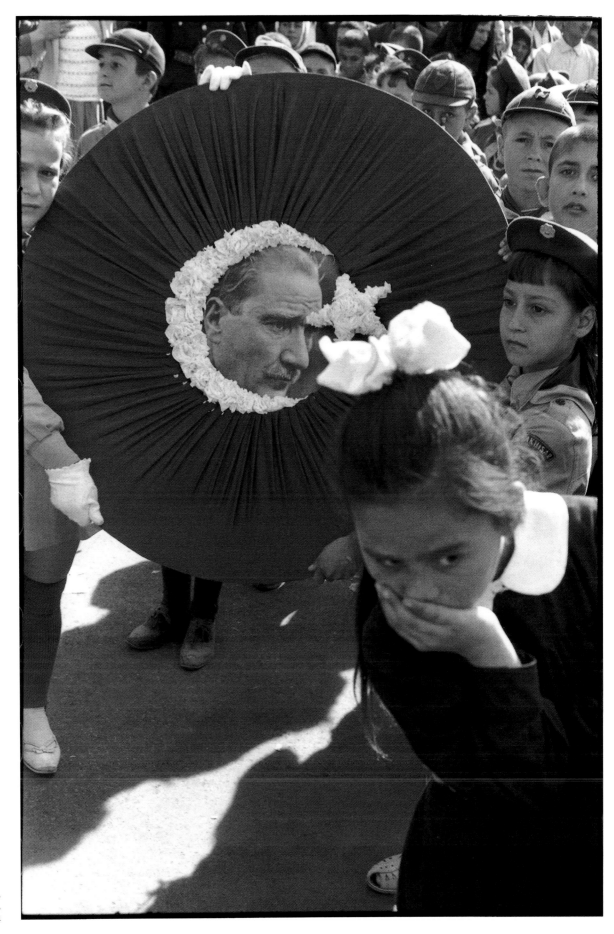

Portrait of Atatürk,
Republic Day, Turkey,
29 October 1964

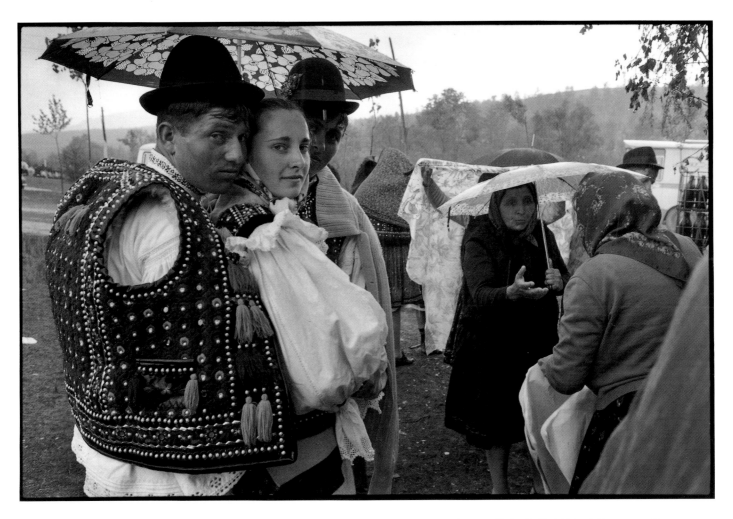

Spring festival, Hoteni, Maramures, Romania, 1975

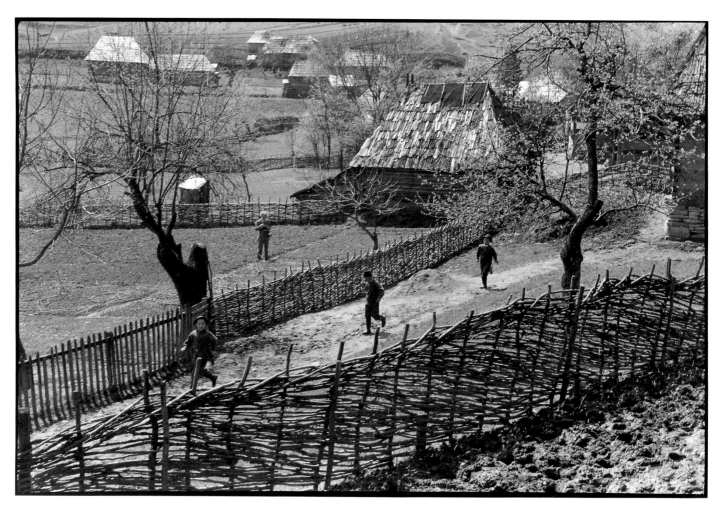

Bogdan Voda, Maramures, Romania, 1975

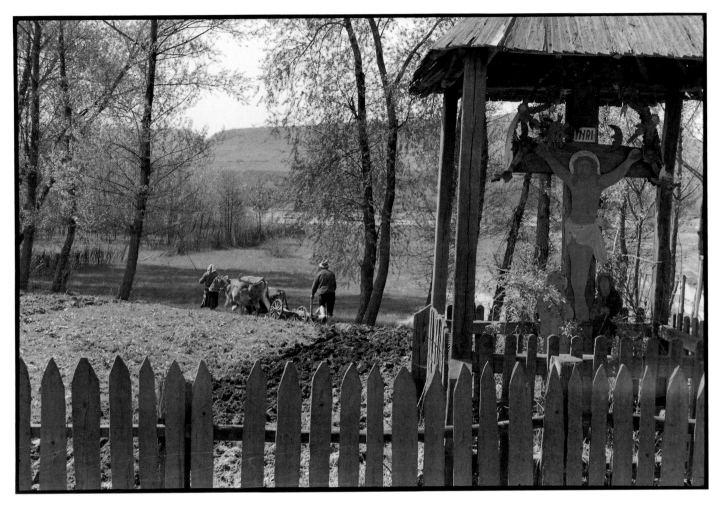

Maramures, Romania, 1975

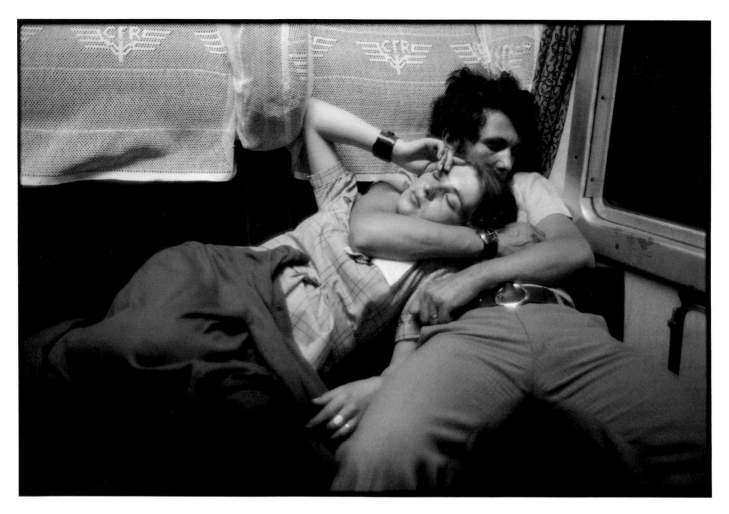

The seats opposite, Romania, 1975

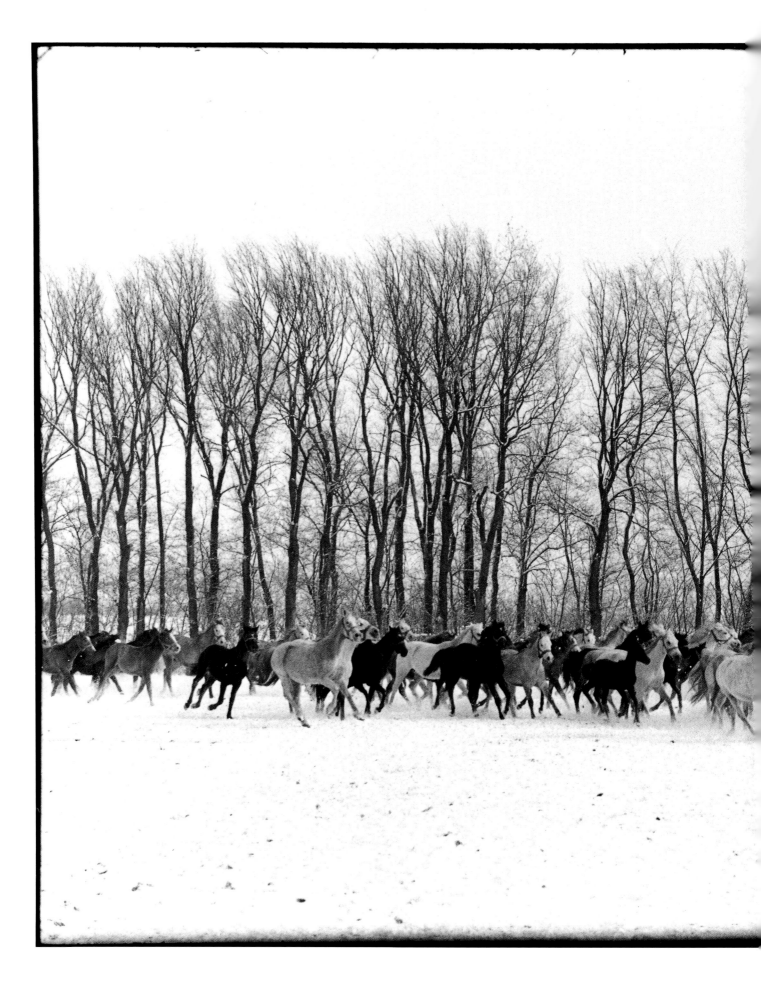

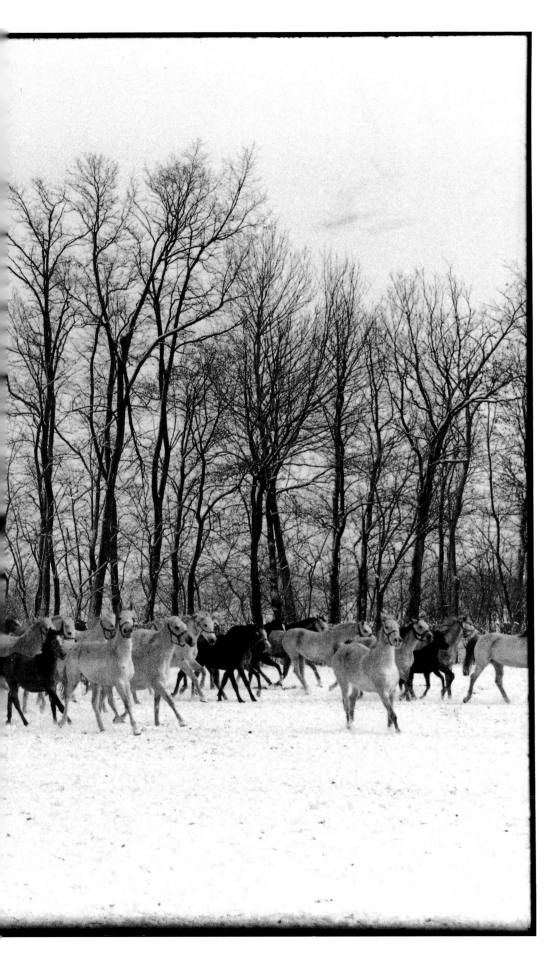

Györ, Hungary,
1964

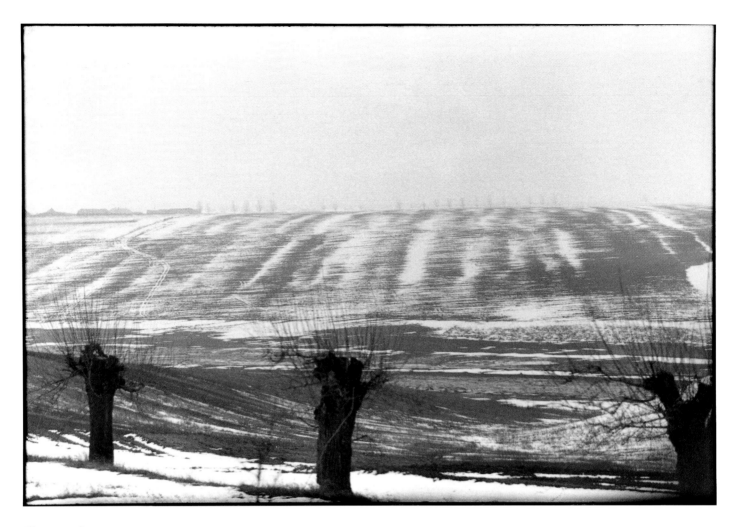

Hungary, 1964

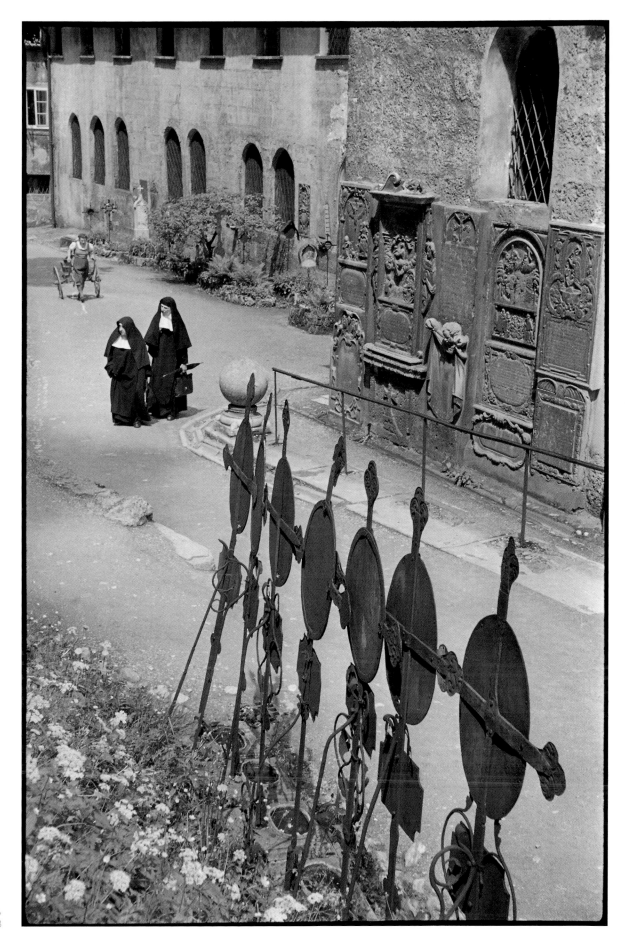

Salzburg,
Austria, 1953

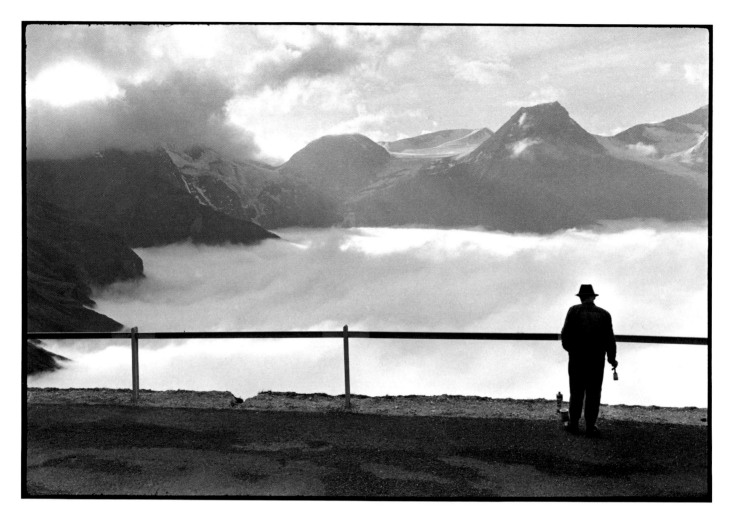

Near Linz, Upper Austria, 1953

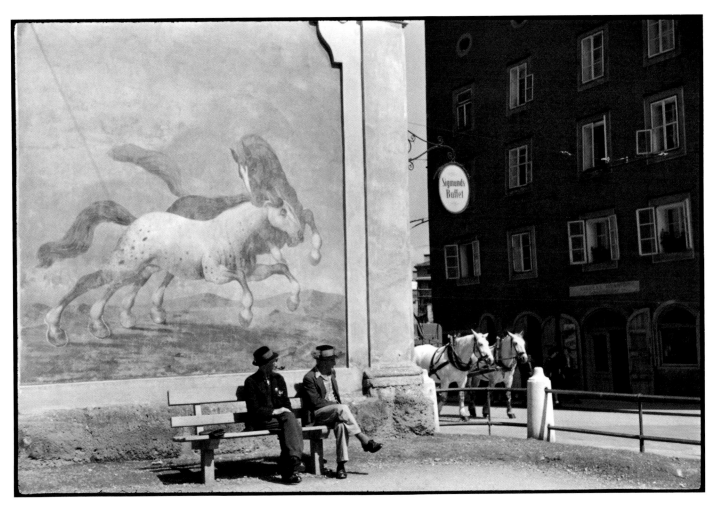

Salzburg, Austria, 1953

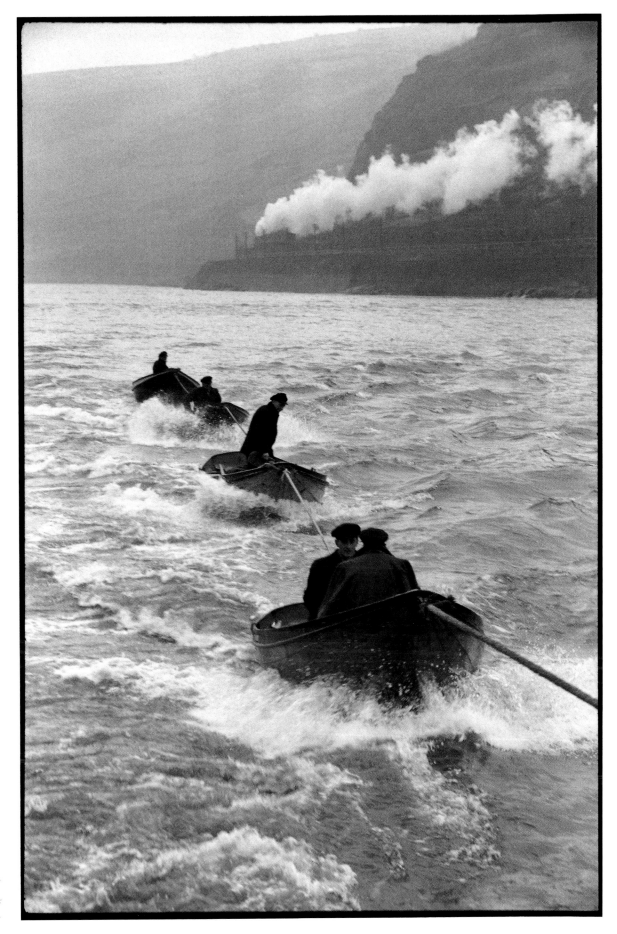

Tug-boat pilots on the
Rhine, near Bingen,
Federal Republic of
Germany, 1956

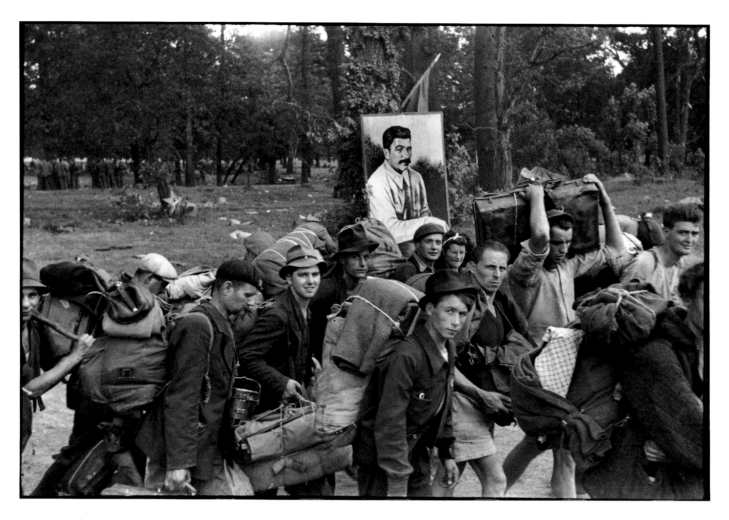

Transit camp for western Europeans, freed by the Soviets in East Germany,
Dessau, Germany, 1945

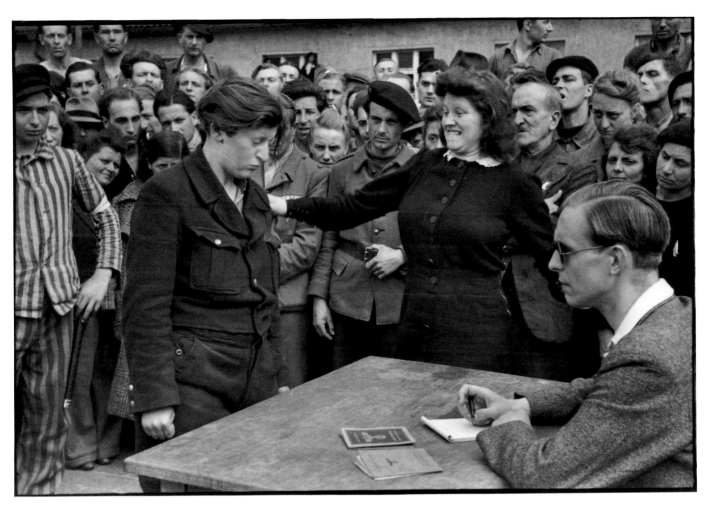

At the liberation of a deportation camp, a Gestapo informer is recognized
by a woman she had denounced, Dessau, Germany, 1945

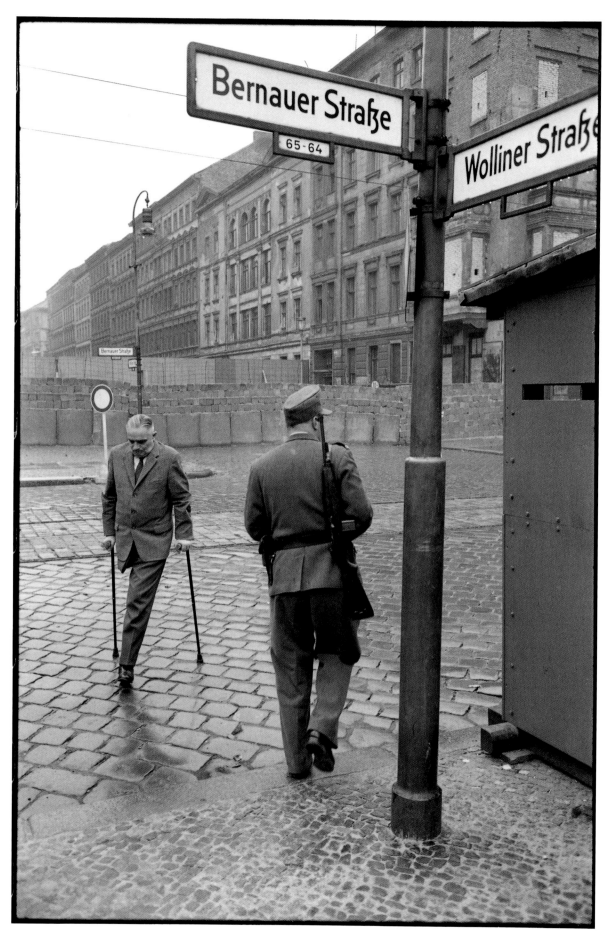

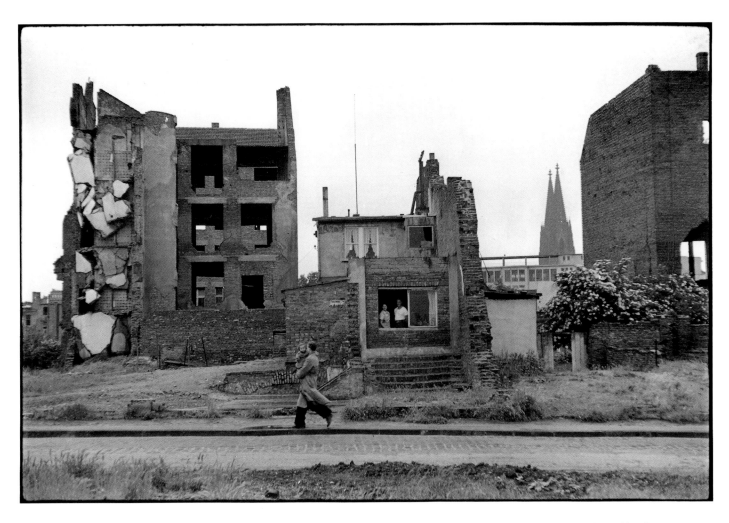

Cologne, Federal Republic of Germany, 1956

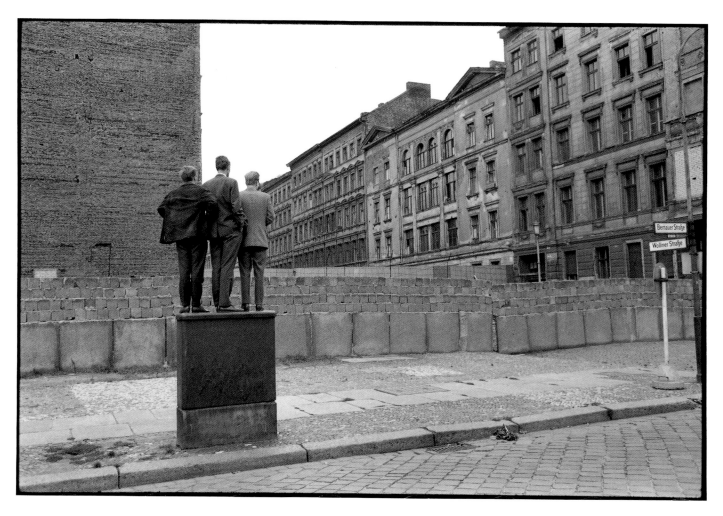

The East seen from the West, Berlin,
Federal Republic of Germany, 1962

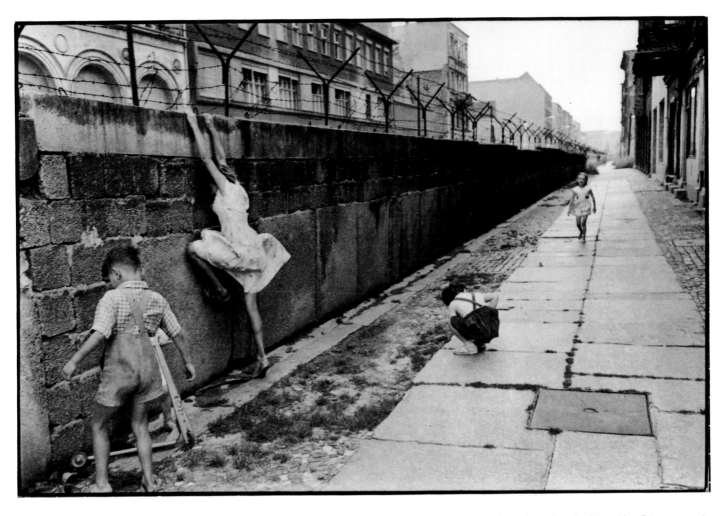

The Berlin Wall, Federal Republic of Germany, 1962

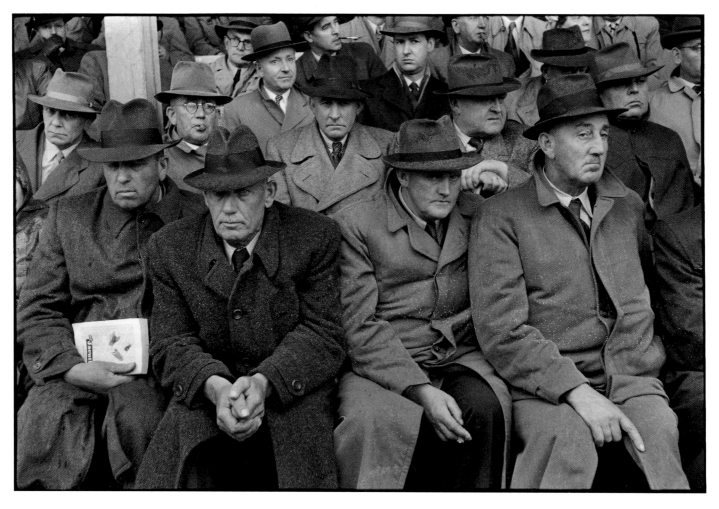

The opening of the agricultural fair by Chancellor Adenauer, Cologne,
Federal Republic of Germany, 1953

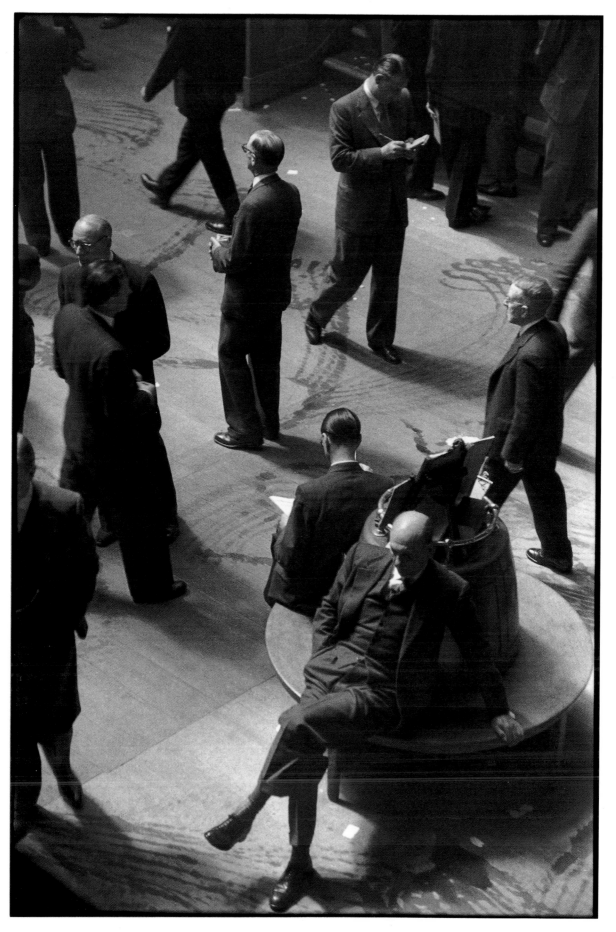

The Stock
Exchange, London,
England, 1955

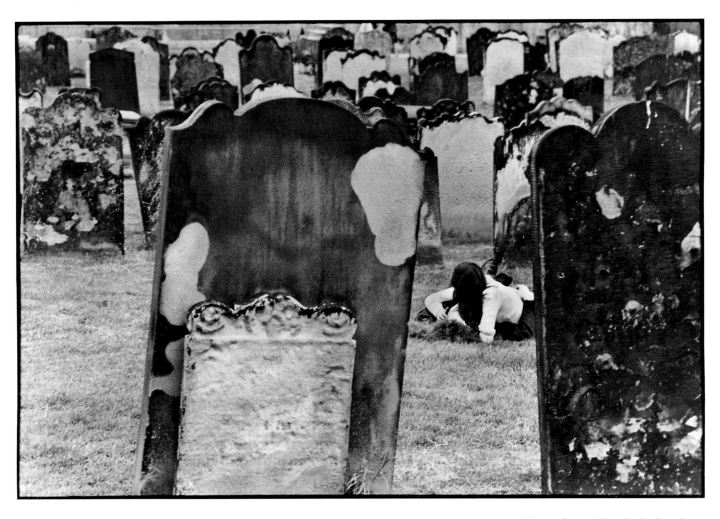

Newcastle upon Tyne, England, 1978

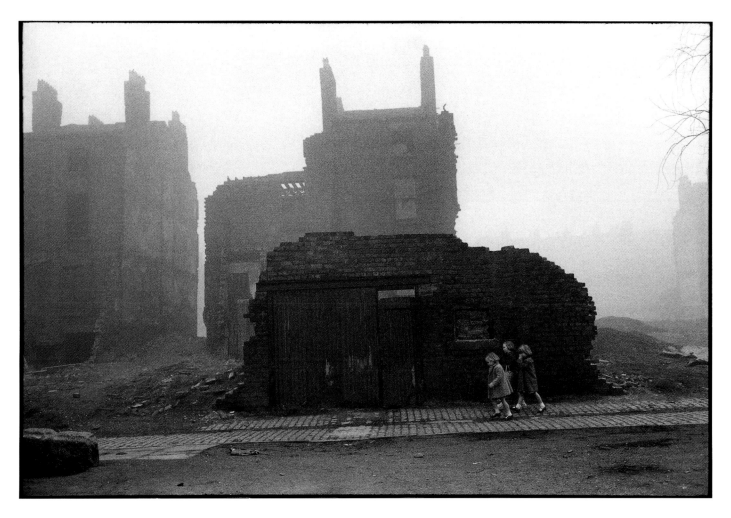

Liverpool, England, 1962

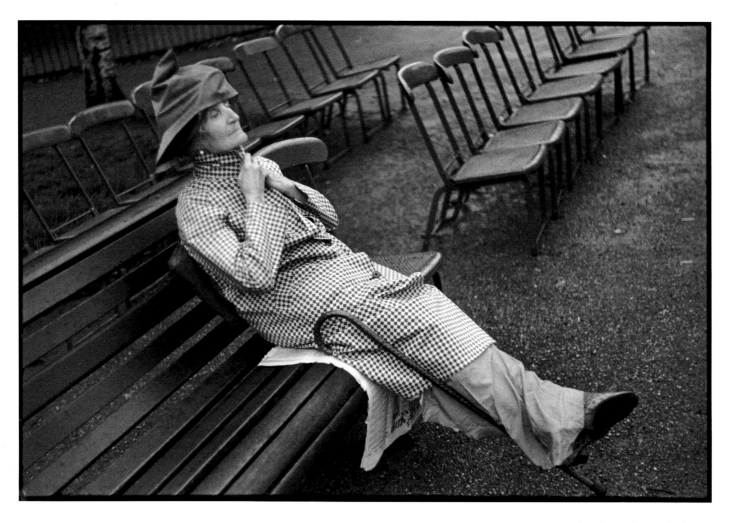

Hyde Park, London, England, 1937

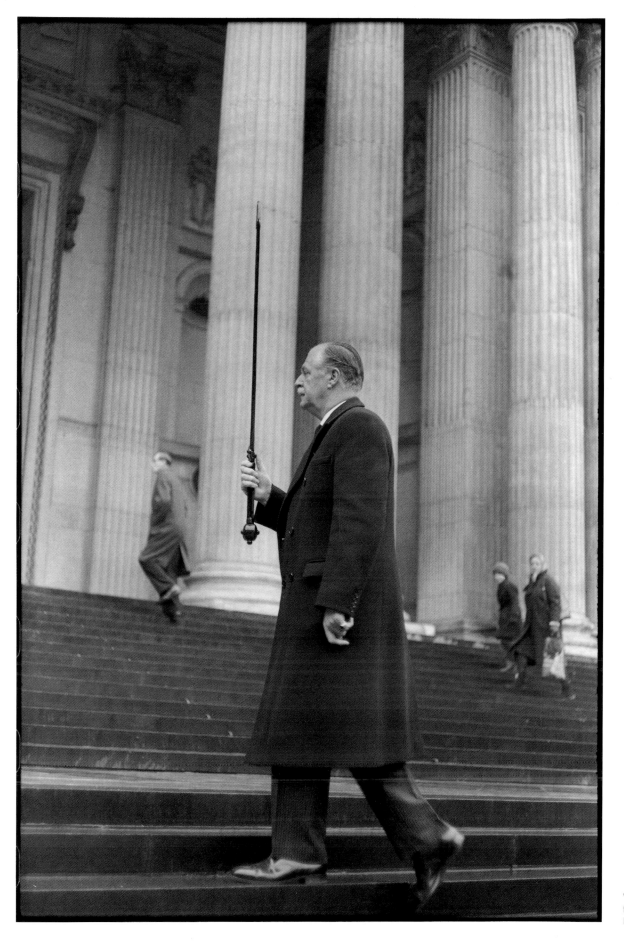

Winston Churchill's
funeral, London,
England, 1965

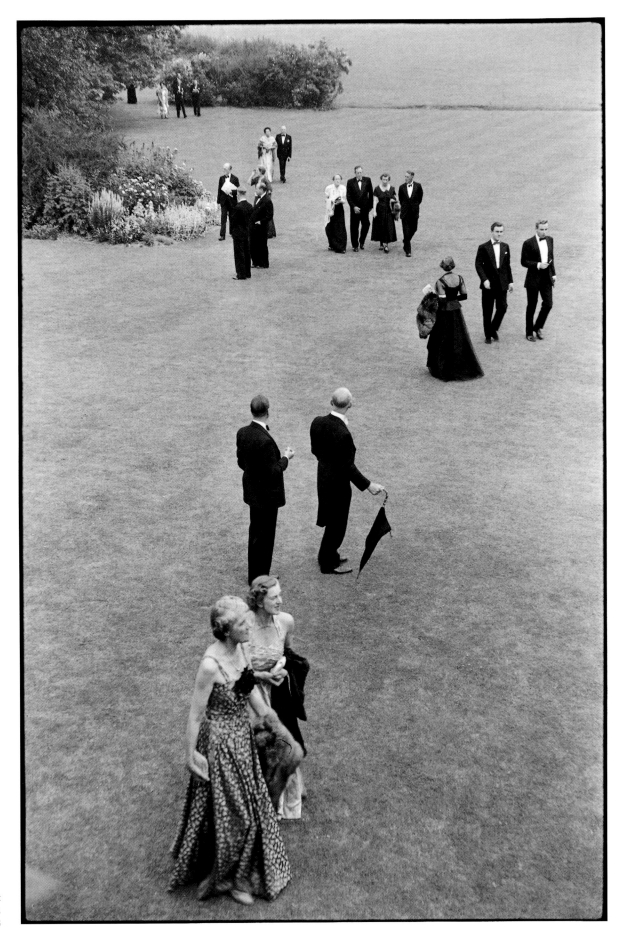

The interval at
Glyndebourne,
England, 1953

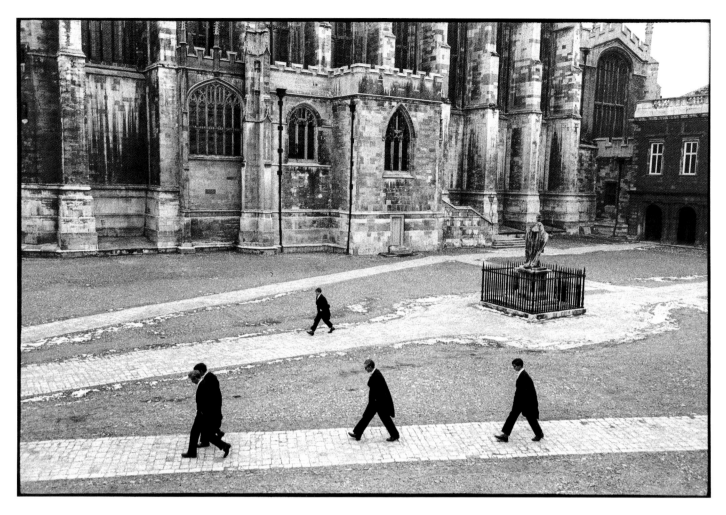

Eton College, England, 1962

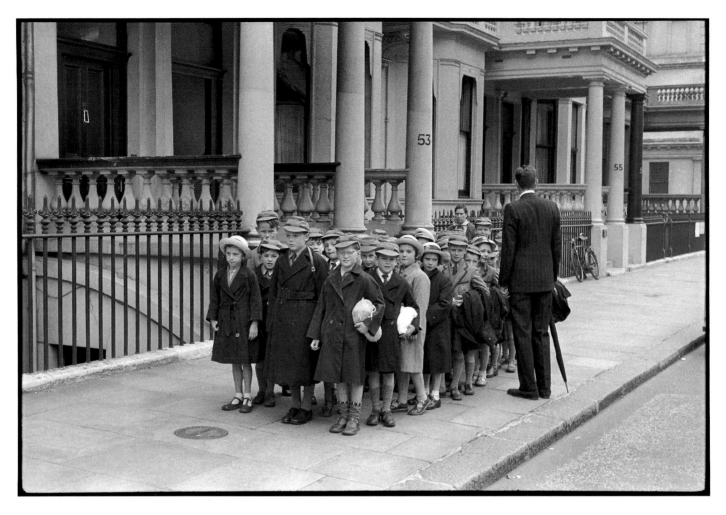

Kensington, London, England, 1955

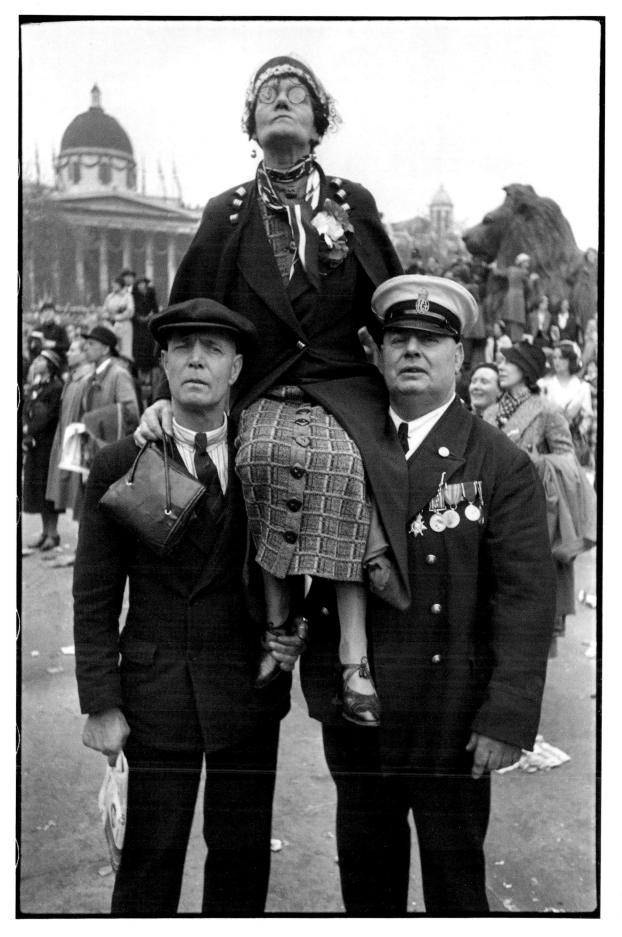

George VI's
coronation,
London, England,
1937

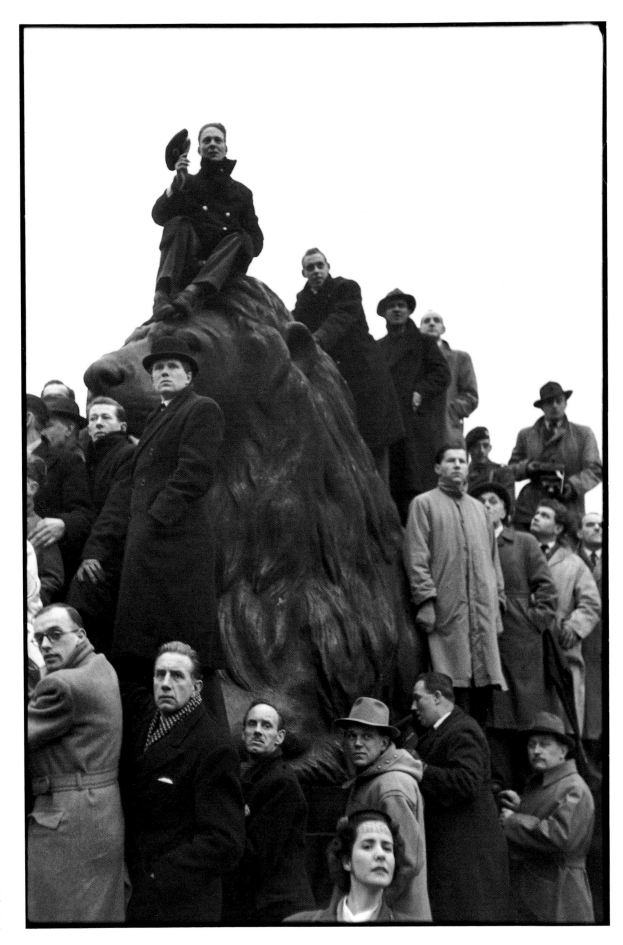

George VI's
funeral, Trafalgar
Square, London,
England, 1952

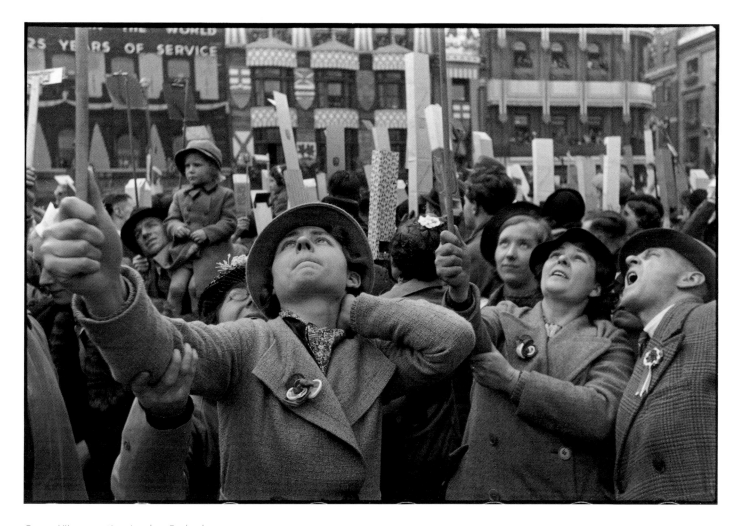

George VI's coronation, London, England, 1937

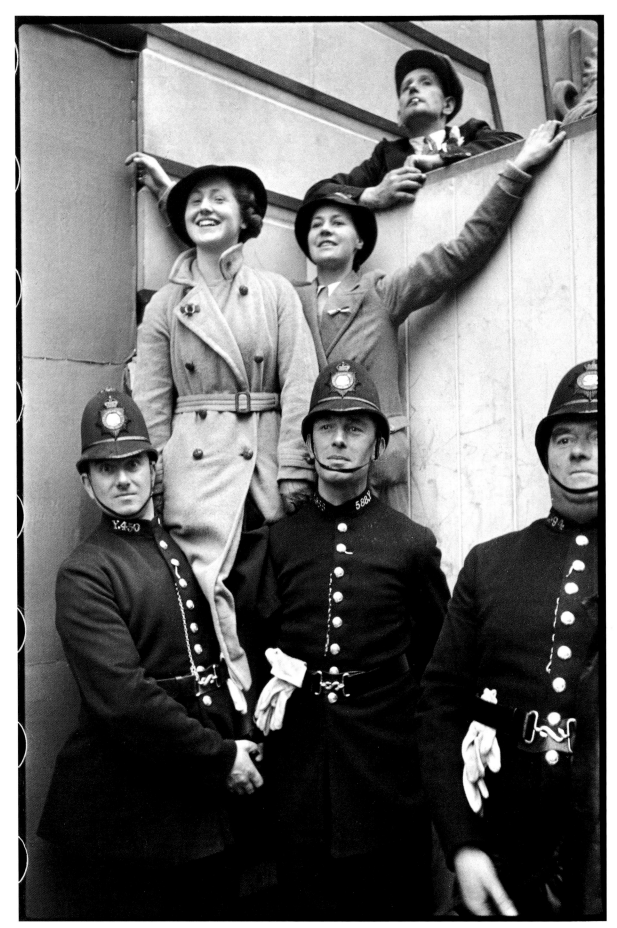

George VI's
coronation,
London,
England,
1937

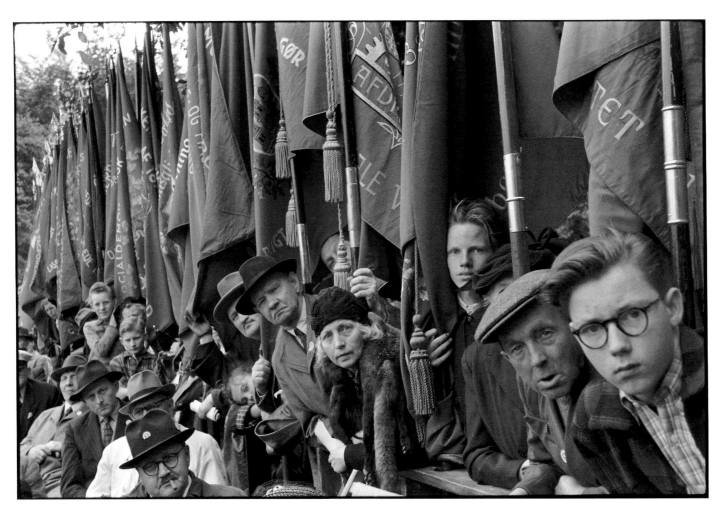

Militants from the Danish Socialist Party, Constitution Day,
Faelled Park, Copenhagen, Denmark, 5 June 1953

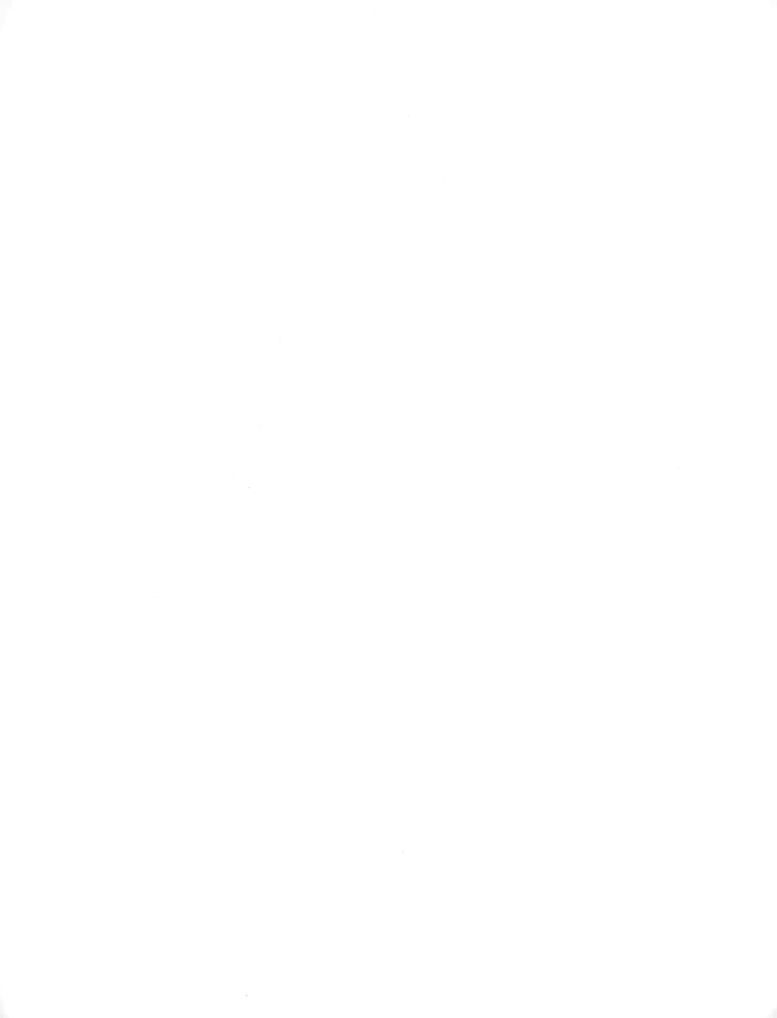

Sweden, 1956

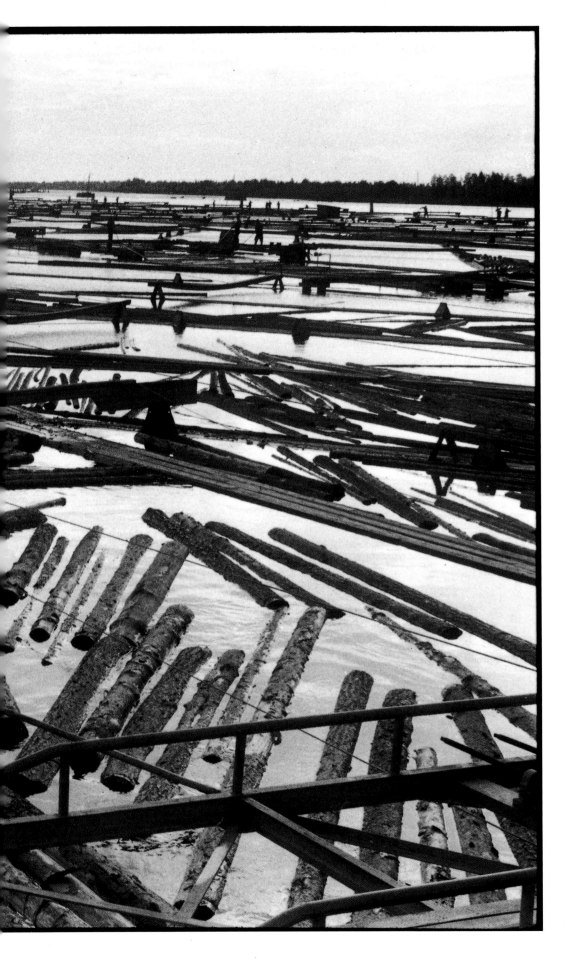

Sweden, 1956

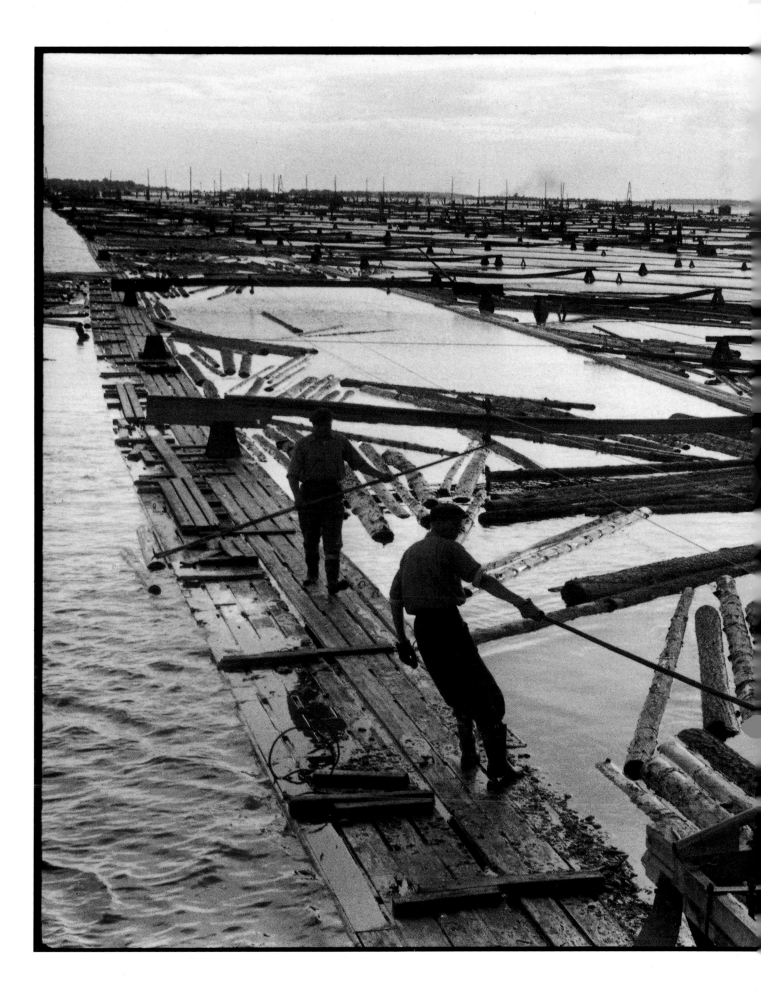

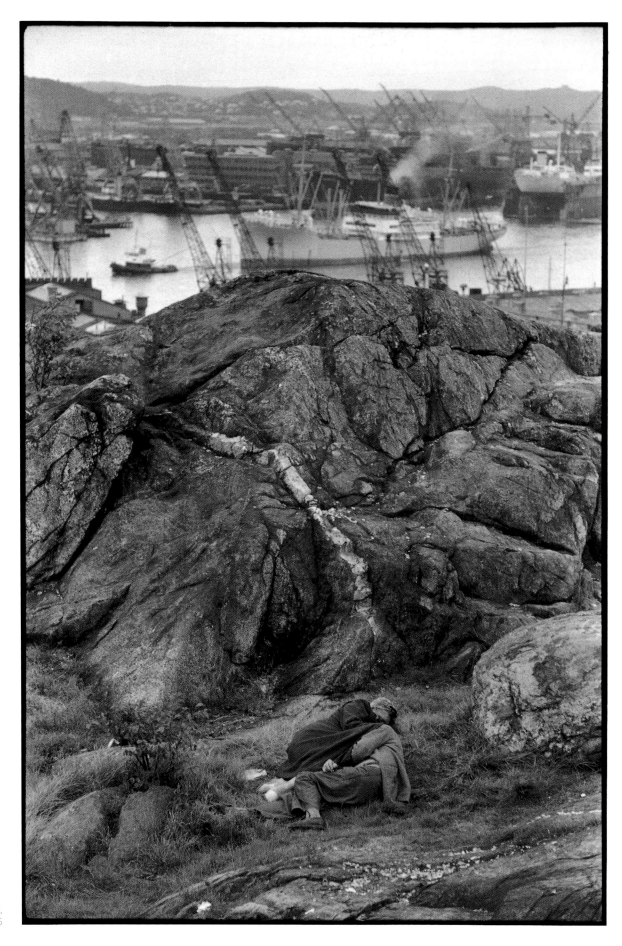

Göteborg,
Sweden, 1956

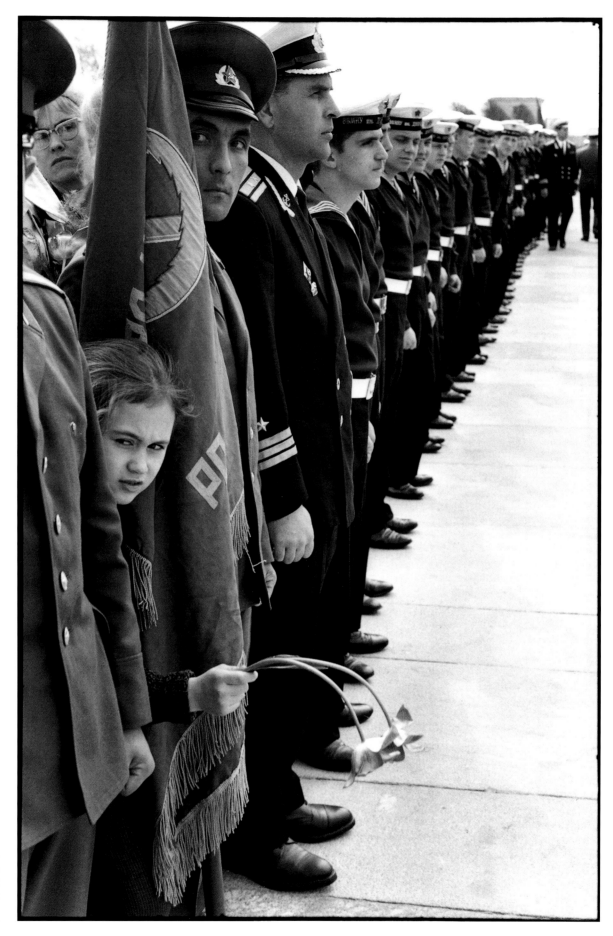

Guard of honour
at a ceremony
commemorating
Leningrad's
liberation, USSR,
9 May 1973

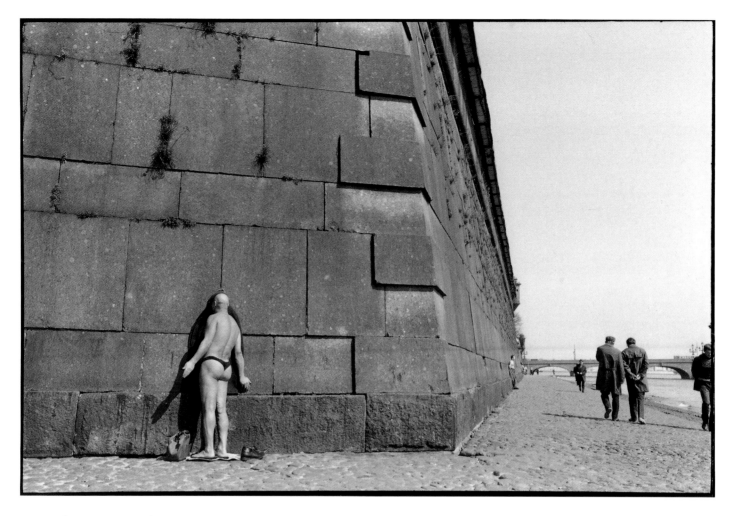

Peter Paul Fortress, Leningrad, USSR, 1973

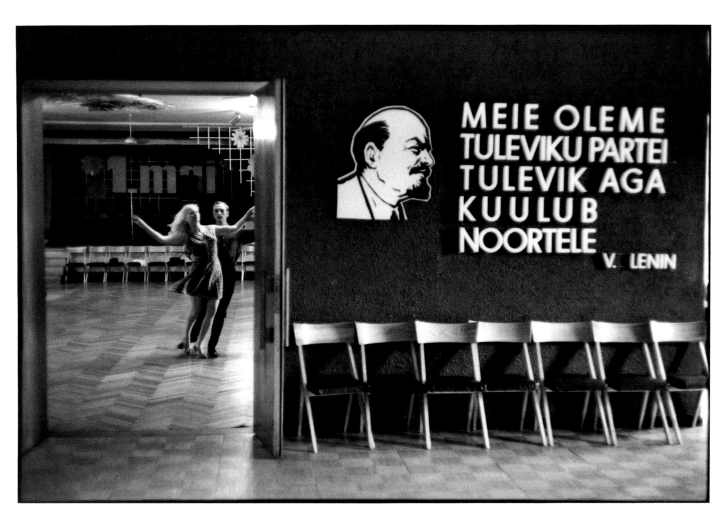

Dance contest, cellulose factory, Tallinn, Estonia, USSR, 1973

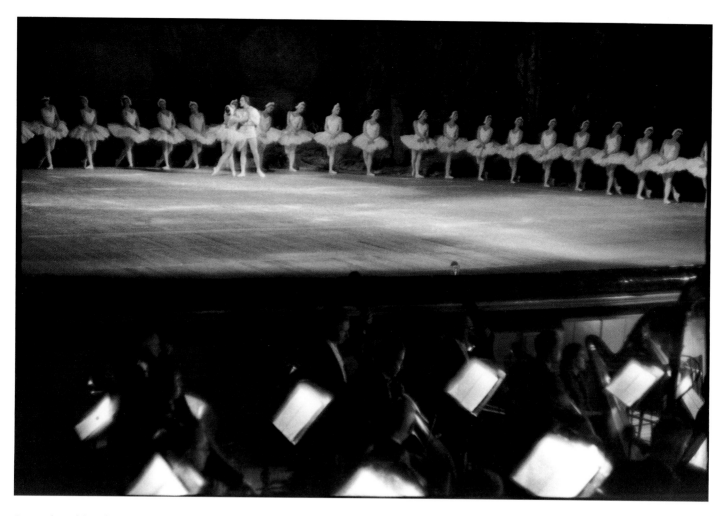

Swan Lake, Bolshoi Theatre, Moscow, USSR, 1954

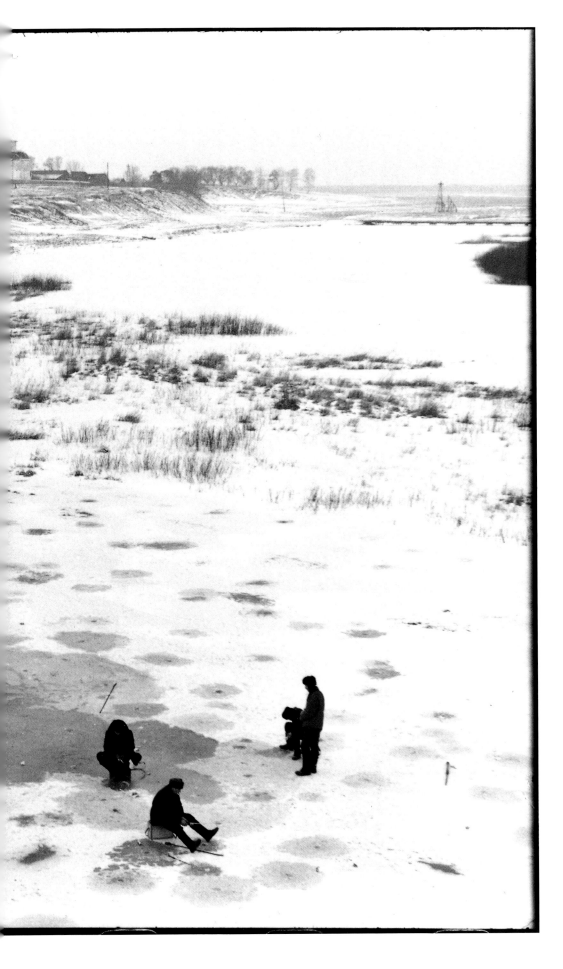

Fishermen, near Suzdal,
USSR, 1972

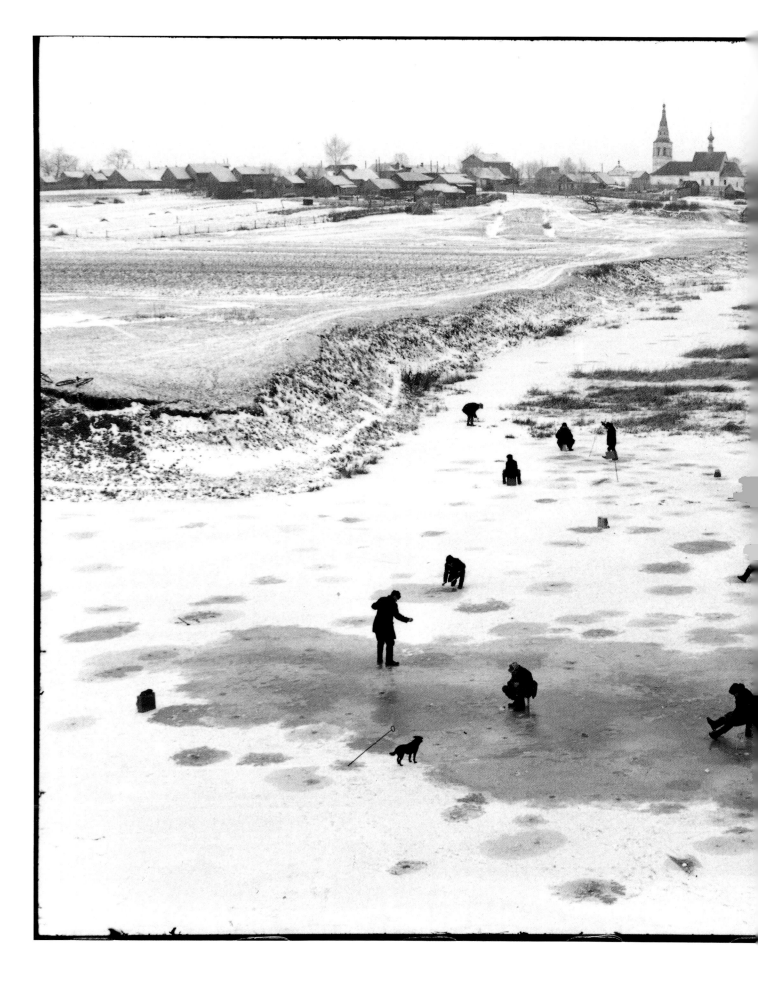

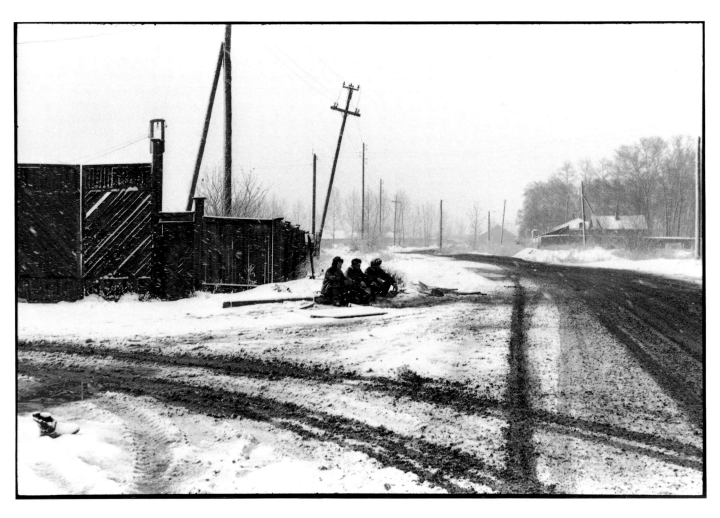

Near Irkutstk, Siberia, USSR, 1972

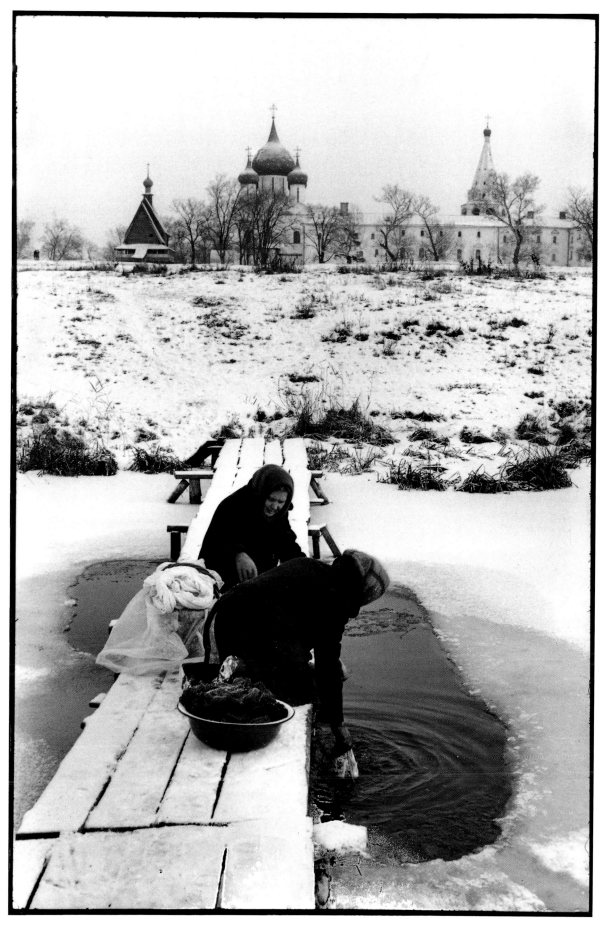

Washerwomen,
Suzdal, USSR, 1972

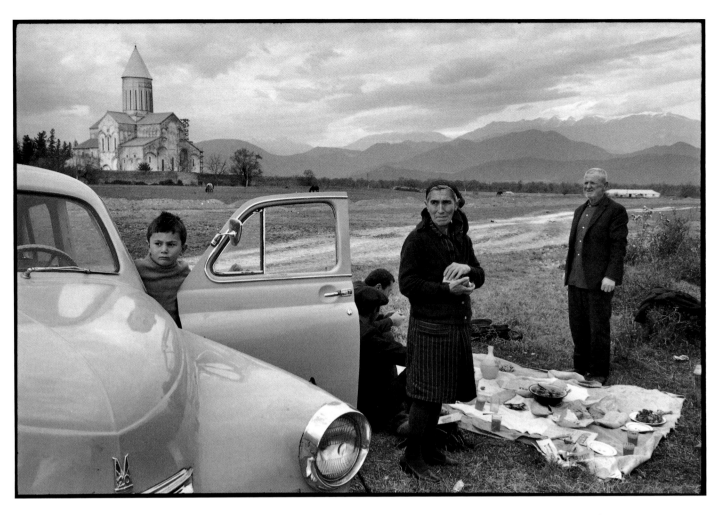

St George's day, Alaverdi Monastery, Telavi, Georgia, USSR, 1972

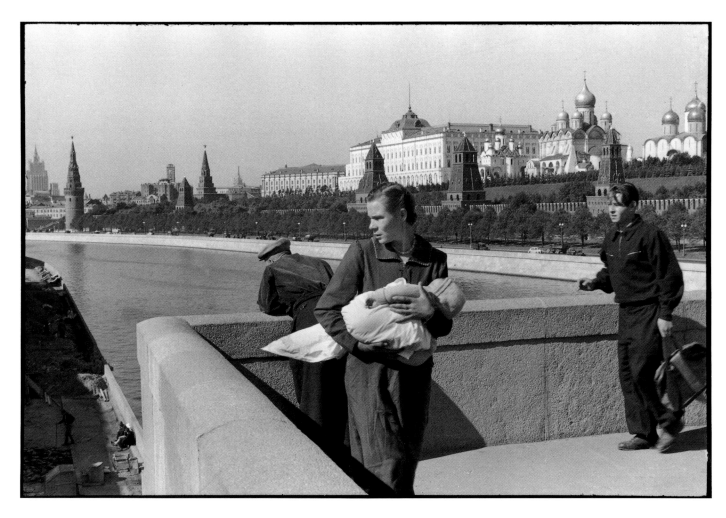

View of the Kremlin from the banks of the Moskva, Moscow, USSR, 1954

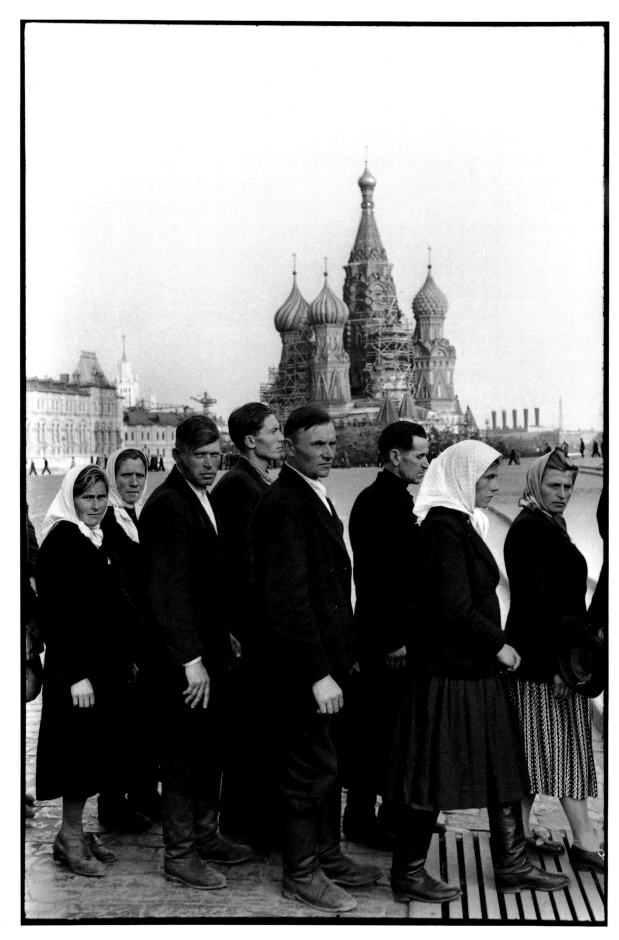

Lenin's and Stalin's
Mausoleum, Red
Square, Moscow,
USSR, 1954

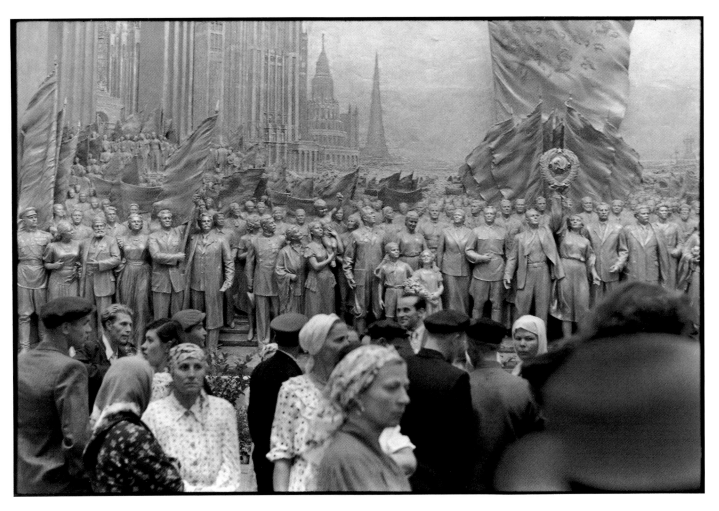

Agricultural show, Moscow, USSR, 1954

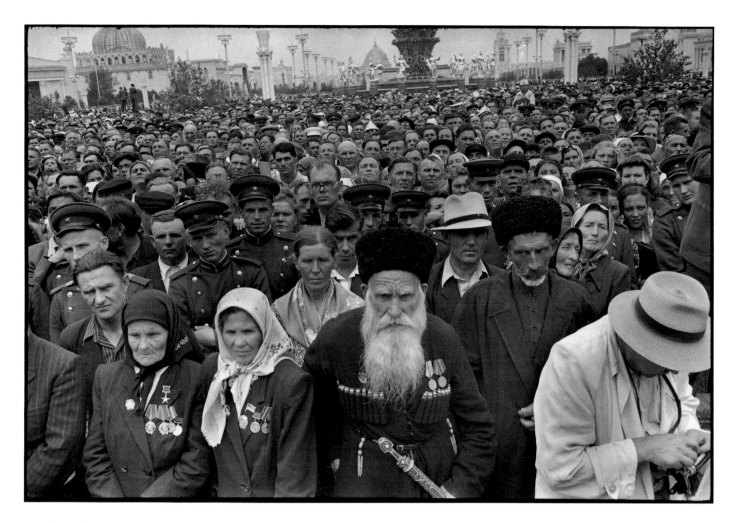

Agricultural show, Moscow, USSR, 1954

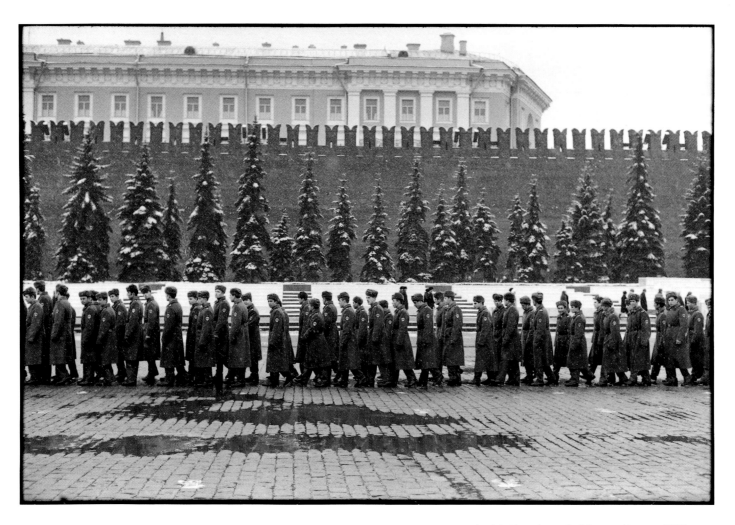

Lenin's Mausoleum, Red Square, Moscow, USSR, 1972

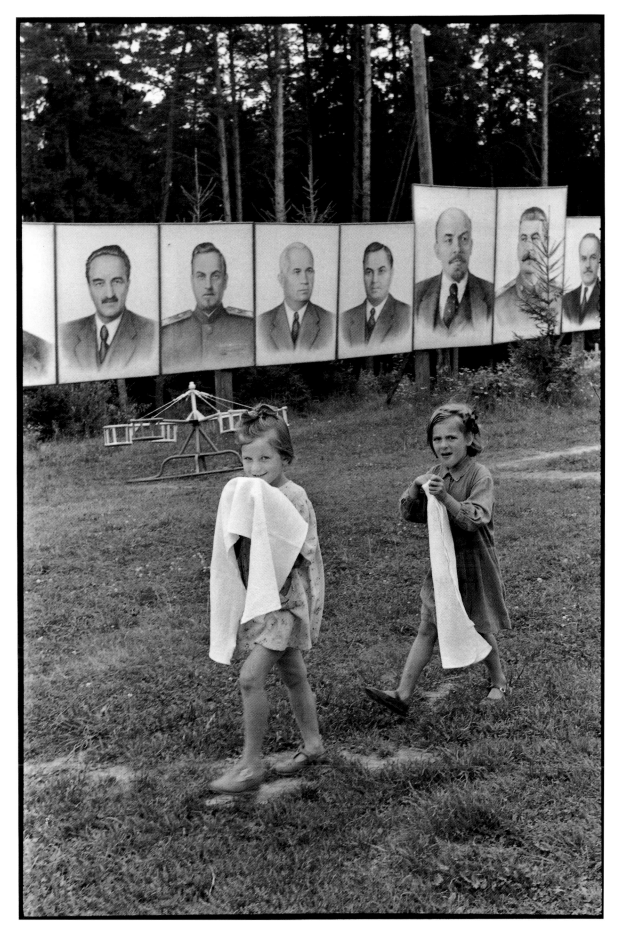

Pioneer camp,
near Moscow,
USSR, 1954

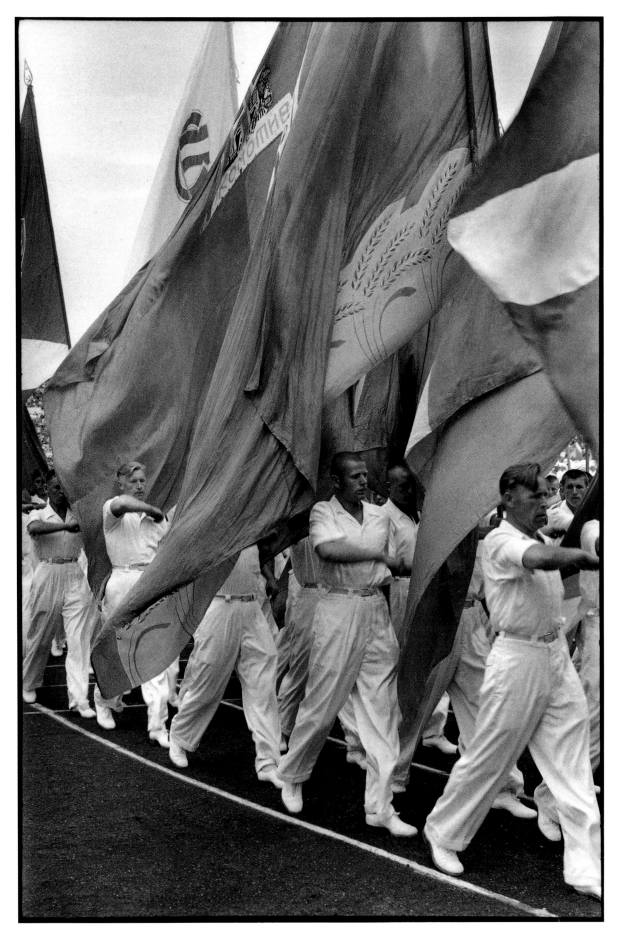

Sports gala,
Dynamo
Stadium,
Moscow,
USSR, 1954

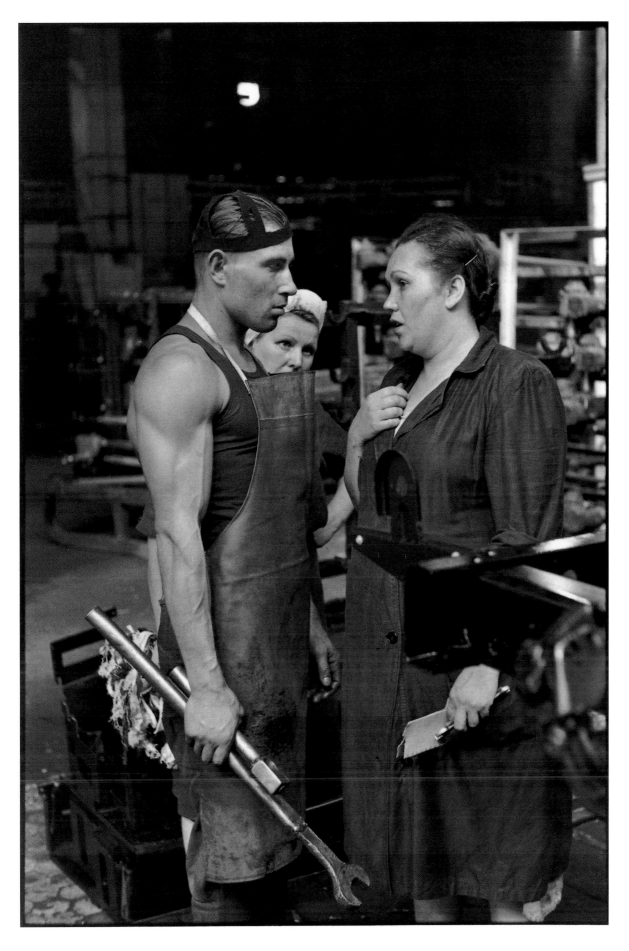

Worker and
supervisor, car
factory, Moscow,
USSR, 1954

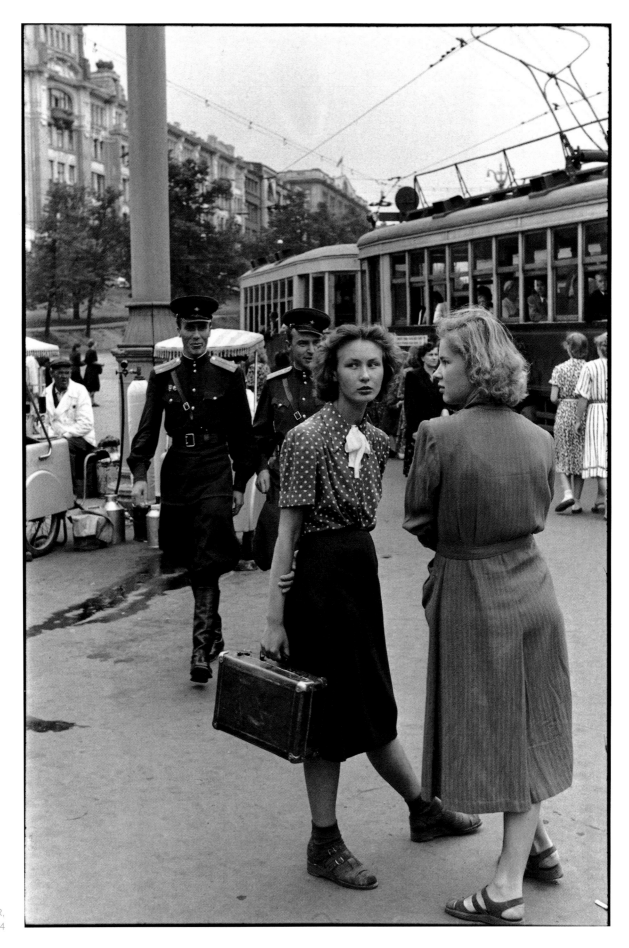

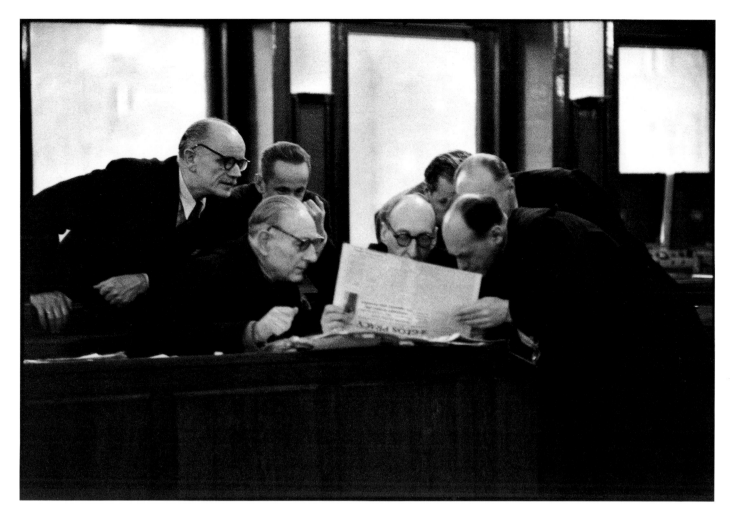

During 'Polish October', national mass movement leading to a brief liberalization of
power, with Gomulka, Warsaw, Poland, 1956

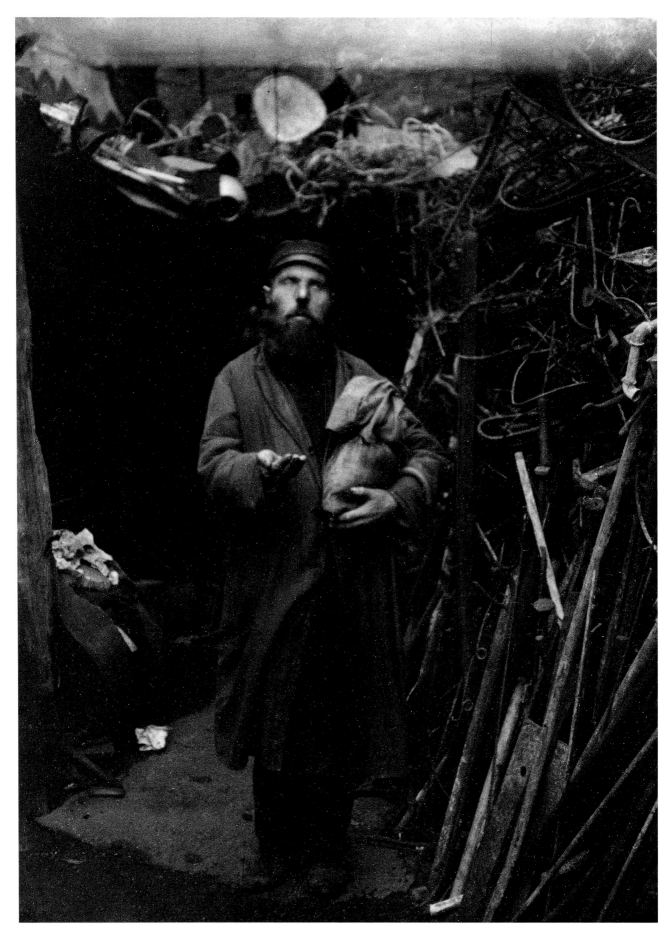

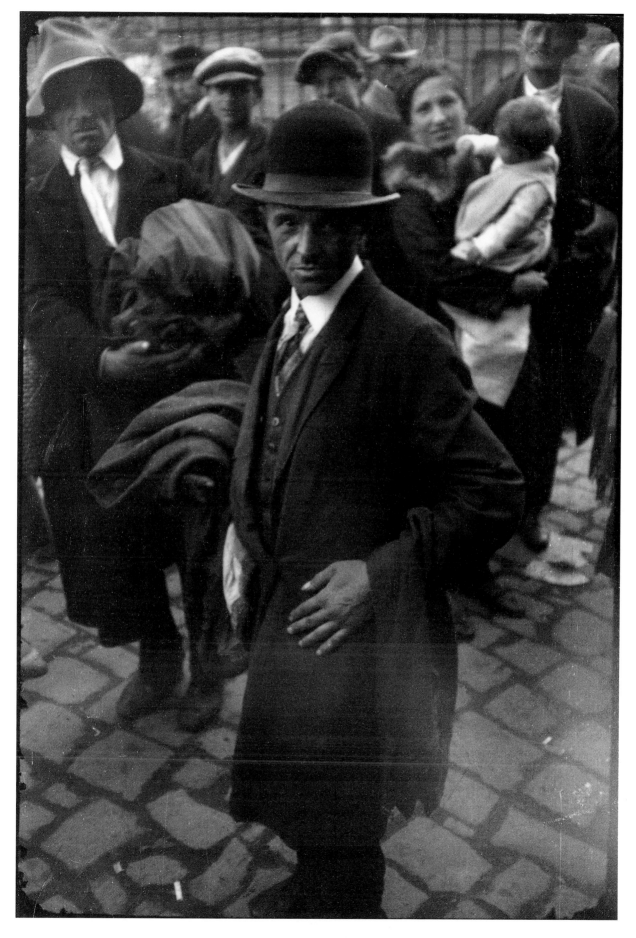

Cracow,
Poland,
1931

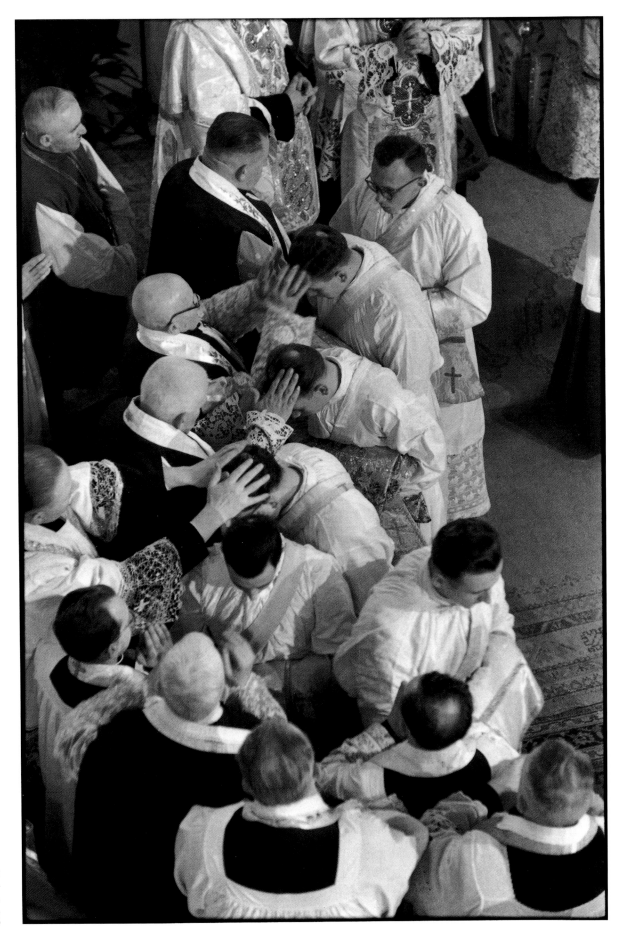

Cardinal Wyszyński
ordaining twenty-
two priests,
Warsaw, Poland,
1956

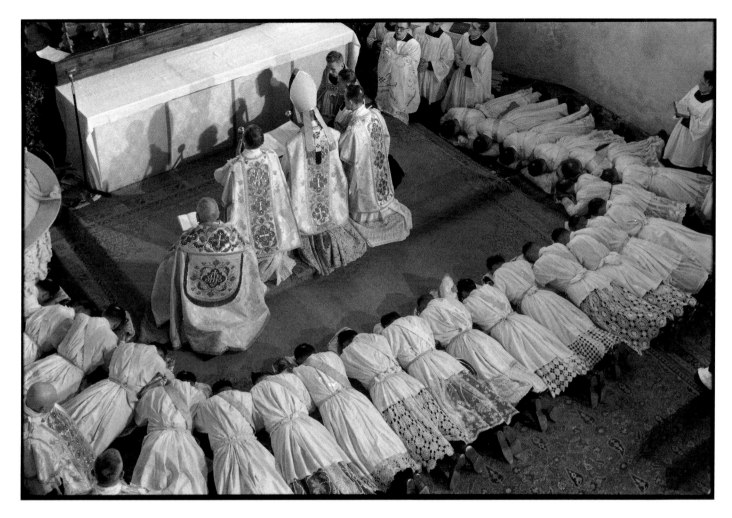

Cardinal Wyszyński ordaining twenty-two priests, Warsaw, Poland, 1956

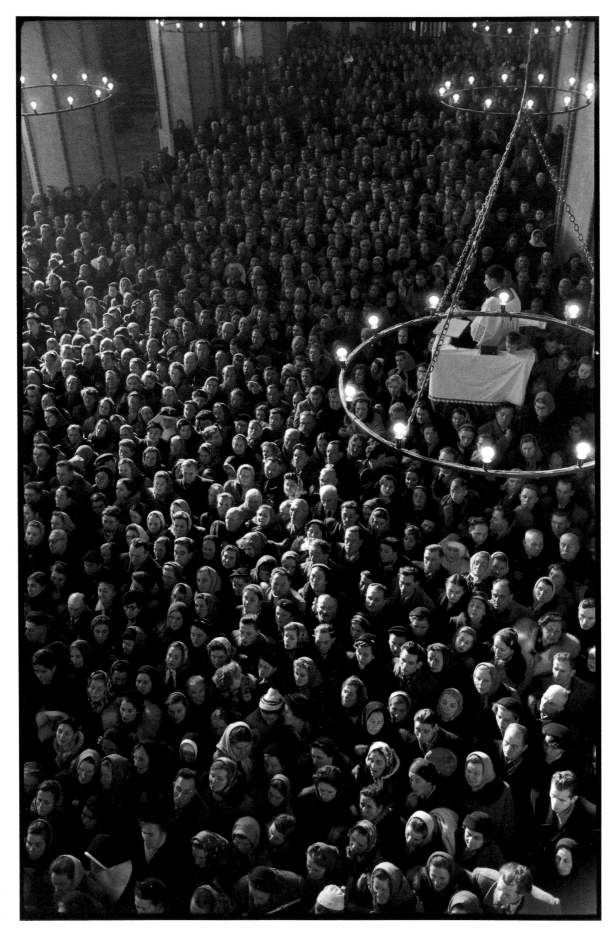

Cardinal Wyszyński
celebrating Mass,
Warsaw, Poland, 1956

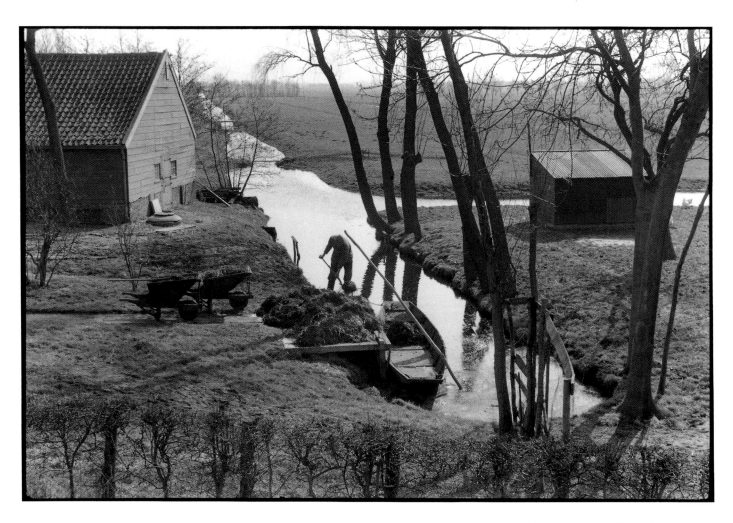

Near Schoonhoven, The Netherlands, 1961

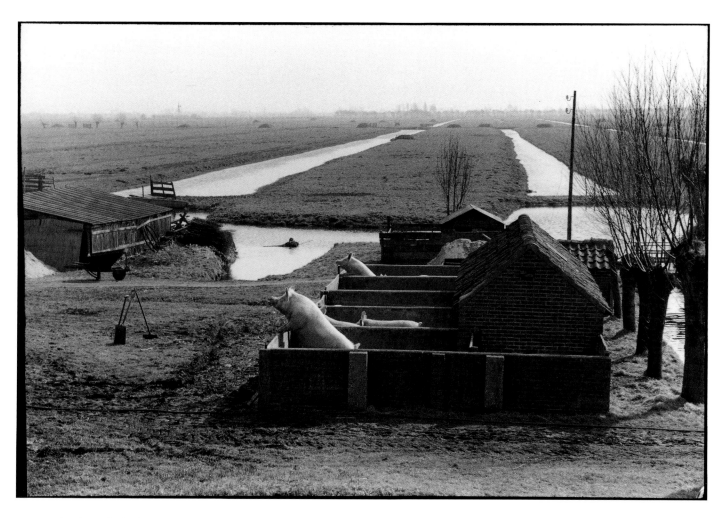

Near Gouda, The Netherlands, 1956

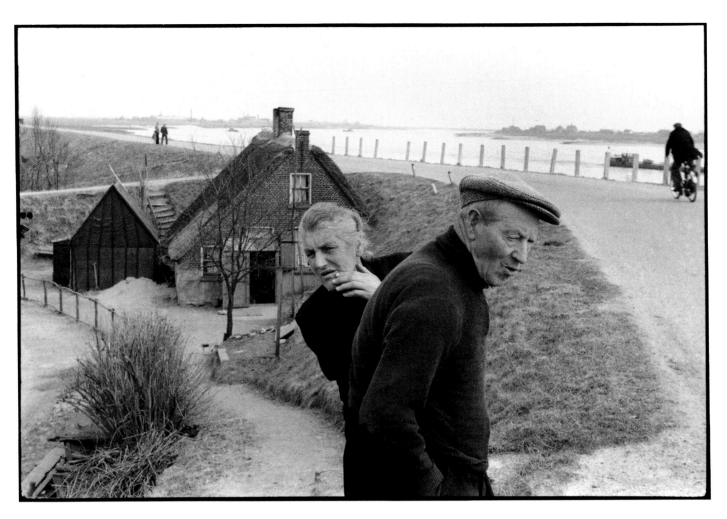

Herwijnen, Gelderland, The Netherlands, 1956

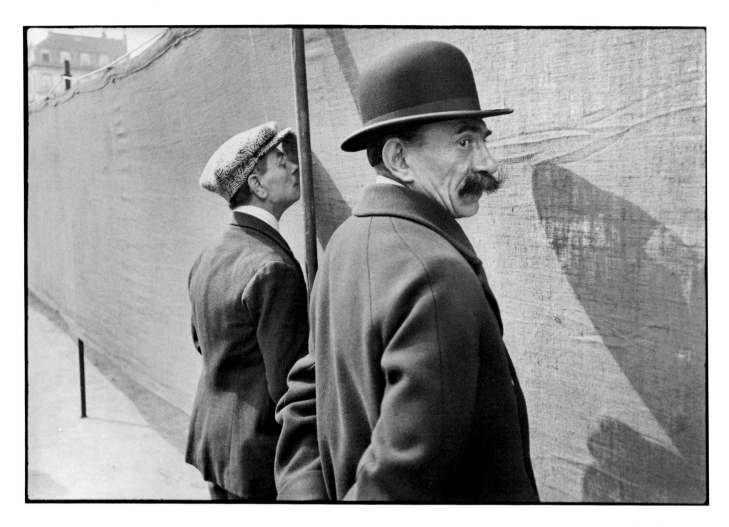

Brussels, Belgium, 1932

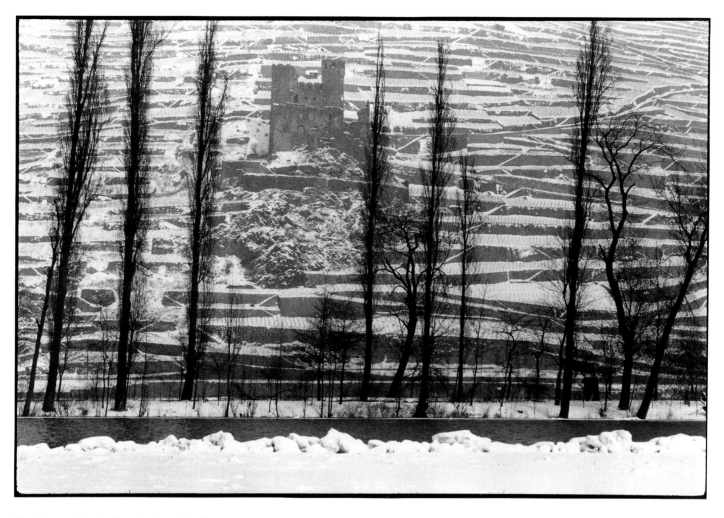

Near Bingen, Rhineland, Federal Republic of Germany, 1956

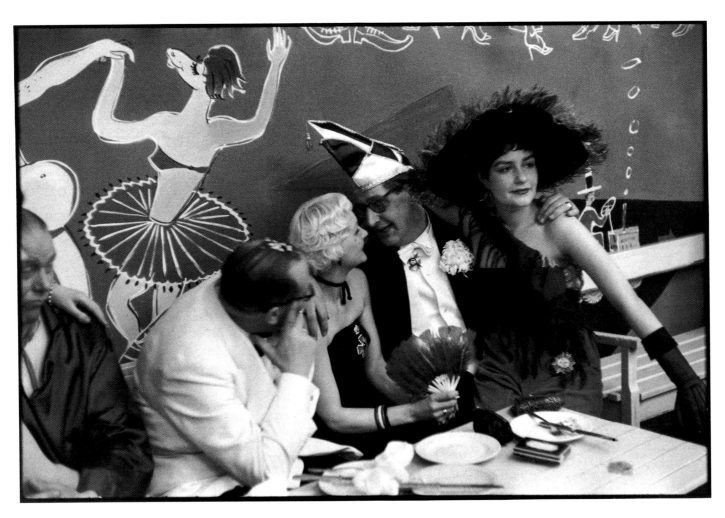

Carnival, Düsseldorf, Rhineland,
Federal Republic of Germany, 1956

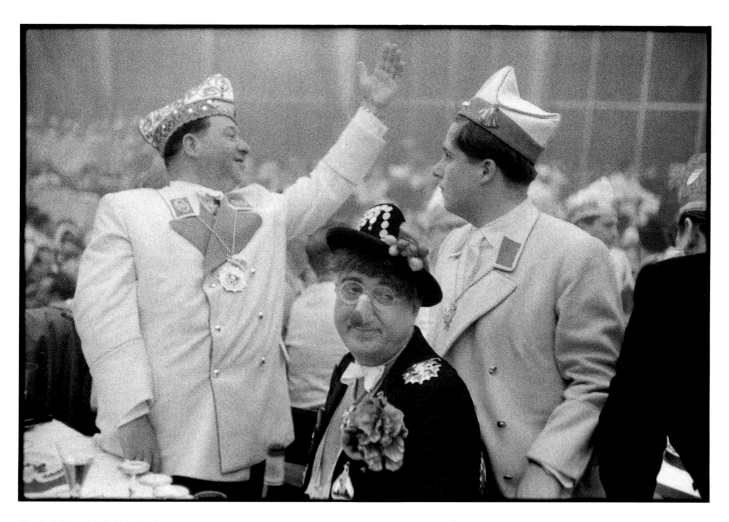

Carnival, Düsseldorf, Rhineland,
Federal Republic of Germany, 1956

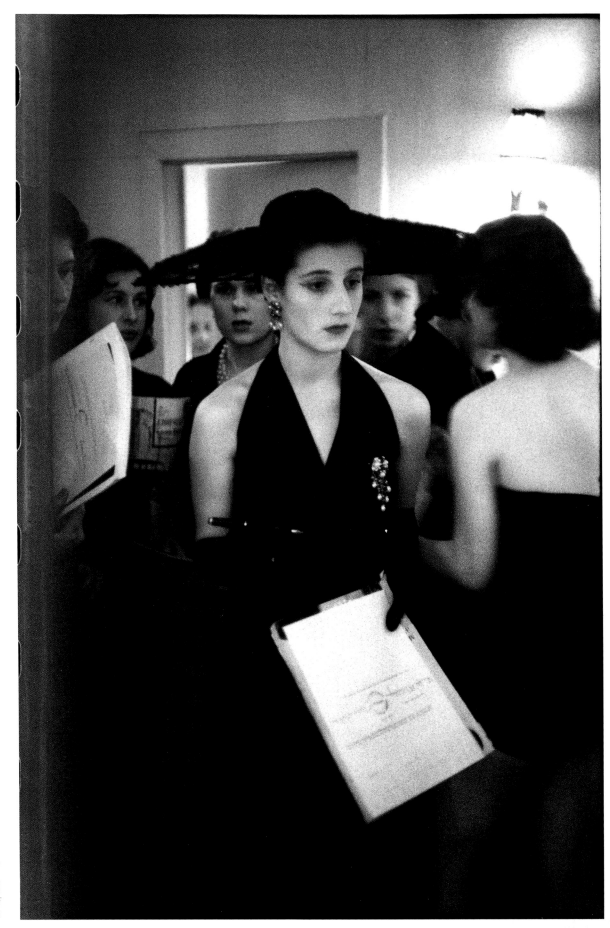

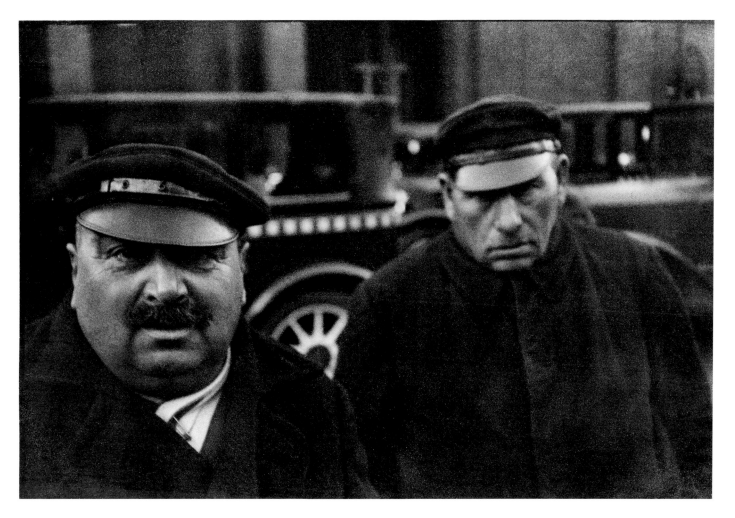

Taxi drivers, Berlin, Germany, 1931

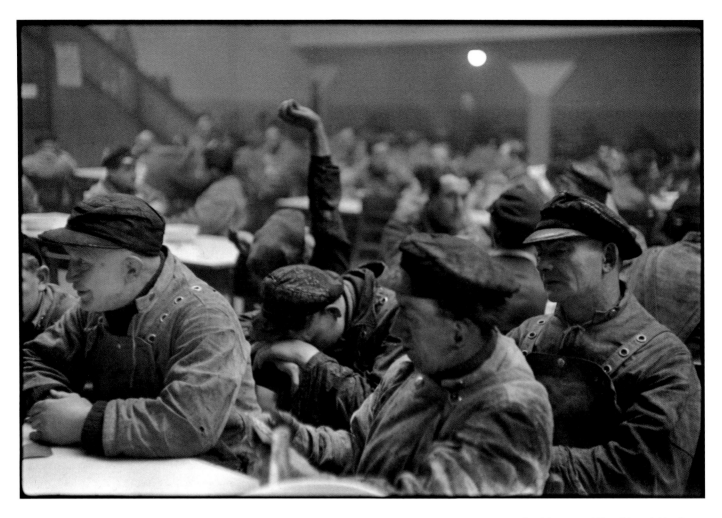

Break between shifts, shipyard, Hamburg,
Federal Republic of Germany, 1952

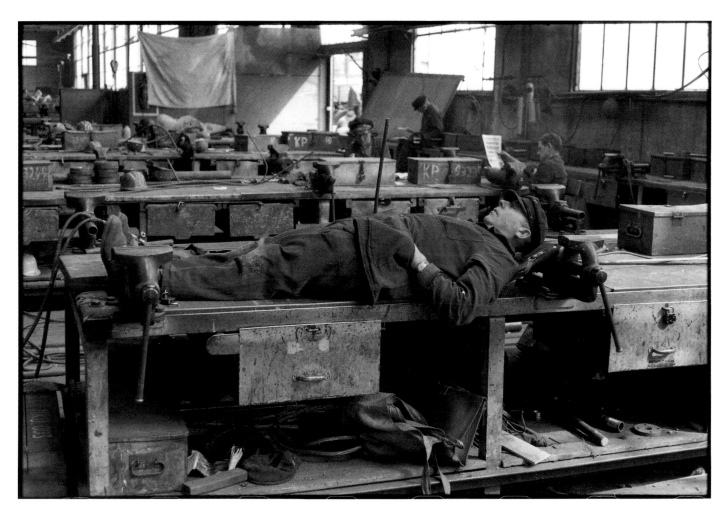

Break between shifts, shipyard, Bremen,
Federal Republic of Germany, 1962

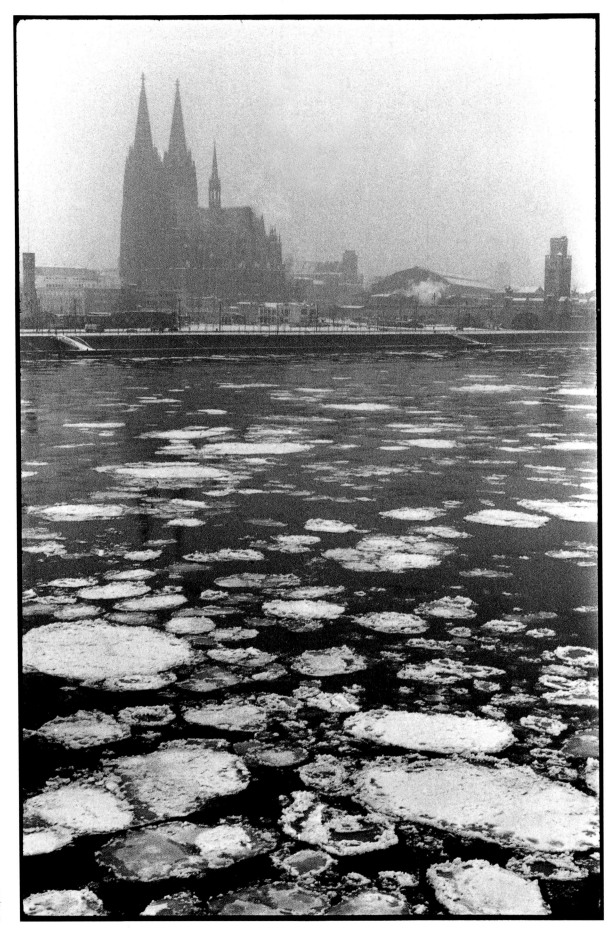

Cologne, Federal
Republic of
Germany, 1956